THIS YOUNG MONSTER

Charlie Fox is a writer who lives in London. He was born in 1991. His work has appeared in many publications including *frieze*, *Cabinet*, *Sight & Sound*, *ArtReview*, *The Wire* and *The White Review*.

Fitzcarraldo Editions

THIS YOUNG MONSTER

CHARLIE FOX

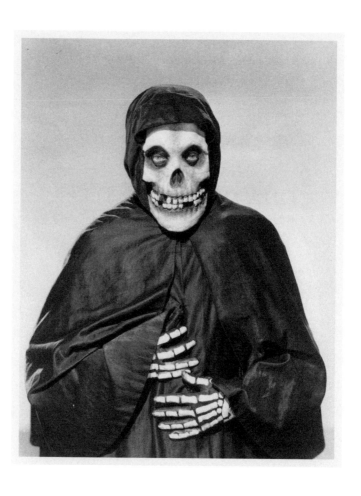

For my brothers

CONTENTS

'I call "monster" every original inexhaustible beauty.'
— Alfred Jarry

'With a terrifying roar
The house exploded again.'
— John Ashbery

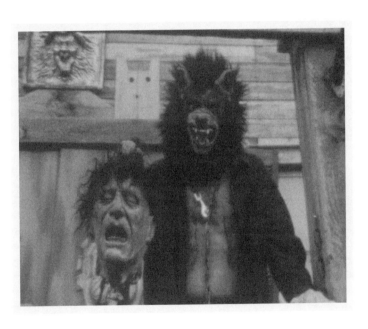

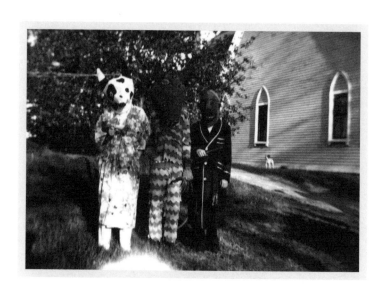

SELF-PORTRAIT AS A WEREWOLF

'Are there many little boys who think they are
a monster?'
— Anne Carson

Hey Beast,
There's a scary picture I want to show you: three kids
outside their house, all wearing masks and grinning like
devils. One has a crocodile head, another is a cartoon
dog covered with funky spots and the last wears a de-
ranged face drawn on a paper bag, eyes bugged, mouth
crammed with jackal teeth. They're dead now. They
appear in this book called *Haunted Air* (2010) collecting
old American pictures by anonymous photographers
of folk in costume on Halloween. I'm guessing from
the fuzziness of the picture that it must have been taken
in the 1930s, roughly aligning with the time that Judy
Garland crash-landed in Oz. There are tons of other pic-
tures I could have fetched for you – David Bowie on the
cover of *Diamond Dogs* (1974), half-alien, half-hound –
or the Count's shadow climbing the stairs from *Nosferatu*
(1922), but beginning on Halloween seemed like the
most potent clue to the festivities up ahead. Ghosts run
amok, identities melt, everybody's in costume, and real-
ity is nowhere to be found. Think of it as an invitation
asking you, as Captain Beefheart once howled, 'to come
out and meet the monster tonight!'
 You're one of the first monsters I remember meeting,
both as a cartoon in Disney's *Beauty and the Beast* (1991)
and in huge illustrated books where you were usually de-
picted with a touch of the owl or hog. Almost everybody,
if they're lucky, sees monsters for the first time in fairy
tales where the traditional response to their appearance

is astonishment. When the Evil Queen in *Snow White and The Seven Dwarfs* (1937) changes into a witch thanks to her psychotropic potion, even her beloved raven leaps back in fright and hides inside a skull by her cauldron until he's just an eyeball, panicky, staring out of somebody else's head.

Scary pictures were one of my earliest obsessions and I'll try to explain why later on in this dumb fan letter to you, dear Beast. I don't have a picture of myself to hand: not the snapshot in which I appear wearing a werewolf mask as a small boy on my birthday, or the other where I'm a vampire stalking through wet grass, sun low and red, squinting like a drunk through slender trees. I was a woozy child, the world was slow, it was fun to watch myself disappear in the mirror, face turning full moon white with make-up, fake blood drooling sweetly from my mouth, a little black crayon around the eyes for that buried alive stare: that was my face and yet it was not. When I discovered a new monster lurking in the forest of a film history book – David Naughton in *An American Werewolf in London* (1981), gazing at the hand that's no longer quite his own, or Lon Chaney as *The Phantom of the Opera* (1925), gaunt and scalded by acid – I felt the same shiver: fear speedballing with wonder. I was electrified inside. That was the monster feeling.

Right now, of course, there are monstrous entertainments everywhere. Check the data: 'ghost drone' videos on YouTube (military tech enlisted to spook trick-or-treaters on Halloween); sell-out exhibitions dedicated to Alexander McQueen at the Met in New York and the Victoria & Albert Museum in London; the pop cultural ubiquity of zombies who now have their own parades in cities worldwide; the enormous success of the television series *Stranger Things* (2016), in which a bloodthirsty

alien known only as 'The Monster' prowls 1980s sub-urbia; FKA Twigs videos, especially 'Water Me' (2014), directed by Jesse Kanda, where the singer is turned into a post-human doll sprung from the uncanny valley; and Oneohtrix Point Never's album *Garden of Delete* (2015), conjuring puberty as a nightmare state through scrambled fragments of heavy metal, noise and electronic dance music, or its artwork showing a pre-teen boy, mid-scream, his liquid flesh melting away to reveal a robotic eyeball, synthetic teeth and bone.[*]

The abundance of monsters in circulation now proves that the collective imagination is in a strange and disorientating state, at once fearful of what can be done to the body through technology or trauma and fascinated by the possibilities those changes represent.

[*] FYI, sir, *Stranger Things* is the most mainstream symptom of a fascination with 1980s horror that's haunted pop culture for the last decade or more. Boutique labels such as Death Waltz and Waxwork deal exclusively in reissuing the soundtracks to the era's horror flicks on vinyl in luxurious packaging whilst an ongoing plague of remake mania afflicts old favourites such as *Friday the 13th* (1980; 2009), *A Nightmare on Elm Street* (1984; 2010) or *Poltergeist* (1982; 2015). This vogue might be due to nostalgia for the last era when monsters were neither slick digital chimeras nor ghost train squeaks in the dark (see the franchise horror of *Paranormal Activity*, 2007- or *REC*, 2007-2014) but flesh-and-blood bogeymen working in prosthetics and costumes, and thus imbued with villainous charisma. Or it may be another sign of a present cultural moment all about time warps and revivals, either demonically (re)possessing material from the past or bringing it back from the dead.

Yet there's also the feeling, brought to life throughout *Stranger Things* and creepily barfed back up in its closing moments, that what's really pined for is the ultra-cosy depiction of American home life that predominates in those movies just before the monster appears, as if the originals weren't always rancid with irony.

In our present situation, dude, this seems like a good moment to go back, rewind, assemble some sort of history of monstrous wunderkinds and refract the present through them to mind-altering effect. If the monster is so now, it's also one of art's oldest inventions: there could be no other classification for the hydra killed by Hercules. If I was making a taxonomy, I'd keep you in the same group ('Mythological Monsters') though you don't have the same connections to antiquity as the serpent or the maenads who slaughtered Orpheus and, through godly punishment, were transformed into shrieking trees. Then there are the new versions of old monsters like the grunge werewolves or vampires seen in *Buffy the Vampire Slayer* (1997-2003), which I was obsessed with in childhood and haven't stopped thinking about since – *Buffy* uses supernatural metaphors to deal with real horrors so skilfully (all lovers are vampires) – and the contemporary monsters responsible for hideous deeds that still excite a slimy fascination. Check this recent newsflash, Beast: 'Following the killing, the teenage couple took a bath to wash off the blood, had sex and watched four *Twilight* vampire films, abandoning plans to kill themselves'. ('What if I'm not the hero? What if I'm the bad guy?' as Robert Pattinson asks in the first movie when he's playing Edward, the hot young bloodsucker.) And the body can be mutilated by accident or from birth and assume a monstrous condition. I've spent plenty of time reading and re-reading testimony from the woman who received the first facial transplant in 2005 (she was mauled by her dog, which was trying to rouse her from an overdose of sleeping pills) who said, of the months before the operation, that she had 'the face of a monster'. 'She had no mouth', a report continues, 'and her teeth and gums were exposed, skull-like.'

A monster is a fear assuming a form. I never thought at first, dear Beast, that the whole book would be so rotten with dead things. But I'm not as fascinated by the monster's Rorschach blot properties as I am with another more dizzying (and urgent) pair of questions, entwined like Cupid and Psyche or Sid and Nancy: namely, what's it like to be a monster and what kind of art does such an identification demand you make?

Mute and solitary, I guess you haven't made much art but your condition has been an inspiration for all kinds of artists. In the video for *Thriller* (1983), Michael Jackson turned into a werewolf and dancing zombie after warning his date, 'I'm not like other guys,' hinting at the erotic complications bedevilling his personal life that were only rumours back then. Meanwhile, Ryan Trecartin became a helium-voiced lion cub in his phantasmagorical romp *A Family Finds Entertainment* (2004) to prove all the brain-melting imaginative possibilities available at the turn of the millennium. I figured you'd understand, not just because you were hexed early in your youth (Disney has you transformed by a witch's spell; Cocteau makes the change a punishment for your parents 'who didn't believe in magic') but also to acknowledge that you've hungrily chased children through their dreams since 1740 when Gabrielle-Suzanne Barbot de Villeneuve (a fancy dame) turned your existence into the stuff of fable. As a metaphor, the monster (especially this belief in the beast inside taking over the body) remains indestructible, haunting any notion of the human. A ghoul leaps out of the closet at a little girl at the start of Trecartin's film (Scissorhands on angel dust) and she ignores him. I wanted my monsters to sneak me out of the house. When there was a full moon, I'd stand outside in the dark and howl. I

rewatched Jean Cocteau's version of the story from 1946 a little while ago and the old faun makes being a monster look like no fun at all. Tell me Bacchus didn't have a killer time at his parties. Ovid writes in *Metamorphoses* that he was brought to term through a gash in his father's leg and later poisoned his grandparents with deadly snakes. The kids in the video for Aphex Twin's 'Come to Daddy' (1997) (directed by Chris Cunningham) have a wonderful time, terrorizing the same London estate that Alexander de Large roams in Stanley Kubrick's *A Clockwork Orange* (1971) – Beastie, you haven't seen the last of him. I used to watch 'Come to Daddy' over and over again, half-scared, half-delighted by watching these kids, all wearing masks of the Aphex Twin's bearded and grinning face, cavorting in the alleys like a bunch of feral Victorian urchins. Aphex (Richard D. James) is the poltergeist snarling the chorus inside the TV ('I'll eat your soul!') and the appliance later spawns that freaky cadaver, suggesting Nosferatu mated with the creature from *Alien* (1979), which howls a storm wind in an old woman's face: the ultimate juvenile delinquent.

I'm through with thinking of the monster as a wholly negative role, which is your curse, since you live in wait for a love that will probably never arrive. Even though the origin of the word lies in the Latin 'monere' ('to warn') and plenty of monsters' lives are cautionary tales, that doesn't mean their transgressions should be rejected. Leave that to the well-behaved children. In her book, *Our Vampires, Ourselves* (1995) the theorist Nina Auerbach claims that 'a vampire is simply more alive than it should be', but doesn't 'more alive', in all its ambiguity, sound exciting? Wrecking those boundaries is a thrill. Transformation, which is the monster's whole

game, simultaneously altering their bodies and changing the surrounding culture like radioactive fall-out, is a mode of catharsis, along with a strategy for abjuring a body that feels way too vulnerable or out of control. These changes can be accomplished with magic spells, prosthetics and all the other means of invention offered by art. In certain cases, the title 'monster' should be reclaimed in a spirit of punk triumph to become a great honour. Monsters cause trouble, they disturb definitions, they discombobulate what we think we mean. All of which is brave and wild, not to mention something like art's task.

I was going to ask you about being queer. That seems like a plain perverse question to ask a supernatural creature but then monsters exuberantly mess with conventional ideas about sexuality. Even in J. M. Barrie's *Peter Pan* (1911), there are 'fairies on their way home from an orgy'. Maybe you've just shut down, maybe there's no such thing as intimacy for a Beast and you're like Ducky from *Pretty in Pink* (1986), all alone in your haunted castle at night? *Black Swan* (2010) was the last film I remember that dealt with supernatural beast-fucking anyway, that raw backstage moment where Von Rothbart the magician takes the form of a black monster (was he a kind of werewolf combined with an ogre? He was machismo off the leash) ravishing Natalie Portman's rival. Sucker for a tale of metamorphosis that I am, no matter how much schlock it contains, I loved *Black Swan*, even if some audiences find it (in every sense) way too hysterical. But only a truly heartless brat couldn't get rapturous at the moment where Portman's beastliness and beauty couple in that deranged *pas de deux* near the end and she turns into that magnificent winged bird in the middle of the dance.

In *La Belle et La Bête*, you're definitely a metaphor for illicit love, unable to romance Beauty in your animal form and left just 'to lay down and die'. Your tears turn into diamonds; your face fades. When I was small, I always thought your demise was brutal and your return as a prince, eyes green as polluted lakes, was a grotesque error. Only the good witch Angela Carter, in her story 'The Tiger's Bride' from *The Bloody Chamber* (1979), has Beauty becoming a beast, too, pearls turning into water that slips down her 'beautiful fur'. You could've eaten up raw honey together like opium, gobbled up aristocrats and licked the blood off each other's paws. Shadowing the lives of nearly all my favourite monsters is some resistance towards being loved. And love can be monstrous, too, lovers can devour each other, like the beasts in Maurice Sendak's story book, *Where the Wild Things Are* (1963): 'We'll eat you up! / We love you so!'

And you certainly helped me articulate my own feelings of otherness back when I was the same age as Sendak's hero Max in his white wolf suit. Some kids identify with monsters to make sense of themselves. Adults are inscrutable, other children are cruel but monsters are misfits, too, and make an ideal gang of imaginary friends. To me, cheering for the hero in a cartoon would have felt as unnatural as playing sports. I wanted the wolf puppet in *The NeverEnding Story* (1984) to take the lead role and spend the whole film skulking through that landscape covered in dry ice. For some kids, this identification is related to the early rumblings of their sexuality. 'To hell with Dorothy,' the film-maker John Waters writes in his memoir *Shock Value* (1981): 'The Witch had pretty green skin, a beautiful castle and all those wonderful winged monkeys. Dorothy just had a dull home in Kansas, dreary farmer aunt and uncle

and an ugly little dog that bothered the neighbours. I even tried dressing up like the Witch to terrify my neighbourhood.' In the Italian documentary *Divine Waters*, shot in 1985, his mother recalls his childhood, observing, 'He always liked the villain in the story: he liked the Wicked Witch in *Snow White*.' On the subject of his dressing up in costume and channelling these deviant heroes, she notes, 'He was always somebody and it was always the bad person.' That's obviously an allegiance for a child also marked as a difficult or 'bad' child to make. (Waters remembers his mother calling him 'an odd duck' as a boy when she thought he was out of earshot.) It also seems to forecast other tastes or infatuations that grow through adolescence and into adulthood. In a 2015 interview with *Hazlitt* magazine the writer Derek McCormack, who has dwelt, deliriously, on the experience of living with a diseased and queer body in his fiction, echoed this experience, claiming, 'I was the Wicked Witch four Halloweens in a row as a kid [...] I wanted the green... I loved everything about her. I feel that it's an identification that a lot of screwed-up kids make.' In another letter, I can tell you all about the school teacher I had who swore, 'The gays will die out because they can't breed.'

Now, before I tell you the story of my own childhood desire for supernatural powers or a lycanthropic body to soothe the routine boredom of being a misshapen child in suburbia, Beastie, let's note that assembling anything close to an autobiography gives me the creeps, like a third-person dream in which I have to survey my own corpse. At a time when craven self-promotion and mock-confessional bloviating remain, unstoppably, all the rage, there seems to be a certain *unheimlich* power in zoning out, staged disappearance or vampiric imitation,

especially when my subjects are up to the same tricks, making myths and masking what might be dopily called their 'authentic' selves. Rainer Werner Fassbinder traded in confession, yes, but like a smart hustler he always remembered the necessity of delivering such intimate material in a spirit of mad flamboyance or via the occasional act of cunning displacement. Like a ventriloquist, he frequently used figures unlike himself, including a transgender woman, to voice his most scarifying personal revelations.

I hated autobiography as a child, too, dude, which is why I was repeatedly told off for drawing myself as a vampire, a werewolf or witch in class. Studying the picture, I'd feel the telltale jolt of recognition; 'There I am.' And I liked to draw the moon watching over the proceedings like a severed head and roll out the night around myself in its shiny batwing coat. Old problems came back if I wanted to draw myself in a so-called normal way: the schnoz rubber, evocative of the masks worn by nightmare clowns. Obliterate the face; begin the face again, like that moment in Disney's *Beauty and the Beast* when you drag your claws across the portrait, maiming the handsome prince you used to be.

I was obsessed with horror in any form, knowing passages from *Dracula* (1897) better than the order of the alphabet ('the window blind blew back with the wind that rushed in, and in the aperture of the broken panes there was the head of a great, gaunt grey wolf') and checking out books on special effects to see how my body could be artfully disfigured with prosthetics: fangs here, purple scars there. I knew the origins of all the different monsters, like a freaky poem: werewolves transform when the full moon comes out, poor Edward Scissorhands was a boy left unfinished by his inventor (the concept

of a gentle monster touches a soft and peculiar zone of the heart), zombies are the dead brought back to life, the Joker from *Batman* fell into chemical waste that turned his hair green, his lips red and made him insane, and ordinary people become vampires once they are bitten in the neck. The conditions in these various tales are metaphors for disability since they imagine damaged or abnormal bodies and spell out the reasons for their existence, much like a doctor explaining an affliction to a patient. The future is often bleak with no possibility of romance or cure. Think of the devastating moment in *Edward Scissorhands* (1990), so like your farewell to Belle, where Kim (Winona Ryder) tells Edward, 'Hold me,' and knowing his touch is deadly, he murmurs, 'I can't.' These creation myths are like warped parodies of birth scenes; the characters they produce are problem children. I didn't know that my obsession with monsters was bound up with feelings I had that my body was beastly, too, operating as if it was stitched together from mismatched parts: wonky gait, shaking limbs, flat feet, panic always crackling in my stomach, eyeballs askew, slow learner, a total freak. All this confusion and noise came with being 'me', whoever that was, and I wondered until the room got dark about how I might abandon my body in a faraway ditch and come back from the dead as something way stranger than a little boy. Horror and gothic fiction, as you know, are the forms where we go to rehearse our fears about the body coming undone or being infected by unknown entities, sensations that I understood deep inside.

Special anxieties are kindled by the thought of deformed children, manifesting a fear about what the human may become in the future and stimulating bad dreams about innocence and beauty fatefully warped.

'It's got ten fingers and ten toes,' the painter Francis Bacon remembered his mother telling a friend on the telephone about a new addition to their family before adding, bewildered, 'As if everyone was expecting some sort of monster.' A flesh-crawl moment occurs in David Lynch's *Eraserhead* (1977) when a distraught mother-to-be moans, 'They're not even sure it *is* a baby.' For a monster to be created, something must go wrong at the beginning of the story.

Wise to the fact that I needed an origin story just like you, my mother tracked all the problems with my brain and body back to a haemorrhage she had while I was in the womb and she was discovering who killed Laura Palmer on that night's episode of Lynch's *Twin Peaks* (1990-91). The denouement proved that Bob was responsible, having occupied the body of Leland Palmer, the girl's father. The scene runs as if the world is under a malign enchantment: a giant brings word of what's about to oc-cur, a white horse materializes in the living room where the evil deed is done and the killing is accomplished in groggiest slow motion like everyone's reeling from the effects of dissociative drugs. Bob is a beast that we see in the mirror grinning back at us, a trick that hints he's within everyone, waiting to take over, werewolf-like. Maddie, Laura's brunette double, screams and the noise distorts, girl warping into animal – 'somebody help me!' – as Bob twirls her in a spotlight. Sometimes Leland is in control and Bob vanishes; reality ghosts back into the nightmare. The world is still cursed when Maddie lies dead: lock-groove on the turntable, drone on the soundtrack. Fade out on red curtains to suggest the end of a magic act. Bob may be related to you if you think of your turn from boy into beast mirroring Leland's switch from ordinary fellow into demon: they're both alike as

tales of split selves. And you're both warnings to curious girls, telling them to beware big bad men, which we can trace back to Bluebeard (is he in your neighbourhood?) who kept his castle's attic crammed with the corpses of his slaughtered brides.

According to *Twin Peaks'* lore, Bob has no earthly form (except for an owl in the woods). He's a spirit of malevolence who possesses the innocent after first appearing to them in their dreams. 'He is Bob, eager for fun', according to a rhyme recited by another character in need of an exorcist, 'he wears a smile, everybody, run!' His appearance is another example of what David Lynch once referred to in typically cryptic fashion as 'the inside/out thing', a horror that only exists inside the head coming out to play in reality. In *Twin Peaks*, the boundaries between earthly woodland and dreamscape dissolve with little more than the swaying of Douglas fir needles. This thought excites a different intensity of dread than any trip to your magic castle since the darkness of the woods is brought indoors; supernatural menace obeys none of the regulations we're taught in fairy tales. The 'inside/outside thing' is one of the most acute ways of thinking about what a monster is: something from the mind manifesting here, three-dimensional and ferocious. That doesn't only happen in stories.

In his book *The Elephant Man and Other Reminiscences* (1923), the doctor Frederick Treves describes his first encounter with his most famous patient, Joseph Merrick, whose body was the stuff of medical legend, encrusted with tumours that distorted his figure and obscured much of his face. Lynch, who adapted the story of their relationship into a film in 1980, likened these unruly growths to 'smoke trapped under the skin'. Merrick was

twenty-one years old when Treves saw him in a grim Victorian shop: 'Lit by the faint blue of the gas jet, this figure was the embodiment of loneliness,' he writes, 'it might have been a captive in a cavern or a wizard watching for unholy manifestations in a ghostly flame.' The precise nature of Merrick's condition is difficult to ascertain. Contrary reports state that he was afflicted by neurofibromatosis, where patients are marked by an anarchic excess of tumours, whilst more adventurous practitioners claim he had an extreme case of Proteus syndrome, a relatively new-fangled malady first identified in the 1970s and named after the shapeshifting sea god from Greek myth because its sufferers are afflicted with weirdly mutated bones.

Much like your first meeting with Belle in the moonlit woods where she faints in terror, Treves' encounter captures the horrors and thrills of looking at a monster. Seeing what can happen to the body stimulates a hideous internal squelch – we come face to face with the instability of our own flesh – but these sensations are also frequently coupled with feelings of glee. Treves knew he was staring at the kind of chimerical figure only previously imagined in mythology and adopted him at once, concerned by the treatment Merrick received and animated by the knowledge that he could achieve renown with this 'discovery'. Early in their acquaintanceship, the doctor soothed himself with the belief that Merrick was so mentally disabled he could have no knowledge of his plight, which turned out not to be the case. When his intelligence was revealed, Treves' sense of tragedy grew more acute:

> Here was a man in the heyday of his youth who was
> so vilely deformed that everyone he met confronted

him with a look of horror and disgust. He was taken
from the country to be exhibited as a monstrosity and
an object of loathing. He was shunned like a leper,
housed like a wild beast and got his only view of the
world from a peephole in a showman's cart.

Until he was found by Treves, the freak show was
Merrick's habitat. In a short story called 'Scenes from
the Life of a Double Monster' (1958), Vladimir Nabokov
assumes the voice of a conjoined twin – his brother
remains mute. The narrator tells of how they were ex-
hibited together by devious relatives, including various
'newly acquired uncles' scenting lucre on their deformed
bodies and how, as 'the rarest of freaks', they became ob-
jects of macabre fascination in their hometown. Lurid
rumours claim that the boys' deformity is inevitable
owing to the circumstances of their conception since a
'German collector of birds' or 'a taxidermist' raped their
mother, as if that crime could shape what emerged from
the womb. Unspeakable acts can produce equally unnat-
ural gifts.

In the course of all his usual contemplation of twins
and their sinister allure, Nabokov coins the classifica-
tion 'monsterhood' to define these early years when the
boys journeyed all over the map for crowds to gawk
at them, suggesting this state was transient and, like
childhood, could be outgrown. I'm going to swipe this
term from the old butterfly catcher; another name for
it would be 'adolescence'. Everyone experiences mon-
sterhood in their teens: the body mutates, new chemicals
flow through your veins, parents turn loathsome, good
behaviour goes to hell. The need for a remedy to these
bodily and psychic disorientations is often entwined
with all the wicked fun you can have when monsterhood

peaks, thanks to drink, drugs, fucking, and the transformative powers of art. All big fun that shouldn't be recoiled from as somehow insignificant or merely the domain of snot-nosed kids. Getting high is a way more noble occupation than getting rich. It still amazes me that there isn't a more *Buffy*-like treatment of your tale as an account of adolescence since most retellings have you, the brash young prince, hexed in what would seem to be your teens or early twenties. Plenty of teenagers look in the mirror (if they can bear to look at all) and hate what they see, too. Whilst talking about horror movies in an interview from 2015, Daniel Lopatin (alias Oneohtrix Point Never) said, 'The most appropriate time for that content to make sense is puberty because your body is a site of all these horrific things, and I think kids like watching horror movies because they feel that way.' Maybe you're in the castle at this very moment, listening to My Bloody Valentine and tripping on acid as every teenager has a right to do.

But in every retelling I can find, your life in solitary confinement sucks, even if you possess all the luxuries that Cocteau lays on in fantastic excess, the enchanted forest, magic fruits, the severed arms on the walls attending to your every whim (I always wonder if they're supposed to make you think of the mutilated limbs of dead bodies from the war) and it must break your big dark heart just knowing that some monsters strut around in daylight since the condition can assume subtler forms than thick fur and fangs.

The *enfant terrible* is a more discreet manifestation of anxiety projected monstrous children, their talents turning from the supernatural to the simply prodigious but still causing all kinds of trouble. Alex from *A Clockwork Orange* (1971) is a teenage Mephistopheles

with a taste for Beethoven and milk spiked with amphet-amine. He also enjoys rambunctiously indulging in all the 'horror-show' antics he can – gang-bangs, beatings, murder – with the energy of a hoodlum in a musical: 'Come and get one in the yarbles!' Indeed, speaking the baroque Nadsat slang invented by the book's author Anthony Burgess and twirling a cane, Alex is like a sci-fi descendent of Dickens' Artful Dodger. His foppish corrections officer Mr Deltoid asks, 'Is it some devil gets inside of you?' and that's how he charms the audience in that spirit ('O, my brothers', he calls us), whispering his narration in our ears as if we were a bunch of droogs. There's no werewolf split between good or wicked im-pulses, only the government reprogramming him to be virtuous through its behaviour modification scheme.

Kubrick revels in the devilish properties of his me-dium by making cinema the stimulus that causes his hero to transform. Screaming as his eyes almost pop from his skull, Alex watches atrocities flicker on the screen. Those same properties soon came back to terrify Kubrick as his enticement to the audience – 'Look at how great it is being evil!' – led to kids performing copycat crimes followed by a near-three-decade ban in Britain. Alex's whole seduction is so knowing: remember that moment when he toasts the songbird with a glass of milk and his stare fixes not on the glamorous 'devotchka' in question but straight at the audience; we're in cahoots.

Only someone as senseless as a piece of moon rock could be immune to Malcolm McDowell's charms in the movie since he takes the role of Alex as if the boy was some wicked prince, eyes alight, dedicated to sensual intoxication and always grinning like existence is a big filthy joke. Even when he wanders back home, now un-able to express his sadistic impulses, it still plays about

his mouth. But he soon discovers that Basil the snake, his slithering familiar, has been sold and there's a blonde he-man on the couch between his mother and father. A factory floor bully masquerading as a heartthrob, he swears, 'It wouldn't be fair now or right for me to go and leave you two to the tender mercies of this young monster who's been like no real son at all.' (Sometimes a line jumps up and yells, 'You're it!') Not that Little Alex's story degenerates into a tale of woe– he's a rare thing, a monster who triumphs. The government will return him to his old self and the future promises to be one huge banquet, full of naked girls, golden fruit and 'Ludwig Van'. Monsterhood regained. 'Some men', as a lady observes in Cocteau's film, 'are much more monstrous on the inside.'

But, Beast, I never asked you about your transformation. When your hands buckled into paws and fangs grew in your mouth and your body was slowly covered in shaggy black fur, the boy you used to be vanishing in the mirror... did it feel good?

Your droog and humble narrator,
Fox

PS. I'm not so much of a wastoid that the gothic implications of all this are lost on me, sir. Mary Shelley's *Frankenstein* (1818) comes to life with a quartet of letters that an arctic explorer writes to his sister. The wretched figure of Victor Frankenstein emerges, gaunt, through the blizzard and unfurls the story which took 'the gallant vessel' of his life and 'wrecked it – thus!' *Dracula* claims to be a compendium of letters, journal entries, notes-to-self and transcriptions of recordings, which means it's also a fugue for different voices. I like swooping,

bat-like, between forms; I like that ominous sensation of the book shape-shifting in your hands. A boy jumps up out of nowhere like a scarecrow, makes his confession and then – boo! – we're suddenly elsewhere.

'THE LITTLE BOY WHO CAN'T
BE DAMAGED!'

'Well, it seems to me that my coming into this world
was a terribly hard fall.'
—— Kaspar Hauser

On a chill afternoon in autumn 1898, Buster Keaton
went head over heels again: he saw sky where the land
should be, heard rough beasts howling in his skull and,
as his little jackrabbit heart thumped from terror, felt the
wind shaking his bones into jelly. He was three years
old but this wasn't a little child's hi-def fever dream nor
were there evil spirits at play under his skin: the chaos
was real. He was whirling through the sky, all the dogs
were barking, deranged, the fields were exploding and
the houses were upside down. Kansas, which lay some-
where above or down below him, was very far away. A
tornado had arrived, sweeping the boy up into air and
now the world was making no sense at all. Soon this in-
cident would be known as the greatest of the child's early
stunts. In the films that came later, he always played the
moonstruck boy who found himself involved in just this
sort of outlandish trouble. There would be wars and un-
settled weather (cyclones, gales, avalanches); he might
hit the floor, flat, as if freshly slain by high noon bullets
or dash up a rickety ladder, making its legs do a sick
moonshiner's jig back and forth. Some unreadable com-
munication raced between his muscles, brain and magic
skeleton, at once performing the crazed acrobatics and
assuring he would arise unharmed.

 When the weather turned ominous, Buster lay sleep-
ing but soon climbed out of bed, curiosity kindled by
the eerie susurration surrounding his house. 'I went to

the open window,' as he recounts in his autobiography *My Wonderful World of Slapstick* (1960), 'to investigate the swishing.' Tornados are typically very quiet until they come close, coating the land with a weird undersea hush. The air turns waxy, the passing of time is measured out in heartbeats and the sun is the afternoon's loot, buried somewhere in the clouds. Certain tornados have a drunken swagger, tilting to-and-fro as they suck in barns and throw up trash. Others are like thunderclouds, overgrown, ink-dark, and some are enormous smokestacks dancing, rowdy, in the distance. By Buster's recollection, the tornado which came to collect him was the faithful twister, snaking over the parched terrain. He was on tiptoes, peeping eagerly at the approaching menace when suddenly, as he claims, 'I was sucked out by the circling winds.' If you read the dizzy testimonials of those who have survived being seized by a tornado, almost everyone caught in the vortex remembers reciting extravagant prayers and hallucinating shattered coffins. But young Buster was presumably not thinking anything except for early childhood's fuzzy pop-up book thoughts: panic! Some hungry animal must have come and snatched him up. Picture his mother wandering, stricken, from room to room, calling out his name and, when she sees the open window, stopping as still as the sky outside.

But for a mischievous child, the whole experience might be huge fun, like a wild new rollercoaster's mixture of vertiginous joy and sheer terror. In Kansas, at that time, only the birds and the bats flew: a boy achieved flight by being spun in his father's arms or by jumping off the roof of his house. If you had no hot-air balloon to steal or no golden wings stitched onto your back, the sky was unknown territory yet here he was, swooping over

the land like a happy devil. The tornado proceeded to obliterate the little town of Piqua where the family lived and Buster was born, but lay the child down smoothly. (He achieved tornado-assisted lift-off in Kansas two years before Frank L. Baum wrote of Dorothy accomplishing the same feat.) Once the storm faded, he was discovered in the dirt, stunned and streets away from home. Some anonymous figure came and carried him to their cellar, handing the boy over when his father arrived, breathless from the search.

That story may be apocryphal, a tall tale concocted by Joe Keaton later in order to promote the family's vaudeville act, but interpret it as pure myth and the event acquires a premonitory force. This episode would be the auspicious beginning to a life that was subsequently all about achieving outrageous highs and allowing for terrifying falls, staging accidents, escaping injuries and entertaining danger. Throughout his life Buster remained the poor innocent thrown around by circumstances beyond his control. A far more wily character, his father sniffed out major dough as he led the child back through the storm's aftermath: here was a fantasy, a readymade lure for simple folk. Come and see the boy who fell to Earth! He survived a fate that claimed the lives of men three times his size! But other thoughts must have rumbled through his mind, too: what kind of scary hint was this occurrence? Joe Keaton wasn't far from the world of backwoods demonology and folk superstition. And there was indeed a lingering sense of something enchanted about the boy. To the crowds, he would look as if he was simply sprung from a different substance, too limber in his skittering or too light when he fell to be made of flesh and blood: like he was a bewitched marionette. He always looked like he was

dreaming, as if the air he inhaled was laced with ether. His mother was sixteen and his father ten years older when he started wooing her by night at the carnival. Myra was a dark-haired soubrette who sang and played piano; her father ran the show. Joe was a prodigal chancer adrift, supposedly, from an obscure Midwestern town named Dogwalk. (By Buster's recollection, the place once lay in Indiana but he inherited his showman father's mischievous indifference towards facts.) Before discovering his shy nymph, Joe rode freight trains to California hoping to stumble onto a Gold Rush fortune, but had 'not much luck', according to his son. Trading the dowser's wand for a map, he set out to Oklahoma in search of a few cheap acres for sale but that get-rich-quick dream burned down fast, too. Somehow the rogue charmed his way into the travelling circus and straight-away long-slumbering talents emerged. In Buster's fond description, he was 'a self-taught acrobat and natural clown'.

The company scrambled across the country, pitching up in small town fields by early morning light and providing entertainment as the hawkers purveyed a potion (their tonics routinely mixed dashes of cocaine, witch doctor aphrodisiacs and a swirl of miscellaneous placebos) to an audience of curious rubes. Bleak and unchanging as conditions were for poor folks at the end of the century, it's easy to see how the yearly appearance of all these attractions could turn the rough world Technicolor. Before and after, there were slaughtered dreams, dust, cruel birds, and land, as James Agee still found nearly half a century later in *Let Us Now Praise Famous Men* (1941), acrid with 'the sourness of dead fire'. But for a few days you could score a planet of candy floss, gasp at the men eating fire or the ladies juggling

knives and stare at the human oddities.

At first Joe Keaton was billed as an 'eccentric dancer', tumbling onstage in the faithful costume that he would soon have his son adopt, combining a bedraggled clown wig with trousers baggy as a decommissioned zeppelin and proceeding to unleash a firecracker racket with his hot feet. Sometimes Myra played hectic accompaniment on the piano as Joe exhibited his notorious mule kick, knocking hats from the heads of various local goofballs to smitten applause. They were married in 1894, just before she hit eighteen: the wedding cost two dollars; she was pregnant with Buster. Medicine shows were small time, mere 'tent work' in the era's showbiz argot, compared with the flash world of vaudeville and the couple quickly switched circuits, headlining alongside a young Harry Houdini as the muscular escapologist did card tricks and slipped out of handcuffs. Buster was born the following October and, according to another oft-repeated legend, it was Houdini who named him six months later when the child tumbled down a flight of stairs, miraculously landing at its foot without sustaining a scratch or beginning to cry. A 'buster' was the backstage name for a bad injury. The fateful nickname stuck and slowly he wandered into their act.

The boy had a preternatural talent for slapstick. 'Did your father teach you how to fall?', an eager journalist asked decades later when Buster was far into grizzled middle age: 'Nope', he replied, 'it just seemed to come natural.' Knowing this was the big gimmick he'd always hungered for, Joe used all his huckster cunning and styled his four-year old son as 'The Little Boy Who Can't Be Damaged!' This was back when every show had a gimmick: if nobody had fallen for the indestructible boy, Joe could've obtained a crocodile and wrestled

with the beast onstage, or practised magic, shocking the crowds as Myra spun shimmering tunes from a calliope. Still in his ample trousers and clown wig, Joe assumed the role of a crazed father endlessly attempting to discipline his little hellion. Buster was helped into a costume, transforming into the impish double of his Pop, all scratchy black beard and outsized tailcoat – he referred to them as their 'grotesque' or 'misfit' clothes. Joe barked fatherly wisdom while hurling Buster around the stage: 'Throwing me', as Buster claimed, 'through the scenery, out into the wings and down onto the bass drum in the orchestra pit.' The show must have won extra laughs from Joe's verbal energy: his highfalutin' educational monologue totally at odds with the savage methods he employed in order to knock some sense into his irrepressible charge, but the act was truly all about the ductile wonder of his son's body and the joy of seeing a boy transformed into a supernatural projectile.

Meanwhile, Myra swapped the piano for a saxophone, improvising on the horn as all the lunacy happened in her cool orbit. During hot summer shows, she traded her favourite farmer's daughter dress (funkily embroidered with Native American glyphs and melting black roses) for a swimming costume. Even on this scene, the saxophone was a bewildering distraction. According to Buster, most audiences 'didn't even know what the instrument was'. Though they were peripatetic by necessity, the family's larks were always performed against a backdrop depicting a barnyard: a make-believe stake in the nation's heartland. Houses in Buster's films are always perverse, falling around him as he watches, puzzled, coming inhabited with clever skeletons or accidentally resembling Expressionist asylums with their crooked windows and jagged roofs.

Not only were audiences drawn by peculiar music, the braggadocious claims about this tiny child's gifts or his bizarre invulnerability: his appearance must have chilled acres of expectant flesh. With his prematurely wizened mug, blanched by layers of make-up, Buster looked like a runaway ghoul. Even if he was feeling delighted inside, he decided to never crack a big grin: the comic's lifelong custom of keeping an expressionless face whatever injury he suffered was established by his fifth birthday. This created his eerie aura: amid all the bloody laughter, there was a boy looking as lonesome as a lost hound.

To befuddle the child protection societies that tracked the act's progress across the country with vulturous attention, Joe circulated extravagant rumours to the effect that Buster was a frisky teenage dwarf and his mother was his spellbound bride. New York City physicians tirelessly checked him for broken bones or lush bruises but discovered nothing and had to set him loose. The law was always monitoring them: Joe was frequently arrested for child cruelty and found himself spending jittery days between the bars with thieves and hoodlums. A hysterical reporter in California called Buster 'the most vociferously pitied child in the country'. (This was at a time when Lewis Hine's photographs of child labourers were making plain that streams of children's blood sustained the nation's brave industrial future.) Devious logic was required to beat the rap: if the law insisted that no child under the age of sixteen could legally perform acrobatics, cartwheel over a trapeze or play music for an audience, it never said anything about kicking him or her in the face.

Sometimes, so his father could escape the trouble of paying an extra fare, the boy was listed as a prop on

official forms and had to sleep under his mother's vo-
luminous skirts on train journeys. His autobiography's
early chapters are a montage of flaming hotels and over-
turned trains in which the family appear as panicked
extras, dashing away from the wreckage and into dark
fields. In promotional photographs shot on the run,
Buster's cherubic aspects are concealed by dressing him
up in bowler hat and trench coat, twirling a fancy gang-
ster's cane. The scheme was a success: far from looking
like a boy messing around in his Pop's best ballroom
threads, the plucky scamp appears unaccountably cool,
like a sly little prince on the make. Such was the crazed
rhythm of life on the road he had almost no schooling
but for the occasional vague lesson from his mother. Joe
dreamed of enlisting all their other children into the act
– the 'big family' gimmick guaranteed yet more cash –
but after a few discreet appearances they all escaped to
school. None of them possessed the same grace or ready
acceptance of danger as his first-born and even if they
had, their inclusion could have wrecked the act's special
chemistry. Perhaps this was strictly a father-son game:
Myra left after half a decade, attending to the other chil-
dren, and with her departure the act got wilder.

'I was so successful as a child performer,' Buster
claims in his autobiography, 'that it occurred to no one
to ask if there was something else I'd like to do when
I grew up.' He had an easy knack for mechanics and
calculations that was crucial for staging the artful gags
that run through his films – see how every new railway
beam lands in exactly the right place to knock the pre-
vious one from his path in *The General* (1926) – and he
wanted to be an engineer, though he didn't have any-
thing like the formal qualifications required for such
a career. When The Three Keatons played London,

Buster was awed by the performance of 'Peter the Great', a chimpanzee more boy than ape who concluded his act by putting on pyjamas and clambering into bed. There were ugly murmurings there and back home that Buster was none the wiser than these animals. The bearded rapscallion of childhood was growing to be, in his own mute way, beautiful, a heartbreaking mixture of boy and apparition. (He was happy to exploit the androgynous contours of his willowy figure, too, appearing as his own wife in 1921's *The Playhouse*.) Thrilling as his agility remains, the real captivating moments in his films are the pauses, those times where he falls into thought or swoons over a girl and only his spooked vulnerability is left to see.

With his mother off the stage, the early madness of the father-knows-best routine was reformulated into a hellacious cat-and-mouse game between Joe and Buster, a live-action forecast of a *Tom and Jerry* cartoon where the bloodthirsty feline was sometimes triumphant and which simultaneously suggested the most dysfunctional family relationship imaginable: 'Why, you little – !' They brained each other with brooms, the wigs flying together from their agitated heads. There were inevitable fumbles, nights where one or the other's aim was erratic and brutal accidents happened. Joe knocked Buster out for eighteen hours with a wonky kick to the boy's cranium; Buster had his revenge when he shot a basketball at the back of his father's head as Pop pretended to shave, the three-pointer's velocity knocking the paterfamilias into unconsciousness. At some point on this never-ending tour, Buster blasted his father in the face with a pop gun (dig that patricidal name!) and the act staggered on with Joe's face bloodied and blackened by powder. Before the curtain went up on a show at a dismal venue

in the North Country, a heartsick waif in the audience shot himself in the head. Father and son were duly dealt the task of trying to upstage a still-warm corpse and, as Buster vouched wearily, 'the corpse won'.

Vaudeville was dying, too, at a subtle rate. Green money seemed to be everywhere, radiant as the leaves on spring fever trees: theirs was still the only major 'wild child' act touring the country and all its success depended on Buster's feral splendour. But promoters were growing tougher and the fees were beginning to dwindle. New wonders flew over from Europe, shaken from their native territories by the First World War: any whip-cracking ringmaster looking for a hot act now had an international assortment to choose from, meaning the more familiar tricks of homegrown acts were rejected. There was the minstrel boom: country boys in blackface affecting plaintive 'Negro' croaks and singing 'Massah's in the Cold, Cold Ground'. Cinema had come to life as their mischief went on: the spectral figures of new comics repeating this or that hoary piece of comic schtick on film were now packing out theatres, circuses and even the tents. At this vital moment where the landscape was beginning to mutate underfoot, Joe began to drink like a man condemned, as if gloomily anticipating his obsolescence.

Sharp characters came calling from Hollywood, asking if he wanted to ditch the old game and make the leap to movies. This wouldn't be a risky transition: many of the era's comic one-reelers creak under their inheritance from vaudeville since the rhythms of comic cutting had yet to be struck and the escapades on screen rarely exploited film as anything other than recorded theatre. Buster was eager to play with the new medium. His own films are elaborate jigsaw puzzles, full of

ticklish parodies, complex tricks and moments where reality playfully misbehaves: in one flick, he journeys downriver on a horse as if the stead was a rowboat; in another, he was chased by thousands of cops for an unknown crime and he dived into a hole in California, only to reappear years later in a sun-dappled Chinese garden. Joe decided he didn't want the agita and rejected every gilded offer. (The man's instincts remained acute as radar: most agents were prone to major league skulduggery, that was traditional.) 'We spend years perfecting our act,' he yowled at the last fleet-footed wise guy to arrive from Los Angeles, 'and you wanna show it for a nickel a head on a dirty sheet?'

Their last show was a baffling fiasco. Joe leapt off the stage to chase a rogue promoter he spied in the audience onto the street, and started pummelling the trickster into mulch. Buster was left onstage alone, aged eighteen, a bored angel on the brink of adulthood: 'I didn't know what to do. I sang a song, recited, jigged until Pop came back.' The show was over, the act was dissolved, and Buster, suddenly a solo act, fled to New York to answer a studio courting him to appear in movies.

The claims repeated throughout his life that all this came 'natural' are innocent talk, a wide-eyed boy's attempt to explain himself, but the notion of such wonders coming unchecked makes them sound anything but everyday and only intensifies the air of astonishment that surrounded him. He had his first revelatory taste of hooch down by a river in Illinois when he was fourteen. All his catastrophic drinking in adulthood was a way of bringing back the sunny conditions of youth, if only until the blackouts came and every memory vanished. Aged six, he mimicked his beloved Houdini's handcuff act; by his mid-thirties he was writhing out of

straitjackets just as the master had done but he achieved the feat alone, whiskey-soaked and speechless, in the padded cells of various sanatoriums. Still chasing his father, the drinking was maybe a strategy to assure some fragile continuity between them, keeping the double act alive at a distance. Spend your early life attempting to outfox or beat a raging father and damaging psychological reverberations will inevitably come back to haunt you later on.

Or maybe there were no bad habits written into his blood and no critical traumas to blame. Far from the toxic prize of early stardom or lunatic activity with Pop warping his head, Buster had other troubles to battle and, like everything else in his past, they were uniquely his own. Since he was so young when he began to work, Buster never had to purposefully labour or shape himself according to its demands. Everything just happened through an odd kink of fate: he awoke in possession of prodigious gifts he could never shake. The future was laid out for him before he had the chance to interpret all its unruly promise or could be left alone to puzzle it over by himself. Talking pictures killed silent film, replaying in turn how they had crippled vaudeville and Buster got lost in the accompanying hullaballoo. His early life was nothing but high flight, every success yielding kaleidoscope-style to reveal another like the dancers cavorting through a Busby Berkeley production, but now there came the sudden fall: bad contracts, marriages that left him destitute and a long stretch of time lost in twilight, ruined.

Though his story might be seen as tragic, back at the wild beginning nobody could have guessed what snares and deserts lay up ahead. For those few glittering years, he could live with raucous joy, right at the centre of his

own strange world. When he tumbled, he landed, almost always, in the correct spot. So delicate and precise are his movements on film, they have the same tingling certainty as a sleepwalker's. For *Sherlock Jr.* (1924), he plays a projectionist who slips out of his body during a dream – a double exposure trick sees a ghostly young Buster marvel at his own sleeping figure – to climb into the story playing on the picture palace's screen. That trick was also a nod back to his past: he had first crossed onto the stage in the same spirit of dumb glee, making his debut without the slightest apprehension. He used to be a boy with electricity in his heart: all he had to wonder about was where he would play tomorrow night, the audience applauding and the awesome noise sweeping through his head again as he took a bow.

UNTITLED (FREAK)

'Nothing is seen... that ravishes the senses more, that
horrifies more, that provokes more terror or admi-
ration than the monsters, prodigies or abominations
through which we see the works of nature inverted,
mutilated and truncated.'
—— Pierre Boaistuau

'The two other girls sat stiffly, with downcast eyes,
strangely numb.'
—— Bruno Schulz

She famously wrote, 'Freaks was a thing I photographed
a lot' but what is a freak exactly?

The ghost responsible for that line – a brag with se-
rious fangs and claws – was Diane Arbus. She claimed
these characters have 'passed their test in life. They're
aristocrats.' Following a suicide, facts about the dead
person – 'their test in life' – can feel suddenly incom-
prehensible or opaque, offering no solace at all in the
attempt to make sense of what's happened or who has
vanished, thus this chaotic aftermath of quotations,
statements, ('case notes'?), riddles, buzzing incessantly
as a fridge.

She cut her wrists in the middle of an infernal New
York summer, 1971: fully dressed, she was discovered
in an empty bathtub, soused in blood and stuffed with
barbiturates.

(Trying hard to ensure none of these sentences too
closely resemble epitaphs.)

1923-1971.

She was named after the heroine in a Broadway show
called *Seventh Heaven.* She was an aristocrat, too, but one

of a way more conventional breed. New York royalty, her father ran a fur emporium on Fifth Avenue and her mother was a beauty whose depressive chills she would inherit.

Almost half a century after her death, she remains best known as New York's great freak photographer but what happens to an artist when she submerges herself in this secret world for years? And what exactly are the reasons (voyeuristic, carnivalesque, perverse) for her electric attraction to such characters?

In his fat cultural history, *Freaks: Myths and Images of the Secret Self* (1980), the critic Leslie Fielder notes that an estimated 75 million Americans visited freak shows every year throughout the 1960s. *Identical Twins, Roselle, NJ, 1967*: maybe the little girls from this picture in their eldritch Victorian smocks think they're auditioning for a double role in a TV adaptation of *Sleepy Hollow* to be broadcast next Halloween. Maybe they'd sing 'The Maid Freed From the Gallows' whilst clutching pumpkins that flashed wicked grins: 'Did you come to see me swinging / High from this hangman's tree?'

When she was small, she devoured books, especially collections of fairy tales. Quiet as a doll, she stared for hours from the windows of the family's palatial Manhattan apartment, surveying the lush terrain of Central Park.

She might have thought she was Rapunzel.

Questions, questions.

Is it odd to picture this imaginative child dashing through the park she came to wander in adulthood, looking Liddellesque and possibly wearing a crown weaved from winter branches or recalling the little figure glimpsed in Jacques Henri Lartigue's eerie self-portrait from 1901, taken when he was seven years old, a spectre

50

howling in his pyjamas, on the run from an assortment of multicoloured leopards, alligators, witches, wolves?

The freak sentence appears in the eponymous monograph assembled by Arbus and published soon after her death.

Symptoms, clues, dead-ends.

In a high school essay recounting her childhood, she wrote, 'I can always remember the feeling I had. I always felt warm and tired and there was warm sun on me and I didn't want to wake up.'

.

Disappearing into this labyrinth of biographical salvage might not be the wisest strategy for exploring exactly what's still so bewitching about Arbus' pictures. As the critic Rhonda Lieberman cannily noted whilst hailing her blockbuster retrospective in 2003 (the excess of delirious grotesquerie on show was underscored by its trash title, *Revelations*), 'If Arbus' life were the plot line of a biopic, one would bristle at all the time-honoured Woman Artist clichés: Boho princess escapes privilege (and early marriage to fashion photographer) for self-discovery as an artist by communing with freaks, within a few years producing an intense oeuvre, then kills herself.'

Her ascent to the premier photographer of oddball characters everywhere, from the early 1960s to the fiery edge of the 1970s, occurs against a backdrop of prevailing strangeness, radical havoc and public acknowledgement of shape-shifting sexual tastes. The mood of the time could be classified as deeply freakish without even bringing her into the frame. Switch on the TV: Detroit on fire, Los Angeles on fire, Paris on fire;

The Munsters (1964-66) in syndication and dead sons in the jungle 'Healter [sic] Skelter' scrawled in blood on the refrigerator door and *Fun House* by The Stooges (1970) on the turntable. 'A coven of thirteen members,' writes the feminist den mother Gloria Steinem in a piece for *New York Magazine*, published in April 1969, 'of W.I.T.C.H. (Women's International Terrorist Conspiracy from Hell, celebrating witches and gypsies as the first female resistance fighters) demonstrates against that bastion of white male supremacy, Wall Street. The next day the market falls five points.'

There were plenty of discreet textural presences in Arbus' photographs that matched up with the rather arch tastes of various hip young cadres. Her garish interiors provide a primer in 'camp' just as the concept (so notably glossed by the raffish Susan Sontag, a one-time Arbus subject who later slammed her in the 1977 essay 'America, Seen Through Photographs, Darkly') was accomplishing its kinky critical ascendance and permitting the re-examination of square suburban taste as an outré area of aesthetic interest*.

* In that essay, Madame Sontag, knives out, royally dissed Arbus as 'a dogged exponent of the Surrealist bluff.' Proclaiming herself redoubtably neither shocked or entranced by Arbus' convulsive beauties, she went on, 'The freakish is no longer a private zone, difficult of access. People who are bizarre, in sexual disgrace, emotionally vacant are seen daily on the newsstands, on TV, in the subways.' Never for a moment does she acknowledge that, several years after her death, Arbus' photographs are one of the reasons why 'the freakish is no longer a private zone' or for this heightened appreciation of 'the bizarre'.

Wrongheaded though she is in her approach to Arbus' photographs, the grey eminence's essay remains a thrilling rhetorical performance, describing Arbus' wish to 'violate her innocence' through picture-taking, and pays vivid tribute to their creepiness by noting, 'The *subjects* of Arbus' photographs

Every year, Fellini came into town with his latest trippy epic, conjured up after a treasure hunt within the grottos of his unconscious. Roll up! Roll up! Behold *Satyricon* (1969) in which a return to Ancient Rome is the only plausible way to report on the decadent present. Deranged orgies in the banquet hall, beasts roaming underground and ghostly cherubs running wild in the streets. Reality had acquired the texture of a far-out carnival long ago.

Amid all this activity, Arbus cast herself as 'an anthropologist of sorts', the kind of callow description which has made her collected works vulnerable to claims of cold-blooded ogling and exploitation ever after. Obey this wonky logic and her company of freaks (those dizzying 'things') has the dubious celebrity of a secret tribe to which only she has access. Oddly self-aggrandising yes, but there's a note of candour in play, too, which permits Arbus to stress the significant heritage of her project, aligning her with a practitioner such as August Sander whose vast work of portraiture *Face of Our Time* (1929) similarly apprehends its subjects in all their alien idiosyncrasy like some undiscovered breed of animal. At times she seems to have dedicated herself to an encyclopaedic celebration of North American tastelessness, scrupulously noting its once-contemporary (beehive hair) and hallucinogenic traits alike (see the dizzy Op-Art syncopation of the wallpaper backdropping the

... are all members of the same family.' That's supposed to identify another failing but the mind reels at its repulsive yet suggestive potential. Revise the alleged symptoms of inbred children and catch the correspondences with Arbus' subjects: deformity, uncanny repetition of certain features, spellbound vacuity. If Arbus provides a model for the American family, the institution must be sick at heart.

subjects of *Triplets in their bedroom, NJ, 1963*.). A sick truth but as The Rolling Stones sang in 1969, 'We all need someone we can feed on,' and vampire Arbus found her sustenance by wandering a peculiar territory whose inhabitants span from the sweetly eccentric (*Mexican dwarf in his hotel room, NYC 1970*) to the totally monstrous (*Patriotic young man with a flag, NYC 1967*).

But the real achievement of these pictures is that they seem to exist within a zone where nothing is normal, not the glum shag carpet nor the waxy cake the drag queen eats on her birthday. The surrealist and ecstatic pornographer Georges Bataille unwittingly hinted at this sensibility decades before Arbus picked up a camera in an essay on 'Deviations of Nature' from 1930: 'Beauty would be at the mercy of a definition as classical as that of the common measure. But each individual form escapes this common measure and is, to a certain degree, a monster.' She cast a spell on whatever she saw so that it came back infected. Those unnerved by her funhouse mirror effects or her supposedly rotten-hearted appropriation of the unfortunate as found material scorn Arbus as a 1960s P. T. Barnum who punks out on all the pathos of her misshapen subjects by presenting them as two-dimensional oddities. This is the same brand of acid but avowedly 'moral' criticism that was later used to flay Harmony Korine and David Lynch circa *Wild at Heart* (1990). Bataille (who kicks off his essay with those juicy lines by Boaistuau from 1561) also proleptically snares the attitude found in many rejections of Arbus' work when he writes, 'The pleasure of going to see the freaks today is seen as a carnival pleasure and characterizes the one who comes forward as a "gawker."' To which the obvious remedy would be contemplating the sadness quivering within a picture such as *A Jewish giant*

at home with his parents in the Bronx, NY 1970 where the circus attraction Eddie Carmel appears with his body prematurely wizened and hunchback shadow crooked as a crow. Wonder and fascination are forms of tribute, too, which don't preclude or mark the absence of deep feeling.

Not that she was ever so nuts about 'reality'. Consider this loping meditation on 'a big dog' she once saw, which follows a few philosophical lines on Kafka's dark authorial metamorphosis into a hound for his 'Investigations of a Dog' (1922):

> 'I don't particularly like dogs. Well, I love stray dogs, dogs who don't like people. And that's the kind of dog picture I would take if I ever took a dog picture. ... There was a dog that came at twilight every day. A big dog. Kind of a mutt. He would come and just stare at me in what seemed a very mythic way.'

A spooky scene, heavy with presentiment, Arbus' own tale of a mutt's spectral investigations paws right at the heart of her art. The staring contest between them is traditional – so many of her subjects throw eerily catatonic stares as if they were bombed-out on tranquillisers. But by skulking the crepuscular scene, there may also be an acknowledgement of how she discovers an uncanny 'twilight' of perception between the ordinary and perverse, along with the radiance of the dog's 'very mythic' properties. For Arbus, mythology had not retired to the foothills of Parnassus to get loaded and inspire the occasional loopy thesis, it was alive and hustling down at the park just before sundown. (She once described a grungy New York tenement lobby as being 'a lot like Hades'.) By capturing those scenes where waking life

drifts into myth, she might also regain the distorted visions of a childhood sustained by Edgar Allan Poe and the Brothers Grimm and make pictures with the same ensorcelling power. In his poem 'Alone', Poe wrote, 'From childhood's hour I have not been / As others were – I have not seen / As others saw.'

She might have liked her misfit 'things' because they were akin to stray dogs. She might have felt like a stray dog, inside.

In her 1982 biography, *Diane Arbus: A Life*, Patricia Bosworth describes how the photographer went 'again and again' to a New York revival cinema for a phase in the 1950s, eager to watch Tod Browning's notorious film *Freaks* (1932). A downtown hepcat, she typically smoked three or four joints across every showing of this wicked little tale. Pungent as the scene is anyway, that glimpse of Arbus smoking weed along to the film provides a literal illustration of the wide-eyed rubric to her work: 'Freaks are intoxicating.' Eighty years on from its original release, still only available in disfigured form since its maiming by an unsettled censorship board and long purveyed as a midnight movie owing to its cast of genuine sideshow performers, Browning's film remains a shocking fairy tale about the secret world of the circus. What made the movie so addictive for Arbus was doubtlessly the way in which Browning pulls off the rough trick she soon came to perfect, juxtaposing the fantastical and the humdrum. Legless 'half-boy' Johnny Eck dances on his hands as chickens strut in the background and the limbless Prince Randian suavely rolls himself a cigarette. But there are also moments of odd beauty. Daisy and Violet Hilton, a pair of conjoined twins, fall in love and when their suitor kisses one of them, the other swoons in response.

Itself an awkwardly conjoined production, *Freaks* combines these vérité scenes with a Grand Guignol melodrama and for Arbus, knowing the whole thing reeked of the Brothers Grimm's kitchen, there was also the joy of watching the film stagger towards every fairy tale's climactic explosion of macabre punishment. Much like in Poe's fiery yarn 'Hop-Frog' (1849), an enemy is tarred and feathered and the misshapen imps are triumphant. As the director Werner Herzog claimed, *Freaks* is 'one of the greatest films ever made ... the monsters are portrayed with real tenderness.' (A twin study of Arbus' and Herzog's art, tracking the echoes between their works, would prove uncannily fruitful. They are both fascinated by marginal characters; they reveal the ordinary to be undulating with sinister promise. Her picture of some wizened midgets (*Russian midget friends in a living room on 100th street, NYC, 1963*) is a premonition of a shot from his *Even Dwarfs Started Small*, 1970.)

She wrote, 'There's a quality of legend about freaks. Like someone in a fairy tale who stops and demands you answer a riddle.' A few months before the end of her life, she stopped in Maryland and took the photograph *Hermaphrodite and a dog in a carnival trailer, MD 1970*. The heroine is a glittering conundrum. Riotously sequinned, her bra marks the juncture between the contrary sides of her body: the left smoothly suggesting an ageing Vegas dame, the other bristling with rugged masculinity, the arm practically wolverine with hair and emblazoned with a fading sailor tattoo. This broad is a trailer park Tiresias stuck midway through her transformation, her body illustrating the paradoxical facts of her condition with deadpan elegance. Meanwhile the hound nestles moodily around the mystery juncture of his mistress' crotch, wondering who's come to intrude

on this moment of between-the-acts melancholy. So calm, the subject of this picture exudes the same blank cool as the intersex believer ('It was a man and woman both. It pulled up its dress and showed us') discovered at the carnival in Flannery O'Connor's Southern Gothic tale 'A Temple of the Holy Ghost' (1955): 'The freak had a country voice, slow and nasal ...: "God made me thisaway and I ain't disputing his way."'

But the sexuality of figures in Arbus' photographs is always enigmatic. The freckled subject of *Girl sitting on her bed with her shirt off, NYC, 1968* has crash-landed at some uncertain zone in between raggedy urchin and psychedelic babe with her Buckwheat afro, spaced-out Shelley Duvall stare and whippet-thin physique. Another pic (*Two girls in matching bathing suits, Coney Island, N.Y., 1967*) shows wannabe sex kittens hanging out at the beach who could be an unwitting drag tribute to The Shangri-Las. John Waters averred that the coiffeur of the broken mother shot by Arbus in 1966 (Ronnie Spector with a meth problem) was the inspiration for legendary drag queen Divine's bad girl hairdo in *Female Trouble* (1975). (With her dark life, raw art and mordant refusal of the Day-Glo, Arbus was an inevitable heroine for all the proto-punk kids who wanted hippies to burn.) Seen simply as a cataloguer of physical aberration, Arbus proves everyone with body dysmorphic disorder is telling the truth – if you want to see a weird creature, strip off and stare into the mirror.

During her childhood, Arbus kept up a fateful obsession with Lewis Carroll's *Alice* books, which always haunted her imagination. Alice's body assumes a gamut of unusual forms, making her like a party of Arbus subjects all rioting with one body. Alice becomes too huge for the room or microscopic after wolfing down

some magical shrooms, her limbs distend, she meets eerie twins. As a precocious but withdrawn girl, Arbus knew a world of enervating luxury, marked by its seasonal merry-go-round of cocktail parties, distant parents and aimless feasts where icy women talked about the succulence of certain debutantes. Her father, a vulpine gadabout with a penchant for models and all-night poker, escorted young Diane into the fashion industry where she became a stylist and photographer's assistant, concocting Christmas shoots for *Harper's Bazaar* in July. She later photographed his corpse, waxy in its coffin. If there's a hint in patricidal ambition in Arbus' mature achievements, abjuring Daddy by making tableaux where glamour's always gone sordid and attempts at cosmetic beautification only make them more loathsome, she can seem curiously indebted to her past, too. Nowhere would be better than the fashion world to cultivate feelings of alienated disdain towards the human body. And she always maintained a fashion maven's eye for characters in unusual ensembles – the raffish (father-and-son?) duo of *Man and a boy on a bench in Central Park, NYC 1962* with their chequered blazers! They look like they've just breezed in from Jay Gatsby's mansion in West Egg. (The influence of her photography on fashion waits to be fully adumbrated but for a clue to her powers, revisit the cover of The New York Dolls' debut LP from 1973.)

Children remained a fascination for Arbus in her photography because they represented the same trouble as the average freak, combining bodily awkwardness and innocent perversity. See her famous *Child with a toy hand grenade in Central Park, NYC 1962*, waiting in the shade of a big springtime tree. This skinny blonde kid with his brittle limbs, *Casper the Friendly Ghost*-head and

crooked animal claws hits Arbus with a maniac's spacey stare. For him, this incident was presumably just a fun interruption in Saturday afternoon's regular scheduled programme of 'The Battle for Central Park', calling in airstrikes against the enemy's hideout in the trees with his brain all jazzed from that morning's *Top Cat* (1961-62) or *Looney Tunes* (1930-69) marathon. His gaze may be only a stymied hyperactive kid's look of restless fury: 'C'mon! Let me go!' Rediscovered in adulthood for the BBC documentary *The Genius of Photography* (2008), the boy turned out to be an uptown gentleman called Colin Wood whose parents were splitting up when the picture was taken. He was just gobbling a bag of Junket dessert mix, its fluorescent dust all around his mouth – 'I think it was from DOW Chemical', he jokes in the film – when Arbus swooped over, dancing around him with her camera, and caught all his suffocated rage in a few frames.

Sometimes, in these photographs of children, she seems to be making self-portraits in secret. In 1970, the Matthaei family, another moneyed New York clan, solicited Arbus to take their Christmas portraits, presumably knowing they wouldn't come out of this self-conscious dare looking like the Baileys at the end of *It's A Wonderful Life* (1946). A coded autobiography may be afoot in the resulting photographs since the environment so closely resembles the one Arbus knew as a child. Without the merest hint of an Xmas morning grin, twelve-year-old Marcella Matthaei stares down the camera, blonde hair meeting dark eyes that roil with stormy knowledge: being a girl is hell, being a grown-up will be just... *the worst*. In another shot, she's slumped on a love seat in a white party dress – the princess disenchanted with her kingdom. The puppet-like kids from

Teenage couple on Hudson Street, NYC 1963 seem scarcely adolescent. The girl's oversized hand could be Thing from *The Addams Family* and the boy looks like Dick Cavett, shrunken but in his prime. She was wise to the perplexities of photographing young girls after Hans Bellmer and *Lolita* so everyone she discovers looks like a mannequin.

She befriended Eddie the Giant, a big-hearted man in his twenties from the Bronx who worked in circus side-shows and cheerfully appeared in a few B-movies – for *The Brain that Wouldn't Die* (1962) he was billed simply as 'Monster'. At night, as Arthur Lubow's biography *Diane Arbus: Portrait of a Photographer* (2016) records, he was often stomping drunkenly around neighbourhood bars hollering 'Fee fi fo fum, I smell the blood of a virgin!' as if he was in some horny Russ Meyer production: *Jacqueline and the Beanstalk*. Eddie also insisted that Arbus 'came on' to him repeatedly during their early meetings, using all her seducer's wiles to guarantee a few photographs. Their wonky friendship led to Arbus' famous picture, *A Jewish Giant, taken at home with his parents in the Bronx, NY 1970*, in which Eddie huddles in the corner of the living room as Ma and Pop, Lilliputians with a score to settle, stare at him in mute revulsion. The room is lit with the intensity of an abattoir: there's nowhere for anything to hide.

What's so thrilling beyond the gothic details (check the furniture shrouded like corpses in a mausoleum or Eddie's boots enormous as King Kong's paws) is the scene's allegorical resonance: the picture communicates some abject disappointment at the heart of parenthood. Confiding in Joseph Mitchell, *The New Yorker*'s chief reporter on Gotham's subterranean eccentrics, Arbus said, 'You know how every mother has nightmares

when she's pregnant that her baby will be born a monster? I think I got that in the mother's face as she glares up at Eddie thinking, "Oh my god! No!" (Mitchell's writing was as potent an influence as any photograph by Weegee. Among the subjects whose lives he detailed were voodoo priests, deaf-mutes and bearded women.) The scene tilts vertiginously, conventional notions of scale all nonsense, towards some magical point where reality is 'very mythic' at last: the goblin mother sends her giant son out into the winter night so she can get back to watching *Dragnet*.

But for every masterpiece, there were crippling phases of doubt, panic, inertia. She confessed that she never wished to photograph the famous but had to for the cash. (Never a hot proposition for dealers, she had to hustle in order to sell anything. At her first retrospective, visitors spat on the pictures.) The famous, she wrote, made her feel 'terribly blank' and there were times when her own life made her feel the same way. Entire days were killed by lying in bed, the blinds drawn.

Try to assemble a dossier on Arbus' psychological state by gathering together her own statements alongside the testimony of various lovers, friends or acquaintances and the consequence is a chorus of laments so numbing in their monotony they feel like a terribly acute representation of depression's effect.

With all the tact of clinician, her former husband Allan said, 'I was intensely aware of these violent changes of mood.'

Her landlady said, 'I got the feeling she was very anxious and very depressed. I got that feeling every time I saw her.'

She said, 'I feel like I'm hanging by a thread.'

Some days making art is nothing but a process of

confronting, again and again, your own exhausted repertoire of tricks, all your bad faith and joyless copy-catting. If all the work could vanish in a fire overnight, that would be some kind of relief. Arbus also had the trouble of dealing with a style and a favoured subject matter so recognizable they were readily becoming their own handsome brand of cage. Prescriptions were written; pills were downed. A list of projects was out-lined and they all disintegrated: a photo-essay about runaway teens (that would be a treat, a scuzzy New York version of Buñuel's *Los Olvidados*, 1950); a study of sex-ual fetishists; a piece on wild Pentecostal folk, speaking in tongues and twirling deadly snakes. Photography was always a way of tranquillizing her shyness but by the inauguration of the 1970s, making art had become twisted up with various other compulsions: she needed to visit these extreme regions of behaviour to eradicate that 'terribly blank' feeling inside herself.

Her photographs which are uninhabited by any characters broach still more unsettling ideas. Maybe thinking of Kafka again, she took a photograph called *A castle in Disneyland, CA, 1962*. Glowering as darkly as Xanadu from *Citizen Kane* (1941), the building looks like a lair where a tattooed Bluebeard and a wicked stepmoth-er reign together, probably in drag. But the battlements are so cardboard, the nightmare soon seems bogus. *Xmas tree in a living room, Levittown, LI, 1963* shows an artificial Christmas tree squeezed into the edge of a suburban living room in Long Island. Covered with icicle-like glass gewgaws, its plastic fronds outstretched, the object suggests an intergalactic witch. Far-off forests are lacquered on the walls of a hotel lobby (*A lobby in a building, NYC 1966*); the rickety facade of a townhouse, abandoned after an Edith Wharton adaptation, looms

over an empty landscape – *A house on a hill, Hollywood, CA, 1963*. Everywhere, Arbus surveys her surroundings like someone in the middle of a dissociative fugue, discovering new proof all the time that none of this was ever real. Lubow lays on the troubling details, like a carnival barker at an autopsy: Diane masturbated with the blinds up as a teenager in that Central Park apartment's bathroom so the neighbours could see her dissolve in a few hot jolts of pleasure; Diane and her brother, Howard, kept up a lifelong incestuous romance, their final tryst occurring a few weeks before her death. (Maybe that explains her fascination with doubles – incest is the pairing of near-identical counterparts – and why the intimacy she achieves with her subjects always feels so sinister.)

At last, it's difficult to imagine another conclusion to her life as anything more than a fond wish or a consolatory escape from reality. Far from melancholy's gentle blue stupor, depression is a physical fact that can feel more like malevolent possession. Something putrid sharpens its claws on the walls of the afflicted person's stomach and slowly she disintegrates. Perhaps her story is one of ineluctable burnout. By that febrile summer, she was too mortally distressed to occupy her body a moment longer or think about anything much other than killing herself.

.

All that horror makes the sun-dazzled existence of Arbus' *Untitled*, a delirious sequence of photographs shot at two unnamed institutions for mentally disabled people between 1969 to 1971 and first collected in 1995, even more astonishing. In this epilogue to her career,

a teenage girl with Down's Syndrome wearing a candy-stripe dress, sprawls, beatific, in a field strewn with weeds, like a fleshy stepsister to the doe-eyed sirens William Eggleston was photographing at the same time. In the blurred world beyond, a lone figure keeps watch on the swings, playtime paused and the earth still again. The girl's round face has cracked up into an abashed grin, a little tipsy from all the attention this woman with the lullaby voice is paying her. The hot stench of late summer on the air, she could be a mermaid frolicking in her own green pool. In another picture, a girl bends down, legs apart, big rough feet, flat as shovels, fixed in the same dirt, and her head buried, oblivious, in the grass. She might be listening for the noise of the hidden insects or testing out how the sun's nice touch feels against her skin. And there's another girl staring, eyes alight, mouth agape with total dizzy joy, as if she's just seen a golden bird streaking glitter across the sky.

According to Lubow's biography, one of the girls told her, all sunshine, 'I've got a boyfriend. He says I'm beautiful. I told him, You haven't seen the pretty parts.'

The big conundrum of being here is not so much what the self is supposed to be but how to interpret the luscious material supplied by the earth: whatever the animals in the clouds mean, what the grass is supposed to be, whatever the sun is. The girl lying in the grass is thrilled to experience the textural delights of a summer afternoon. Never growing familiar, the world reappears each morning, aglow.

A huge boy stands outside in a rabbit costume, his perky bunny ears knocked flat by the breeze, a lobotomised plastic jack o' lantern, hollow brainpan stuffed with sweets, hangs out in the crook of his arm. Slack-jawed with bafflement in his shabby pyjamas, he's all

dressed up for the Easter picnic. Bugs Bunny loiters on his bib in chill 'What's up, Doc?' stance, chomping a carrot. Next to him is a boy in a flashy red superhero costume and bathroom slippers, his masked head tilted in careful thought (Batman listening to a child), as he nervously twists the fingers from one hand with jittery assistance from its twin. Arbus mostly shot patients in pairs during these excursions, their hands happily entwined.

In their company, certain defences dissolve. Not so lucid as she once was or feeling too bedazzled and vulnerable herself in front of these subjects, Arbus obviously isn't thinking much about the traditional notions of what makes a 'good' photograph anymore. That picture of the two overgrown boys is coated in a haze, transforming Bugs Bunny into a rabbit catcher's mirage and sending their faces out of focus, as if they were obscured by rain. She was smitten with them, since they were characters who didn't want to cheat or hide from the camera, telling a friend, 'I really adore them.'

They were never scared of being ugly; some of them could never have really understood what was happening. As the philosopher Avital Ronell writes in her wise book *Stupidity* (2002), in the most extreme cases of intellectual disability, 'something like interiority does not appear to take hold ... with no language, [those affected] are more or less stranded.'

Psychological realities that many would prefer not to acknowledge or imagine at all are seen in these photographs. One of the most painful pictures in the collection (askew and fuzzily interrupted by an Arbus digit) demands contemplation of how otherworldly waking life must feel for a little blind girl. At play in a room with all the warmth of a bomb shelter, she wears an expression

of feral ecstasy, running a bandaged hand through her shiny black yé-yé bob as her eyes roll back in her head. Nobody could fathom the untameable strangeness that thinking or feeling have for her, stripped of her senses, or the full sound and fury of what seethes in her mind. Ghost dogs howl in her face or weep in faraway rooms, somebody – and what's a body if you've never seen one before? – drags her around like a storm wind. When the sun comes up, everything gets too loud.

Three other kids are present, each in their own solitary orbit. A small boy lies near her on the linoleum floor, knees bundled up, shaggy 'do thrown back like he's on a rollercoaster as he rapturously embraces an upturned plastic chair. Alone in the world with his favourite object, he feels an explosive joy. Two other kids skulk, unknown, in the background, turning away to stare at the walls like a dunce condemned to eternity in the corner. Everyone in the picture is a rejected child, once judged too shameful or difficult to stay with their parents. The unspeakable interpretation is that she was visiting haunted houses, inhabited by monstrous children, and they are all still children, even the ones in adult bodies, untroubled by the history of anything.

But in this sunlit world, questions about age or gender don't seem to matter that much or mean the same things as they do elsewhere. Catch the Halloween pageantry in progress: a wonky figure in a clown mask holds on tight to a girl pulling a big hungry grin, her face painted with groovy symbols. Wait, is it a boy? Gender obscure again, a figure in a cartoon pussycat mask beckons to the photographer, ready to play. A patient in a skull mask and white shroud looms over an empty field. Even if Death disturbs the fun, most of these loveable figures pay no attention – beaming smiles show off rotten

splinters of teeth. Death might not be understood all that well here, making the Grim Reaper into just another scary role for the afternoon. Which means all that's left for everyone is the plain amazement of living, frame by radiant frame.

The most transfixing couple is the very last duo in the book: a Tweedledum and Tweedledee pair, the boy on the left plays the clown, sporting an ample Pierrot costume and pointed cap as the friend alongside him wears pyjamas and a coat too thick for summer. Hard to tell where one ends and the other begins with their limbs so commingled they look conjoined and the two of them in matching masks. One stares straight ahead, the other turns, enchanted, to consider something in the air. The scene around them is a blur they might be dreaming into shape together: nothing but a parade of receding trees and the outline of a house nestled in the shadows they provide. The boys wait, light-headed in the sunshine, with the waking world somewhere beyond those dark woods.

K-10

HERR FASSBINDER'S TRIP TO HEAVEN

'FAUST: Joy is not the issue,
I give myself to frenzy, to pleasure that hurts most.'
— Goethe

'Death stands there with its thing sticking out.'
— Frederick Seidel

'Ah', said the policeman studying the corpse on that summer morning in 1982, 'even Fassbinder is mortal.' The German film-maker lay on his bed in a swank benefactor's penthouse, flesh cold, blood snaking from one nostril and the script for a new project – a spaced-out biopic of communist heroine Rosa Luxemburg – lying next to his body. The post-mortem would later reveal that Rainer Werner Fassbinder, aged 37, had died around 4 a.m. on 10 June, his heart stopped by the fatal interaction between a mixture of cocaine and sleeping pills. Even if this scene related in Robert Katz's scurrilous biography *Love is Colder Than Death* (1987) is cultish apocrypha, there is something in its freeze-framed combination of unbelievable fact, mythic allure and disclosure of a desolate fall that serves to encapsulate Rainer Werner Fassbinder's life. Dionysiac excess was the norm: he drank all day, snorted snowdrifts of coke like a vacuum and gorged on barbiturates by the bagful but work was all that mattered. He spent the next day behind the camera shooting his new project, editing its predecessor at night and writing whatever was next until dawn. 'I really have a drive that's hard to explain,' he said, 'I'm actually only happy when I'm doing things and that's my drug, if you will.'

Adopt his thinking and the merits of coupling sleeping

pills with cocaine are obvious: achieve white-hot exhilaration with coke but smooth that comedown into a sweet dream with a rainbow combination of knockout tranquillizers. If that wasn't a fast enough route to oblivion, he wasn't scared to darken the mixture with a little heroin and promptly vanish down a black hole for the next few hours. The drugs would be syncopated with whiskey sloshed into a pint glass to keep his thinking limber and remove any residual jitters from the cocaine. For any observer, the whole desperate party must have looked like a suicide accomplished in slow motion. Fassbinder had kept up this rhythm for years; his films too were about fatal interactions, encounters between the kind-hearted and wicked that frequently end with the innocent's demise. The policeman was right: he didn't seem to have the same needs or limits as other men – he was, to quote the film-maker Werner Herzog's fond description of his friend, 'an unruly beast'.

This beastliness manifested itself in numerous ways as Fassbinder sought to violate the repressive shibboleths of his society. He was an uproarious queer hoodlum prone to acts of wild cupidity who was well-versed in Marxist arcana and called himself a 'romantic anarchist'. Refusing to see any of these contrary tastes as paradoxical, he irradiated all his interviews with brash provocations ('In this society,' he wrote in response to a magazine questionnaire submitted by a band of school children, 'there's no one who isn't mentally ill,') and made certain all his fiery carousing was public knowledge. Late in the 1970s, panicky tabloids alleged that he was often seen waving 'five hundred marks at male prostitutes' during sultry nights in the city: he knew everybody could be bought, including himself.

Even his addictions were conducted with a certain

leopard-print swagger since he embarked on private jet flights to dealers to soothe his cravings for narcotics and called on a retinue of golden boys to satisfy his lust. The latest object of his affections could expect to be lavished with expensive gifts and he wrecked fast cars like they were children's toys, accumulating enough to start his own junkyard in the process. 'Rainer thought that was cool', his old accomplice Harry Baer remembered, 'the more wrecks the better.' Playing the lead role in *Fox and His Friends* (1975), a gay carnival worker who's won the lottery and suffered nothing but unhappiness since, Fassbinder attempts to sell his futuristic folly of a sports car. The dealer on the lot proves he's scrupulous by cracking the joke, 'What am I, a Jew?' Fassbinder was committed to saying the unspeakable and, in his own mordant fashion, to critiquing the illusory solace purveyed by all kinds of institutions from marriage to doctrinaire communism. Snickering wickedly during a TV interview, he roused the ugliest spectres of German history by announcing that many people still 'require a Führer'.

Such a commitment to acidic candour meant Fassbinder angered many in authority, including right-on gay activists who wished their clan to appear on film as hygienic saints, sapphic dames who called his depiction of lesbian abjection in *The Bitter Tears of Petra Von Kant* (1972) misogynistic or the hare-brained anarchists who scorned him as a traitor for making their movement into the subject of ferocious comedy for *Mother Küsters' Trip to Heaven* (1975). His trademark look – scowl, cigarette, goatish beard and slouch hat – assured he was ready-made for tabloid caricature.

Weigh all that against the expansiveness of his *oeuvre*: forty films in eighteen years, so acute and wide-ranging

in their account of German society they could be classified as a cinematic territory all their own – the critic Ian Penman called it the 'Fassbinderrepublik'. Or return to these productions knowing certain outrageous facts: his episode for the film *Germany in Autumn* (1978), a bleak collective reckoning with the aftermath of the Red Army Faction's attacks and the suicides of its ringleaders, went from conception to completion in ten days. Given this manic productivity, there might be an attendant assumption that more than a few of the films are fuzzy-headed experiments or sly conceptual jests in the style of those early movies from Warhol's Factory but all are masterful productions, moving at a stately pace and totally inimitable in their mixture of artifice, raw cruelty and chill dispassion. He had a system nobody else possessed and taxed it to its limits. 'There's this strange compulsion to work which is certainly a strength and a weakness,' as he admitted in an interview two months before his death, 'I'd say I'm a manic depressive and I just try to be depressive as seldom as possible.' His mother adduced a different kind of desperate energy at work: 'Rainer,' she said, 'simply didn't count on growing old.'

But probe beyond the misanthropic fiend of legend and a far more bewildering figure appears. Despite his ruinous intake of drugs and booze, Fassbinder always maintained an equally fearsome lucidity. There were no signs of a drooling id let loose or canny subterfuge between his public image and private life: this was simply how he lived, none of the illicit joys or furies hidden, in a drama to rival any of his films. In the delirious epilogue to his masterpiece *Berlin Alexanderplatz* (1980), Fassbinder stands in the company of two golden-winged angels watching the hero Franz Biberkopf crawl, mad,

through an abattoir. (Angels are a leitmotif in the later films: their appearance is rarely a happy sign; abattoirs became his favourite metaphor for German society.) One of the angels murmurs to her accomplices, 'Death sings a slow song,' and Fassbinder never pretended he wasn't intoxicated by its sound.

Premonitions of death are everywhere in his films, waiting to be tallied up and hinting that their maker knows the circumstances of his own demise: the ruined hero in *The Merchant of Four Seasons* (1972) downs shots of brandy at the kitchen table until he slumps over, wrecked, his heart stopped; Elvira the transgender heroine from *In a Year of 13 Moons* (1978) overdoses on prescription pills in her bedroom. Fassbinder was thrilled by Robert Bresson's *The Devil, Probably* (1977), a savage little parable about a teenage boy's journey towards suicide which exhibits the same brand of eerie fatalism found in many of his films. But the counterpoint to the unshakeable belief that existence was nothing more than some unholy Totentanz was this equal need to lead a truly incandescent life, one where he would never have to slow down or discipline some of his more dangerous impulses.

Fassbinder was born in May 1945 as Germany lay in ruins. Rebellion was a necessity for many children born after the fall of the Third Reich who could not make peace with those seduced or acquiescent to the demands of fascism. In adulthood, he claimed that his mother and father were out-of-focus figures at the edge of his early life, which was at once the truth and a potent symbolic statement. As Irm Hermann, one of the actresses who took the ice queen role in his films, averred in the documentary on Fassbinder, *I Don't Just Want You to Love Me* (1992), 'We all had trouble with the eyes examining us when we were children, we couldn't trust them.' To love

anyone who had gone through the horrors of the recent past might feel scary, difficult or like some other form of sinister collaboration, considering what they'd seen, or claimed not to see. Growing up, there's evidence of catastrophe everywhere but an ominous silence prevails whenever questions are asked about its cause. Such an atmosphere of smothered dread and secrecy could only be broken by defiance. Fassbinder's flair for misbehaviour combined with that compulsive need to expose the turmoil that others deemed too troublesome to contemplate was a means of retaliation. 'I see things burning,' he told a producer in the 1970s, 'things going wrong,' and they needed to be chronicled. Symbolic, real or spectral, all fathers had to be overthrown. Certain of his contemporaries would choose more violent methods to deal with these toxic feelings that vexed relations between parents and children. Both Andreas Baader and Ulrike Meinhof were known to Fassbinder as their world occasionally overlapped with that of his 'anti-theatre' gang in the 1960s. In reckoning with the traumas of post-war Germany, he dedicated himself to a more subversive mode of cultural terrorism than they did.

His mother remembered that his talent for trashing the establishment and deducing exploitation manifested early on, frequently telling the tale of how he wandered into a church, aged six, and announced to the congregation, 'You say this is God's house but I can't see him anywhere.' His father (gone by the time young Rainer hit what he later called his 'murderous puberty') was a doctor who kept his practice at home and took street denizens as patients. Way before he could be truly conscious of such matters, Fassbinder had some formative awareness that society was a big rowdy pageant

involving all kinds of people, each with their own fears and proclivities. There's a touch of the physician's cold-hearted acuity in the way he dissects the impulses of his characters. His mother translated Truman Capote and Patricia Highsmith, two sharp-eyed investigators of human cruelty and folly, in between spending long spells at a sanatorium recuperating from a lung complaint. Throughout this childhood and adolescence where the notion of family was hazy at best, trips to the cinema offered him a remedy, a substitute world of colour, music and fantastic spectacle. Fassbinder never lost his taste for pure escapist movies or respect for their power over audiences: he was the one who saw Douglas Sirk's movies for the lacerating critiques of American society they really were, praising them in a 1971 essay back when they were regarded as just swoony melodramas. In the dark, something happened – he saw how his caustic intelligence and equal desire to be ravished by the cinema could be brought together to give him a purpose.

More curious habits were surfacing, too. By his mid-teens, he was an industrious pimp, though the only prostitute working for him was an adolescent Udo Kier, the actor who went on to lend his louche matinee idol qualities to other auteurs such as Gus Van Sant or Lars Von Trier and show up amid the festivities in Madonna's book *Sex* (1992), surveying a bunch of nude hunks in Miami with his whip in hand and eyebrow arched. Arriving at experimental theatre rehearsals in Munich when he was still in his teens, Fassbinder had a uniquely loathsome personal aura – nobody wanted to be seen with him – yet within a few weeks he had the whole company under his spell. Whatever the inexplicable particulars of this breathless to-and-fro between

repulsion and charm, it was occasionally coupled with disorientating changes in appearance. Gottfried John, who appears in numerous Fassbinder productions, most notably as *Berlin Alexanderplatz*'s scheming weasel Reinhold, claimed, 'One time he would be a fat, ugly slob, the next he would be trim and sparkling as young Marlon Brando.' In the course of his adulthood he went from acne-scarred but flamboyant imp in a leather jacket and Arabian scarf (there was always a hint of Eastern exoticism about his looks) to the ogreish gentleman of legend. He was a wily young satyr who dreamed of possessing a classic Tom of Finland physique but went to flab and ruin on a diet of junk food, uppers, downers, black beer and white rum.

A giddy little scene from *Rio das Mortes* (1971) catches some of his irrepressible energy. A goofy ruffian dealing with life like it's just a variegated dare, Fassbinder bounces up to Hanna Schygulla (so much the inscrutable muse of his early films) in a tropical club. 'Jailhouse Rock' kicks in and they dance together, Schygulla looping round him like a hungry feline as Fassbinder pulls off some biker boy version of 'The Monkey' and his face repeatedly crumples into a bashful grin. Elvis slips away – a reverb mirage – and callow Fassbinder tumbles back to the bar, legs all water: 'Ciao!'

At twenty-three, he received an early caution from a doctor that there was no way even his robust constitution could support more than a few years of his excesses but he paid the claim no attention at all. Death was waiting for him, smoking a cigarette in the alley, but there was no way he would abandon the white nights, banquets and booze, chasing the eager flesh and tasting new chemicals. Without all those delights, living would have been a graveyard anyway. That was when he was

starring in the lead role in a TV production of Brecht's *Baal*. Shoring up his own myth even then, he plays a poet who meets his early death with a delinquent grin. Harry Baer recalls making a Roadrunner-velocity joyride with Fassbinder through the North African desert: 'Scenery? What scenery?' he joked. *Hurrah, We're Still Alive* was the title of a long-planned but never completed project.

Racing along at that speed there could no moments of peacetime repose. Any idle lacuna had the attendant risk of bringing in unexpected thunderclouds: rage, depression, inertia. Like many compulsives, Fassbinder feared that if he questioned or tested its workings, his own magic formula would no longer favour him. If he stopped, maybe he wouldn't be able to regain the old energy on his return. That turns out to be a reasonable fear if you examine the fragility of the conditions sustaining every film: heaps of cash need to be inveigled out of investors, furious debtors need to be escaped and requisite taxes dodged. And he could be genuinely tyrannical, sometimes in the style of a fairy tale villain. According to the actor Volker Spengler, at some point during the making of *Chinese Roulette* (1976), he locked his actors inside the castle where they were shooting in order to encourage more agitated performances.

Though Fassbinder famously enjoyed subjecting his actors to exquisite manipulations – would he cast you in the next film or condemn you to a winter in obscurity? At dinner would he disclose an end-of-the-night secret you once told him to the whole table? – crucial to his powers of enthralment was a near-demonic personal charm, as exhilarating for its recipient as a hit of military amphetamine. 'The relentless frenzy was only possible,' according to Baer, 'because this superman was

at the helm, telling everybody how beautiful everything was ... [The crew] certainly would have quit if this maniac, who thought of nothing but work, hadn't made it so much fun.' As the sky blushed at sundown, there he was with all the new hooch and cognac, the galaxies of little white pills and stardust powders spilling from his pockets, ready to throw Roxy Music on the jukebox. Who wouldn't be smitten by those bad-boy antics or ignore, until their body shuddered in protest, the risks accompanying his embrace? 'We were drunk all the time,' Baer swore, 'breaking windows and stuff when we were stoned.' But in the midst of this carnival, there was always the phantom threat of black depression or hypomanic collapse: 'I get so sad that I just don't know what my life is all about,' he told a journalist, 'sometimes I'm sitting around with people who don't particularly turn me on. Then I entertain the whole table, simply because I enjoy telling stories. Then I get happy without knowing why.'

As he tells all his stories, Fassbinder demonstrates a chameleonic ability to change his style from film to film, as if he was playing with the whole scope and inventive potential of cinema as smoothly as a prestidigitator. He makes a white-hot piece of contemporary social realism (*Ali: Fear Eats the Soul*, 1974), an enchanted costume drama (*Effi Briest*, 1974), a sci-fi TV series (*World on a Wire*, 1973), a black comedy for perverts (*Satan's Brew*, 1976) and bows out with a druggy gay fantasia (*Querelle*, 1982). Perverting the ways and rules of cinematic genres is also a queer tradition. Consider the subversive remodelling of the high school musical that is John Waters' *Hairspray* (1988). Andy Warhol not only unsettled the concept of what a 'film' was (sometimes, as in *Empire*, 1964, his movies don't move) but went on to suck the

blood from various horror franchises, producing gory marvels like *Blood for Dracula* (1975) – Udo Kier played the Count. (Acolytes at the Factory also gave Warhol the nickname 'Drella', stitching together Cinderella and Dracula to create a new mutant creature. The alias referenced his rags-to-riches transformation from poor kid out of Pittsburgh to prince of New York while simultaneously noting his undead affect and the fact that many in his orbit were left wrecked, if not dead.)*

Queering the straight world is a form of revenge which proves that homosexuals can have their wicked way with modes that so often ignore their existence – Dracula comes back from the dead as a faggot! – and at

* With a little sly self-knowledge, Warhol's 1981 series *Myths*, shown at the Feldman Gallery in SoHo, included a picture of Dracula alongside Mickey Mouse, Santa Claus and Superman. Margaret Hamilton, much aged but in full costume, reprised her role as The Wicked Witch from *Oz*, gleefully mugging for the camera in a bunch of Polaroids. Dracula was played by buff New York model (and Warhol infatuate) Sean McKeon, in full '*I vant to suck your blood!*' mode, joke-shop fangs bared. In the resultant shadowy silkscreen print, his gnashers and hollow cheeks are etched by neon pink paint – pink suggesting 'fag Dracula' again.

 Fast-forward to 21 January 1986 and, as he explained in his voluminous *Diaries* (published posthumously in 1989), he was hanging out with Grace Jones: 'She's so excited she's going to Hollywood to play a woman Dracula. I mean, how many more women Draculas can you have?' *Vamp* (1986), the little-remembered horror comedy in which Ms Jones takes this role does contain a breathlessly strange sequence where she appears dancing to disco in whiteface and wearing a clown red wig – *très* Rei Kawakubo – covered all over in funky hieroglyphic body paint courtesy of Keith Haring. Slave to the rhythm, she falls back onto an altar covered in the same design concluding a radical moment of interracial crack-up, 'woman Dracula' seduction and AIDS-haunted club culture that's owed serious tribute.

the same time, all the gooey sentiments of straight life are revealed to be ridiculous. But Fassbinder's motivations were more elaborate: he never wanted to entertain a hip subcultural crowd but forcefully occupy the consciousness of a mass audience and get right into their living room. Like a double agent, he played the formal tics of a chosen genre against his story. *Fear Eats the Soul* is a flawlessly orchestrated melodrama that turns its attention simultaneously to the then-untouchable subjects of interracial and intergenerational romance. (These taboo desires are also metaphors for homosexual love.) He dwelled on the powers of the Third Reich's military-entertainment complex by creating *Lili Marleen* (1981), a production as fabulous as anything from 1940s MGM. None of his historical films were intended to be immaculate period pieces but rather what he called 'interpretations' of the past created to illuminate the present. Which meant, in the case of *Lili Marleen*, that fascism was alive and well in West Germany.

But *In a Year of 13 Moons* is unique, belonging to no genre at all. Conjured up from the deepest phase of grief as Fassbinder was mourning the suicide of his lover Armin Meier, this film chronicles the last days in the life of Elvira, a transgender woman played by Volker Spengler. Fassbinder kicks off his odyssey at dawn on a cruising spot with a hot tongue lubriciously exploring the hollows of a male body. The goose-pimple eroticism of the moment is wrecked once Elvira's feminine identity is disclosed. There will be a trip to a video arcade where Fassbinder trances out watching a pixellated car repeatedly crash, slyly communicating that his heroine is destined for self-destruction; there will be a visit to the convent where orphan Elvira (then Erwin) was schooled. Mother Fassbinder appears as a

nun, calmly relating how her charge went from a 'good boy' to a rotten creature after he was rejected by a couple meant to adopt him. There will be the usual bursts of nasty laughter, a dream about a cemetery, a fairy tale in which a girl chews off her brother's foot and a horrific trip to the slaughterhouse. Through all this wandering, Fassbinder provides the biography of his degraded heroine, cataloguing a lifetime's traumas, mistakes and bad faith.

At the slaughterhouse, we watch the systematic killing of livestock. A tracking shot follows cattle edging along in procession until, one by one, they are stunned, eviscerated, bled dry and skinned. On the soundtrack, Elvira moves from recalling the happiness she found working here (Armin was a butcher) to reciting a monologue from Goethe's tragedy *Torquato Tasso* (c. 1786-90) in a performance that crosses a threshold from grief-stricken aria into genuine derangement: 'With laurel they have crowned me, to lead me to an altar like a sacrificial beast!' Words writhe, turning into shrieks, mad barks and howls as she grows increasingly maniacal: the body is a straitjacket that must be escaped. Carcasses are strung from the ceiling, hot with gore, just like in the dark interiors of Francis Bacon's paintings, hides tough as sackcloth are torn from bodies to reveal the marbled flesh beneath: 'On this final day,' she screams, 'they lured from me my poem which was my sole possession!' So much is contained within this spectacle: a grotesque meditation on what Elvira has done to her body (she underwent surgery eager to satisfy her infatuation with another man); acknowledgement of the original meaning of 'Holocaust' (a ritual orbiting around an animal sacrifice) in a film dense with references to the Shoah, including the death factory of Bergen

Belsen; and a desperate expression of Fassbinder's own grief. And what *In a Year of 13 Moons* presents is the carcass of Fassbinder's own 'poem', compiled from so much detritus and torn into terrifying fragments.

As Elvira sleeps that night, Fassbinder appears on her TV, being interviewed for an episode of *Lebenslaufe* (*Life Stories*) shot in 1974. 'I hope,' he confesses, 'so far as it is possible to change myself through my stories.' This talk about a personal need for transformation and catharsis resounds in the bedroom of his doomed heroine who has attempted to achieve both – one is a consequence of the other, *natürlich* – and failed. Asked what the reasons might be for the restlessness that allows him to make so many films, he jokes, 'I don't know, it must be a special kind of mental illness.' Elvira will soon be discovered in the same bedroom, dead from an overdose, a record on the turntable repeating the wild-hearted phrase, 'When my dreams become reality!' The words echo as the film fades to black, like shouts from inside a mausoleum.

Following Armin's death, Fassbinder's films became increasingly dreamy. This could be a self-protective response to the realities of grief but he was always more prone to staging hallucinogenic adventure than many like to admit: revisit his debut film, *Love is Colder than Death* (1969) and you can watch the young director cracking the codes of the traditional Hollywood heist flick to create a Godard-addled frolic in Expressionist black and white. But now the films would become closer to trances or drug trips, following their own sleepwalk rhythm through worlds he invented in the studio and dissolving any hint of 'reality' in a range of phantasmagorical effects. In *Berlin Alexanderplatz*, scenes run to the pulse of neon lights; the action is frequently glimpsed through rainy windows or occluded by layers of swirling

smoke. Fassbinder induces a stupor in his audience by reading his narration in a whisper, conspiratorial, as if his mouth is at your ear in the dark: 'Night is coming on,' he murmurs, 'the highways frozen solid... She didn't find the cemetery all by herself.' As the series aired on television, he confirmed this switch into reverie, telling a journalist: 'When the lights go out in the movie theatre, it's as though a dream were beginning.' But it would be dangerous to interpret this talk about flight into dream as 'mere' escapism or ignore its shadowier ramifications: dreams grow out of sickness, longing or loss; they are, after all, where we are at our most isolated. He wrote that 'nothing is equal to the terror of dreams come true'.

Queer film-makers had long departed from cruel reality to explore their desires: James Bidgood transformed his tiny New York apartment into a harem for *Pink Narcissus* (1971), conjuring up the hot daydreams of his teenage hero with all the frisky spirit of some imaginary collaboration between Georges Méliès and a beefcake magazine enthusiast. The short films collected in Kenneth Anger's *The Magick Lantern Cycle* (1947-81) create a world in which fireworks explode from the crotches of lusty sailors and the Grim Reaper is a hoodlum riding a motorbike to a Motown soundtrack. Anger wrote of Lucifer's battle with God as a war between a rascal son and strait-laced Pop: 'Lucifer created his own light shows in Heaven ... Eventually he was expelled for playing the stereo too loud.' A disciple of Aleister Crowley's religion, Thelema, who produced the first instalment in his *Cycle* when he was seventeen, Anger mixed Tinseltown glamour with occult energies to create his own cinematic witch's brew. No insignificant feat to do some of that at a time when homosexuality was being 'remedied' by a few lightning strikes of electro-shock

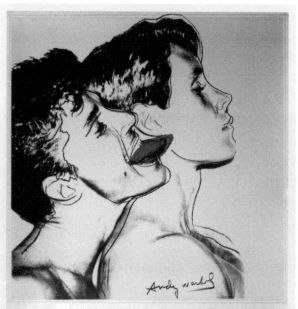

QUERELLE

EIN FILM VON
RAINER WERNER FASSBINDER

NACH DEM ROMAN VON
JEAN GENET

PRODUZIERT VON
DIETER SCHIDOR

EINE DEUTSCH-FRANZÖSISCHE KOPRODUKTION VON
PLANET-FILM MÜNCHEN UND GAUMONT PARIS

treatment. Concerning her early thoughts about young Rainer's homosexuality, which she discovered during his adolescence, his mother asserted, 'I thought it was a disease.'

Nightclubs and drugs were also inspiring him to create his own artificial worlds. There's no evidence of Fassbinder tripping on acid but he achieves psychedelic rapture via Technicolor, saturating every scene of *Lola* (1981) with light. Running amok in New York circa summer 1978, he scores MDA (ecstasy's unadulterated pharmaceutical forerunner) from Cookie Mueller, a member of John Waters' Dreamlanders repertory whose vibe as an actress could be described as 'white trash Edie Sedgwick'. The surfaces in all his subsequent movies radiate a tell-tale glow. Queer nightlife was becoming a jungle all of its own. In New York, there was Le Clique, a travelling disco where actors, acrobats, and clowns performed alongside dancers simulating sex acts in order to inspire new intensities of debauched behaviour among the revellers. (The trapeze hanging high in the club's rafters unwittingly signalled the pre-AIDS mood of looming peril.) And there was also a subterranean topography of more, shall we say, 'adventurous' dens gamely catalogued by Andy Warhol in 1979: 'The Anvil, The Toilet, The Mindshaft [sic], the Cave, the Eagle's Nest ... where the disco workers go when they get off work uptown at 4 a.m.' Quipped Drella, who explored these places with his usual mixture of extra-terrestrial delight and bafflement, 'They're too dirty, too gay, too sexy – for me. They don't let girls in and I'm always with girls.'

Warhol provided the poster for *Querelle*'s American release, a modified Polaroid of two blonde surfer dudes in a bathhouse tryst, shirts off and one whispering naughty

enticements in the other's ear, his tongue painted devilish red. If the picture appears unrelated to the movie, just a *Honcho* snap to lure in the Time's Square crowds, consider it a hint to *Querelle*'s meditation on twins, brotherhood and all other kinds of double trouble. When they met, reportedly in the company of Warhol's 'gymnastics teacher', Warhol squealed, 'Oh, Mr Fassbinder, I saw *Querelle*, it made me hot for the whole day!' Fassbinder said little; he dedicated much of that last New York trip to tracking down a hustler known by the fantastical code name, Rameses II.

By the time of *Querelle*'s shoot, Fassbinder was routinely charting jet flights back and forth from Munich to New York on his weekends off, greedily tasting all the carnal or chemical ecstasy on offer and just having the fucked-up time of his fast-expiring life. The later films approximate the activities in a hot discotheque with their strung-out inhabitants and spangled interiors. He coiled his two sources of pleasure together until there was no telling them apart – a snake devouring his own tail – and each drove him further into more extreme territories. But the dark anonymity offered within such clubs must have also felt like a kind of solace, too: his conventional attempts at love were shadowed by difficulty, ambivalence and death. A deliciously sado-masochistic metaphor from *In a Year of 13 Moons*: 'When you love you are nailed to the cross.' And Oscar Wilde's words are reverberating around his last and wooziest paradise, with Jeanne Moreau as their songbird: 'Each man kills the thing he loves.'

All of which haunts *Querelle* but there are also ghoulish premonitions to be dealt with everywhere, epitaphs tattooed on those smouldering bodies. Fassbinder unwittingly presents a work scarred by its own innocence,

providing a depiction of homosexuality totally invested in its most sinful possibilities just before the apocalyptic effects of AIDS came into focus. What films would he have made about the plague years? *Querelle*'s last words (and therefore Fassbinder's farewell to his audience) are a quotation from Genet, glimpsed in the writer's own fragile scribble and admitting, 'The date of my death seems near.' Amplifying the tragedy in that gnomic line is the ambiguity circling around whose death exactly might be threatened. Parse it, if you wish, as referring strictly to Genet, or as an uncanny reverberation, announcing the loss of a vast subculture, or as Fassbinder ghostwriting his own end.

When the drugs became troublesome, he admitted it in his work. *Veronika Voss* (1982) is the tale of an actress' fall from 1930s glamourpuss to ruined junkie. Her greatest performance, which she will go on to re-enact in waking life once her stardom wanes, sees the blonde starlet play a drug addict in thrall to her crooked nurse. Fassbinder kicks off at the cinema in media res with this make-believe opus, *Creeping Poison*, dazzling on the screen, all shadows and silver light. Veronika's self-immolating vow booms through the theatre, 'I'll give you everything that I have! Everything that I am!' The actress is in the audience: eyes shut tight, she can't bear to see how closely her theatrical convulsions now mirror her real life.

This potent moment is full of Fassbinder's favourite themes (the haunting power of the past, innocence lost, incinerated dreams) and it is also his most vivid confrontation with a problem that troubled him throughout his work and life: what happens when what you love most is a poison, creeping or not. In certain cases, such as Elvira from *In a Year of 13 Moons*, the person

themselves will be toxic – doomed – from the very beginning. Whenever Fassbinder kisses Armin for *Germany in Autumn*, he's like a vampire taking a bite out of a victim. Fox's high society boyfriend schools him in the airless pleasures of the rich and eventually abandons him, destitute. In the train station at the end of the film, once the two wily schoolboys have stripped the hero's body of all its loot with the sort of acquisitive spite familiar from silent films, two old friends will stumble on his corpse. Discovering his heart was stopped by a Valium overdose, they run away: the body is too dangerous to touch. The kids return, pulling at him like a mannequin as jaunty funfair music strikes up: you won't believe what happened to this poor sucker!

Drugs can be practical or sensual, another means of dreaming or disappearance. They are also a commodity: Veronika tells the devious Doctor Katz, 'You've given me much happiness.' 'No,' she responds, 'I've sold it to you.' Fassbinder's pursuit of narcotics was so thorough that any sense of normality was eradicated and replaced with intoxication. Even a metabolism as bullish as his own couldn't take such treatment and operate unscathed. During *Germany in Autumn*'s thorny re-enactment of real life he broaches the notion of having a 'problem' with drugs. Playing himself, Fassbinder acts like a brute. He rampages around dark rooms, variously wracked by fears nobody imagined he had (doubt and self-loathing), hopelessly addicted to cocaine and with his love for Armin in slow decay. He falls distraught into his lover's arms. There's nothing amorous about this embrace, a consoling bearhug with the faintest trace of rocking to it, as if Fassbinder were a child being soothed after a nightmare. Strange to think that Fassbinder outlived the man holding him. Armin

94

committed suicide two months after the movie was released, on Fassbinder's birthday.

In 1980, he outlined a future project named *Cocaine*, at once writing a love letter to his favourite substance and forecasting the stylistic climate of *Veronika Voss*:

> Cocaine freezes the brain, freeing one's thoughts of anything inessential, and thereby liberating the essential, the imagination, concentration and so on. This freezing of the brain ... will be expressed in the film as follows: everything visible will appear covered with a sort of hoarfrost, glittering ice, whether in winter or summer; glasses and windows will be covered with ice flowers, and with all the interior shots in the studio, even in summertime, the actors' breath will be visible, as is usually the case only when it's bitter cold outside.

Fassbinder, much like Freud writing to his dear Martha, exulted in cocaine's power to unleash 'passionate pleasure and tireless work' but there's also a moonbeam chill running through those lines: the director imagines retreating into a Snow Queen's palace where winter never fades. Craving for everything to freeze in a fabulous tableau, including the mind itself, isn't the healthiest wish. The drug had become Fassbinder's muse and *Veronika Voss* is a coke fiend's dream, all snowily sumptuous monochrome and sparkling mirrors. But another dreamed aesthetic preoccupied him, too: he repeatedly commanded his cinematographer to make the film 'look like heaven!'

Querelle may occur in heaven, too (radiant bodies everywhere, all lusts ready to be explored) but captures how eerie exploring that space would be: heaven can only be inhabited by the dead. Where Fassbinder once assured every scene to his name was prickly

with difficult emotions, now he wanted the actors to be lifeless, puppet-like. Fuck the melting sun that stays sky-high for the whole film, those ice flowers bloom in everyone's veins. At a certain point, high can't be distinguished from stupor and desire fades out until it possesses almost no pulse at all. Maybe that was what he wanted, just to quell the fire in his brain for a moment. Taking drugs had become a rational strategy for getting through everyday life, stilling the chaos around him and making all the surrounding pressures recede, if only until the stuff wore off again.

Early in the note on *Cocaine*, he outlines the desired trajectory of his life:

> It is possible, even fairly certain, that relatively unrestrained or excessive use of cocaine over a fairly long time will shorten the user's life, in whatever fashion. On the other hand, the cocaine user will experience this shorter lifespan significantly more intensely, more imaginatively, and will usually be spared the cruel depressions that suddenly befall the "normal person".

Difficult to know whether he was announcing where his allegiances lay or devising a baroque rhetorical premise to explain his submission to the tractor beam of full-blown addiction. No matter what, nobody could ever accuse him of being a 'normal person'.

'When I was very young', he said, 'I already knew I was supposed to make many films.' Those words explain his downfall more plainly than any tabulation of his drug intake: a belief that his fate was laid out from the beginning. He couldn't entertain any pleasure that wasn't also a source of ruin; everything had to be taken too far, beyond abandon or wonder, in the name of that

devouring need, this 'special mental illness'. He had carved out of a vantage point where every black impulse could be indulged, a fortune stacked up (cash was the only mode of payment he tolerated) and work accomplished on a scale that few other directors enjoyed, defying the rhythms of the market, his budgets colossal and his stars now plucked from Hollywood's constellations. But all this could only measure the extent of his isolation. Everyone was waiting for the next masterpiece or expecting a sudden fall into mere adequacy; shadowy background characters chased him wherever he wandered and there was always the ghost of his absent father needing to be bested or silenced.

Half of him was still aflame with ambition and the other was, in Samuel Beckett's desolate phrase, 'burning to be gone'. Beady little reports came in that he had been seen roaming around all the ritziest bars in Paris, a slobbering parody of himself in a filthy suit. Old friends kept away, too nervous to approach him. But still he had films that he was ready to shoot and a headful of more projects waiting to be made. The real trouble was a body and mind operating at radically different rates: one destroyed by two decades of wicked misadventure, the other still dizzying in its agility. For so long, he had outmanoeuvred the physical penalties that struck others but now, at last, they were coming for him.

It really was just like in *Faust*: he had gone so far at such a rate but debts must always be paid. When he was asked to describe his film *The Third Generation* (1979), Fassbinder likened the work to 'fairy tales you tell your children so they're better equipped to bear their lives as people buried alive'. He traded that fate for another, knowing the fall that awaited him all his riotous life.

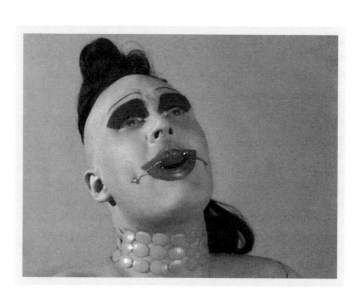

'I JUST ADORE EXTREMES'

'All monsters are queers.'
— Derek McCormack

'Not to chase other men; that is the Law. Are we
not men?'
— H. G. Wells

'A BIG ENTRANCE':
AN INTRODUCTORY QUESTIONNAIRE

To be a shapeshifter, as Leigh Bowery knew very well,
is hard work. A magic wand only does the trick for girls
in fairy tales. Some nights he hit the clubs in London as
a moon-faced goblin with melting green wax for hair,
on others he materialized as a deranged jester on roll-
er-skates, his head explosively crowned by a sunburst of
razzmatazz spikes. His appearance and activities during
these midnight sorties make all potential descriptions
sound hopelessly meagre: 'fashion designer', 'perfor-
mance artist', 'clown', his finest role was being 'Leigh
Bowery', a persona as transfixing and difficult to unrav-
el as any of his costumes. In conversation, this protean
ability was matched by the fact that he was a compul-
sive liar, prone to concocting another outrageous story
just to keep his imagination alight. A biography of him
could be assembled enumerating nothing but his most
notorious lies: he was a boy prince from London, that
he fucked Dolph Lundgren. He dreamed up fetishes for
his friends, which he took great delight in confabbing
about with mutual acquaintances. As if in retribution
for this regal disdain towards the truth, there exist three
magnificent biographical accounts of Leigh Bowery's
life: Sue Tilley's book *Leigh Bowery: The Life and Times of*

an Icon (1997), Hilton Als' essay for *The New Yorker* 'Life As A Look' (1998) and Charles Atlas' documentary *The Legend of Leigh Bowery* (2002). All of which can make a prospective biographer arriving after the mischief is over feel irrelevant, standing on the empty dance floor, clutching the poppers, mirror ball (and mind) still spinning.

Leigh Bowery was born in Australia in 1961 and he died in London on New Year's Eve 1994 from an AIDS-related illness. Once, in the late 1980s, he fired glitter out of his rectum onto the audience in a Brixton club like a cascade of fresh champagne. A snapshot from his childhood shows him as an awkward cherub, moon-faced, on a patch of lush and possibly artificial grass, improbably holding a football like a radioactive bomb. During a radio interview, when asked what precisely it was that he did when he appeared at clubs, he said, 'I just make a big entrance.' Those are facts about Leigh Bowery. Rather than refrying the detritus that's collected in these works again, wouldn't it be way more exciting to think of him as:

a) a mind-altering substance?

b) 'a mythic creature making an appearance in a quotidian world'? (Thanks, Michael Bracewell.)

c) a glitter-encrusted homosexual, performing funky metamorphoses again and again?

d) the history of queer monstrosity artfully compressed into a body?

e) somehow inexplicable?

Sometimes he looked like a psychotic Troll doll; sometimes he looked like a ghost. Consider this subsequent compendium of high-intensity scenes to be the equivalent of Polaroids, all mixed up, documenting various magical looks.

Many might have wished to proffer a questionnaire at Bowery when they first encountered him since he was so bewildering. Towards the end of 1992, a fax arrived from those famously attentive sleuths in *The New Yorker*'s fact-checking department, eager to verify certain incredible claims stitched into his biography. (An essay on Lucian Freud, then painting Bowery in all his ogreish glory whilst chatting with him about recherché pornography and Peter Rabbit, was in the works, hence all the attention from one of Gotham's fanciest publications.) By way of an icebreaker they asked, 'Did you go into labour and give birth to a pink "caul?"' A clarificatory rejoinder indicated that he had also spawned his assistant and future wife Nicola (the marriage was a conceptual jape they performed together) naked with her flesh painted hellfire red in the style of a howling newborn. Facts acquire a neon power when they have the air of fiction. Bedevilling all this insistent pursuit of truth, though, are odd little soundbites such as Nicola's admission, 'his whole persona was a mask', or the artist Cerith Wyn-Evans noting roguishly, 'Maybe the truth isn't the most exciting place to reach in relation to Leigh.'

Another kind of primer is required that doesn't deal in hot factoids but attends to the monstrous conceptual effect of these repeated transformations and plays around with the imagination responsible for them, embracing the mythic trippiness of his whole adventure. Echoing Bracewell again, an interpreter acute as a laser beam, much can be conjured up 'under the sign of Leigh Bowery'. He's a route into brainy exhilaration but he's also frequently baffling. 'He enjoyed confusing people,' his friend and dearest collaborator Michael Clark said, 'he enjoyed creating a response of, "What the fuck was that?"'

QUEER MONSTROSITY

Gay men have given themselves over to creating grand imaginative follies ever since King Ludwig II of Bavaria confected his first castle in 1869. But Bowery's work is never simply whimsical: he belongs to a tradition of queer artists making their bodies monstrous and reckoning with the concepts of taste, shock and immorality. The history of this impulse can be tracked through Wilde's *The Picture of Dorian Gray* (1890) to Anne Carson's *Autobiography of Red* (1998), stopping in between for a wild party with John Waters' Dreamlanders. Quite why queer men or women feel the urge to spike their art with transgressive thrills isn't hard to fathom. Lord Henry Wotton, decadent philosopher and one of Dorian's great admirers, can illuminate the situation: 'The only way to get rid of a temptation is to yield to it. Resist it and the soul grows sick with longing for the things it has forbidden to itself, with desires for what its monstrous laws have made monstrous and unlawful.'

Being bad in art, stimulating outrage or horror, is just another way of behaving monstrously (cathartic? Oh yes!) and a role to live up to when society proclaims your desires to be 'sinful'. To yield, as Lord Henry knows, is so exciting. Shock was a revivifying feeling for Bowery and he spoke of his effects as if describing his escape from the suffocation of the closet: 'There's suddenly more air.' Divine ate dog shit, David Wojnarowicz sewed his mouth shut and Jerome Caja (performance artist and go-go boy at San Francisco's Club Uranus) exorcised the trauma of living with AIDS through a painting of a clown boning a skeleton who jacks off with a crucifix in his hand. Piquant, he called the piece, *Bozo Fucks Death* (1988). Bowery spoke for many queer artists when he said, 'I just adore extremes.'

He hit London in early 1980; early the following summer there would be reports of five gay men in Los Angeles stricken with an obscure form of pneumonia, signalling the arrival of AIDS. By the time of his spangled heyday when he was dancing with Michael Clark, the belief in the monstrosity of gay men was all-too-literal. On 21 July 1989, a hack writing for the *Daily Mail* declared 'homosexuals are potential murders' and described 'a homosexual plague' close to destroying the country with its apocalyptic infection. Bowery was formally installed in a chamber at London's Anthony D'Offay Gallery for four days in October 1988, creating a performance piece where he could exult in his own mutant figure before a stunned audience. He lay on a divan in shaggy grey furs with his face fiery red, half-demon, half-aristocrat. Nobody seems to have noted, amid this Narcissus-like celebration of his solitary body, the eerie eroticism that lingers in the surviving footage (the audience cast as voyeurs breathlessly studying this creature) or checked how the virus infects the freak show scene in which Bowery's body is quarantined, *untouchable*.

TESTICLES

One of the especially arresting biographical titbits that Tilley skates over is the fact that Bowery needed 'to have several operations in childhood because his testicles did not drop'. If this indication of machismo in revolt seems like a mere outré trifle or a far-fetched example of over-reading, dwell on the formative ramifications that such an early and intimate experience of physical malfunction would have for an artist who later dedicated himself to gleefully messing with his own body. He depicted himself as an indecipherable hermaphrodite by obscuring his genitals with 'pussy

wigs'. Revisit the alien intersex waif on the cover of Marilyn Manson's *Mechanical Animals* (1998) or call up Genesis Breyer P-Orridge from Throbbing Gristle to fathom how radical these games can be, making them question what a person is when his or her sexuality is a mirage. (P-Orridge is the best known figure to go far on this adventure and trouble the conceptual fixities of gender, undergoing surgery in order to occupy, with all his usual anarchic verve, a body that appears to be simultaneously male and female, a 'pandrogyne', to use his term.)

Quizzed by *Modern Painters* in 1992, Bowery explained how he began by 'inverting the penis upward and pushing the balls into the pelvic cavity' before gluing down a misty layer of hair. As he recuperated from these childhood procedures, Bowery's mother taught him to knit and sew, schooling him in the arts that would be crucial for his future work. Reverberations from this episode could be tracked all the way into the fact that Bowery performed what's often considered a childish activity all through his life by dressing up, or, as Nicola said, 'becoming someone else for a night'.

TRANS

Towards the end of Bowery's life, when he was routinely birthing Nicola onstage in between emitting mock-orgasmic gasps, the theorist Susan Stryker was wrestling with the monstrousness of transgender existence. Herself transgender, she exhumed fears from the darkest areas of her thinking in a self-portrait which is also a fearless reckoning with Shelley's *Frankenstein*. Stryker writes,

the transsexual body is an unnatural body. It is a product
of medical science. It is flesh torn apart and sewn togeth-
er again in a shape other than that in which it was born.
I am a transsexual and therefore I am seen as less than
fully human due to the means of my embodiment.

A true heroine, Stryker seeks to claim and celebrate
this 'unnatural' body as a source of radical new energy.
Bowery's entire project twirls giddily under the sign of
'trans –' (transgender and transformative) since he re-
fuses to meet any pre-existing notion of what a man or
woman is, remaining a potent symbol of defiance.

Not only switching between male and female – no,
wait, between parodies of 'female' and 'male' – his cre-
ations exist on their own freaky continuum spanning
from 'alien' or 'animal' to 'enchanted object', way before
any sexuality can be detected. As William Lieberman,
a former curator at the Met in New York, said in an in-
terview about Bowery's work: 'The extraordinary thing
was that it was never drag – it was really a costume ... I
mean, he wasn't trying to imitate or personify anyone
else. He was simply creating a new being.' He could be
Godzilla, a big glittery cake, the mysterious heroine
covered in fur from Max Ernst's painting *Robing of the
Bride* (1940) or something in between a doll and a man.
At the same time, these 'new beings' provide metaphor-
ical accounts for the trans person's delirious experience
of switching from one body to another.

If a contemporary had to be volunteered for festively
wrecking notions of gender, exulting in bodily other-
ness and getting closest to appearing truly post-human,
the answer could be Klaus Nomi. David Bowie no longer
seemed to come from outer space by the time Bowery
was famous; he had hung up his Japanese leotards and

105

dresses ('Boys Keep Swinging!'). For another contender in the same category, hail Grace Jones.

'ALONE AT THE PIANO' (c. 1977)

This picture is reproduced in *The Legend of Leigh Bowery*. He's a teenager at home in a white dinner jacket, turned away from the photographer, a painted explosion of orange flowers just above his head. The colours are ill, tinged green as if afflicted with mould. The absence of sunshine from this picture, evocative of phrases like 'watery grave', would be ironic if the whole tableau wasn't so gloomy. The enigmatic pupil in his white jacket occupies the same role as a figure in a painting by René Magritte, paradoxically right there before your eyes and inscrutable: seen and not seen. Which wouldn't be a fuzzy way of thinking about how he appeared in his costumes.

Even if few could recognize him as Leigh Bowery here, from behind, clues to the unconventional sensibility about to bloom are evident: the peroxide sunburst of blonde hair, the lounge lizard tuxedo suggesting Bryan Ferry on a roast-duck-and-éclair-diet. Despite what the picture might (or might not) indicate he was having uproarious fun sometimes: a frisky teen with serious appetites and Wildean curls, he met with anonymous dudes in the toilet cubicles at Melbourne Central Station when he was supposed to be at choir practice. Barren surroundings can be unexpectedly fruitful: the route to Narnia is through an old wardrobe.

BE A BODY

His body was a big, fat, perverse sculpture ready to be manipulated and the clothes were sculptures, too. As anybody who's played a ghost on Halloween or

106

run amok in drag will tell you, costumes can have the same electrifying effect on normal behaviour as bumps of cocaine and hits of whiskey, providing a way, in the words of Parliament-Funkadelic, 'to dance out of your constrictions'. Raid the dressing-up box, darling, throw on those silver wings, mix them with a pair of orange moon boots and shake that glitter-encrusted tail! It's liberating to be an unnameable creature for the night, especially when your body is awkward or ugly: that would be the moral of Cinderella's story if you thought Prince Charming was a brainless Adonis.

Bowery found multiple ways to exploit and make trouble with his body, whether by roller skating through a club with the famous corsétiere Mr Pearl sneakily attached to his back in order to endow him with a hunchback, or high-kicking his way down the street like a drunk Rockette, naked but for a transparent plastic cloak. Check the dictionary: 'glamour' has its origins in 'grimoire', meaning 'a book of spells'. Concocting his own mode of deranged glamour, he turned his body into a magic trick.

LABORATORY

'I liked the way costume could change people,' he said in an interview, thinking about what would come to be known as the performative power of clothing in the early 1990s but, *pace* Judith Butler, trapping its effects without so much jabberwocky. For somebody of a scientific persuasion, Bowery's outfits could be reconfigured as experiments, asking what happens to him or his audience once certain fantastic stimuli are applied to his body and tested out inside the laboratory of the club, much in the way the mind-addling effects of a narcotic can be tracked once the substance is shot into an addict's

bloodstream.

Thinking of himself in the third person as his own magical creation, he wondered what the response would be if he dressed up as a clown from a toddler's nightmare – Bowery's art is not for coulrophobes – or danced around to Hi-NRG disco with peacock tail feathers jazzily erupting from his rump and a Bart Simpson doll obscuring his face. All of this was animated by a masochistic compulsion: 'I've used my discomfort,' he said, 'to explore these areas,' with these dark, anxiety-ridden zones mapping a squelchy region in the head that's concerned with humiliation, longing, and physical pain coupled with the kinky reasons that they might be alternately craved or feared. Bowery was also overcoming a gawky adolescent's shyness so his self-invention could be called abreaction, transcendence or, um, 'owning it'. (Who knows what sex anybody 'owns' if they become a combination of prepubescent cartoon imp and bird of paradise: go ask Icarus.)

Through this process, he also discovered areas where one concept darkly mutates into another: cuteness turned creepy when he dashed down a Tokyo runway in 1986, a self-described 'unusually big heifer carting around sixteen or seventeen stones' dressed as a pink baby doll, and when he hung upside down from a chain by his gold boot in underwear so capacious they could be repurposed as a circus tent. Was that where he combined fetish dungeon thrills with a tribute to Houdini, or when he turned such activities into slapstick? *The New Yorker*'s questionnaire did not broach the question of what he might have been trying to get out of or away from by dressing up.

HISTORY LESSON

By his own account, Bowery was mesmerized by punk and some of the weirder creatures coming out of its cauldron. Punk's mental and philosophical upheaval was radically expressed in fashion, transvaluing the ugly, tasteless or forbidden (snot-green hair, ripped garments, Sid Vicious' T-shirt of the goofy cowboys with their equine cocks *almost* touching) into objects of beauty and thus desire. This would be instructive and empowering for Bowery when he was a teenager in Sunshine, Australia, tracking the activities from far away via imported style magazines as if they were monthly transmissions from another world. Every scene has its mascots: before Bowery was showing up in *i-D* and *The Face*, grinning like a loon, the punks had Jordan, the wild-eyed vixen who writhed around nude, Warhol had his Superstars and the Bright Young Things of the 1920s had droll Stephen Tennant, mixing amphetamine into his cocktails. The requirements for this role were simple: wit, a carefully confected persona and a huge capacity for excess – living by night takes its toll.

Back in 1974, around the time he was singing about a character named Halloween Jack and imagining London as post-apocalyptic overrun with droogs, David Bowie told the *NME* that 'the kids themselves are more sensational than the stars.' As ever, Bowie displayed a seismograph's accuracy for predicting future happenings in culture at large since the effects in this shift from fascination with the star to the crowd would be many and various, ranging from punk rock to rave culture. Bowery's outfits, too, were literally 'sensational'. Outré things, they exist to provoke difficult feelings in an audience.

109

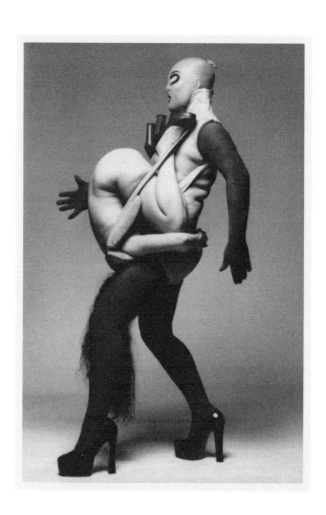

COWBOYS

Dicks hanging out, two lonesome cowboys stand face to face as one adjusts the other's kerchief in a tender fashion 'moment' between dudes. According to the text below their boots, they talk in cockney voices, Fagin-esque, about the heterosexuals wrecking their nightlife:

– 'Ello Joe been anywhere lately
– Nah it's all played aht Bill
– Gettin to [sic] straight

Malcolm McLaren liberated this picture from a copy of the New York artist Jim French's zine *Manpower* and added their lament himself. He also tinted the cowboys red and blood, maybe to signify blood or a tempting neon light, mid-sizzle. One of the staff working at his and Vivienne Westwood's legendary punk boutique and hangout Sex was famously arrested in the shirt when a policeman judged it to be an obscene item. Since there was no original text, only what McLaren dreamed up, something else can be thrown down in its place so one cowboy says to another, 'Love-biting, arse-licking, shit-stabbing, motherfucking, spunk-loving, ball-bust-ing, cocksucking, fist-fucking useless man.' 'Useless Man' was Bowery's showstopper with his band Minty in the early 1990s, which he recited while dressed as a deranged matron: an antidote to straight life. In its own rough way, the cowboy shirt represents all the trouble even representing gay life can cause. Mainstreaming, making homosexuals cuddly, hadn't begun – no *Will & Grace* on the airwaves. If 'homosexuality' was syn-onymous with anything when he attained maturity, it was deviant and potentially fatal. His parents were Christians in the Salvation Army, his mother was espe-cially devout, and they may have wished for a son who was 'too straight'.

DREAM SEQUENCE

On a soundstage in slow motion, Bowery steps out of a limousine in a floor length nineteenth-century gown embroidered with flowers, eyes and mouth revealed by holes in a mask of the same cloth and head topped by a jaunty pink wig. 'Spooky' by Dusty Springfield plays from somewhere. Several outrageously tasteless fibreglass hounds keep watch, lit from within by fluorescent light and wreathed in tinsel scarves. A mirror ball twirls giddily overhead. Orange clouds of dry ice soon flood the scene. Through these menacing fog banks, Divine slinks up to Bowery in her gown from *Pink Flamingos* (1972), fabulously undulant as 'jello on springs' to quote Jack Lemmon's description of Marilyn Monroe from *Some Like It Hot* (1959). Divine sports devil horns and carries a pitchfork. And as the saxophone solo on 'Spooky' kicks in, they smooch wildly.

FILTH

Asked about his old friend and muse during an interview for *The Advocate* in 2015, John Waters pointed out that Divine (born Glenn Milstead) never had any transgender intentions animating his alter ego: 'He didn't want to pass as a woman – he wanted to pass as a monster!'

The Pope of Trash was a primal influence on Bowery. Not only did he recreate the birth scene from Waters' *Female Trouble* (1974) where Divine sires Mink Stole on an ugly couch but took cues from the master on the necessity of turning bad taste to 'a stylish and original purpose ... Good bad taste can be creatively nauseating but must, at the same time, appeal to the especially twisted sense of humour.' All Waters' films provide explosive lessons about how queerness can be at once carnival romp and terrorist activity, rebelling against straight

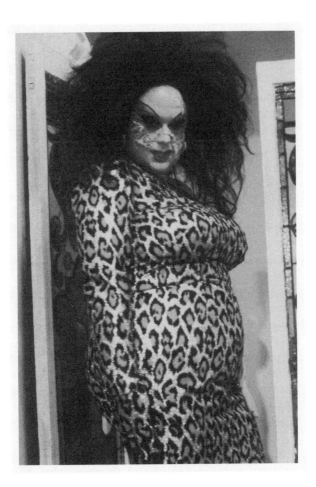

world notions of what's normal with depraved glee. And Waters possesses an imagination that any wannabe surrealist would razor-blade an eyeball to attain. *Desperate Living* (1977) is like a children's story concocted by a perverse but gifted boy: Mink Stole brews up potions in her castle, Grizelda the morbidly obese maid is killed by a collapsing house, a hound dashes off with a severed cock and the queen is roasted like a hog for a cannibal banquet. Trash siren Divine ignores the fact that her body would never be deemed 'attractive' according to the usual rules and makes it into a personal triumph, getting high on the fabulosity of her three-hundred pound figure, undead Jayne Mansfield strut and proto-punk coiffeur.

Bowery took the shit-eating spirit of *Pink Flamingos* (1974) and covered it with glitter. He said in an interview, 'If I have to ask, is this too sick?' he said, 'I know I'm on the right track.' Shock gets a bad rap as somehow cheap or puerile but it can be cathartic, too, discovering where the tasteful limit lies and dancing all over its corpse. Silence was what homophobic adversaries craved: that was the official government strategy in response to AIDS. Ronald Reagan didn't acknowledge its existence in public until 1985, by which time the apocalyptic effects were inescapable; Margaret Thatcher's apparatchiks rejected the thought of issuing public health warnings about the sexual practices that carried a high risk of transmitting the virus that same year, believing such procedures were 'in bad taste'.

NO FIRE ESCAPE IN HELL
Bowery met the dancer and choreographer Michael Clark while tripping on LSD at London's decaying rent boy hang-out The Pink Panther. The exact date cannot

be ascertained owing to the greedy drug intake of all the survivors but in most estimates the year *jetés* between 1981 and 1983. But Michael Clark always remembers that Bowery climbed onto the bar, ripped a poster for limp synth dummies Kajagoogoo from the wall and festively shat all over it. 'And I knew from that moment', Clark later said, grinning, 'it would be an ideal collaboration.'

Clark and Bowery were a mutually intoxicating duo. Within weeks of their meeting, Bowery was dressing the ballet company and eventually he took roles in their performances. For *No Fire Escape in Hell* (1986), he appeared as a precarious jelly on ten-inch heels, waving a chainsaw overhead; he slid amyl nitrate under the noses of any eager dancers in the wings. They soon upped the 'what-the-fuck-was-that?' atmosphere even more by scoring performances with music by The Fall, creating a three-way of mind-boggling forces. The Fall's bandleader Mark E. Smith spat incantations about a ghost dwelling in a mountain over a rattling skeleton groove ('Spectre vs. Rector') as Clark slinked around like a mutt in red leggings designed by Bowery to reveal the full moon of his rump. Clark was, according to one fanzine, what happens when 'you cross Sid Vicious and Stravinsky', a prodigious kid liable to gobble any drugs he could lay his hands on – he gamely took the opiates offered by New Romantic courtiers – and marked by a preternatural understanding of his medium. With the same spirit that Alexander McQueen loosed on haute couture a decade later, Clark took the contemporary dance or ballet and thoroughly ravished them, combining a deep feeling for his métier's traditions with a bad boy need for sabotage: the costumes can be bizarre and sexy, the music should be punk and untrained dancers should mix with the fawns who have classical training.

'He created costumes,' Clark said after his friend's death, 'that allowed me to behave in all sorts of ways.'

TALK SHOWS

Joan Rivers pops up in a pumpkin orange jacket at some point in the early 1990s: 'I'd like you to meet five simple people with a dream and a wardrobe from Hell!' Bowery shimmies out as an intergalactic bride, teetering on space rocket heels with his head replaced by a fiery-coloured foam ball and his counterfeit bosom riding high. He's followed by a bunch of New York club kids, including Michael Alig (later convicted of murder; played by a grown-up Macaulay Culkin in his subsequent biopic *Party Monster*, 2003) and transgender sex kitten Amanda Lepore pulling off a Marilyn impersonation so flawless she may be in need of an exorcist. Smitten Joan will question Bowery's gender ('I'm a man', he asserts with a fruity seducer's purr) and poke with sororal astonishment at his ample breasts. Close-up on the loquacious foam ball as he declares, 'It's not so much about fashion, it's about having fantasies and making them all happen, and ... being a little bit subversive and I think that we deliberately try to shock people as well, Joan.'

Delighted but not so much into this highfalutin' talk, she calls them all 'the cutest things', as if these delirious folk were cartoon mascots. A round of applause; cue commercial break. Still it seems bizarre that Bowery made it onto the tea-and-tranquillisers world of daytime television. But he obviously enjoyed alternately revelling in and mocking its ambience of kitschy cheer – he also cultivated an ironic obsession with the dreariest British soap operas such as *Brookside*. Watching his television appearances is the best way to experience his supernatural powers. He showed up on MTV late at

116

night in 1987, chatting with Bananarama whilst sporting a mask bedizened with fabulous sequins that hinted at unknown erotic practices or deformities, those tremendous legs looking svelte in red jester's stockings. Being so warm-hearted and talking like a sly Edwardian fop during the broadcast's interstitial moments of chitchat makes him seem all the more baffling. He acknowledges this otherworldly aura by claiming, 'I guess it seems rather odd for me to have parents.' Checking out the videos again, many seem to have misunderstood his activities as mere wackiness in fancy dress: 'Give him a break', an audience member cried on another American show as if defending a confused child, 'he just thinks it's Halloween.'

HOME ALONE
'my mom watches oprah twenty four hours a day'
 'my dog is old so is my grandma'
 'i should be at school'
 'somehow i cant get myself to go'
 'its so useless to me now.'

Those are lines from Sadie Benning's short film *Living Inside* (1989) which she made when she was sixteen. Forced from high school by homophobic bullying like a witch chased to the edge of the woods, Benning kept to her bedroom in suburban Milwaukee and recorded this video diary, chronicling her depression. It's not as if every gay kid could or even wanted to follow in Bowery's footsteps and become a Technicolor hooligan: there were plenty of bold young queers who sought catharsis away from the masquerade, disclosing the wreckage of their lives. But split-screen *Living Inside* with footage of Bowery swooning in the Anthony D' Offay gallery and uncanny parallels emerge: performance pieces meet

117

peep shows, both works present homosexual bodies in isolation, ready to be gawked at and monitored by an unknown audience. Bowery dwells, again and again, on the thought of being a girl by obscuring his gender and endowing himself with breasts. Inside themselves, everybody has considered inhabiting the opposite sex at some point even if only as a wild counterfactual daydream, wondering how much of 'me' would remain if they occupied another body.

BURNING DOWN THE HOUSE

In her essay tracking the fairy concept of camp back to the early experiences of trauma or rejection that may torment many queer children, the critic Terry Castle asks, 'What sort of child, apart from mentally or physically disabled, is more likely than any other to elicit parental ambivalence or dislike? Who more likely to associate "home" with abuse or humiliation?' Todd Haynes' film *Poison* (1991) reckons with all this psychological horror in its tale (told in the style of a true-crime documentary) about the disappearance of Richie Beacon, a young child who kills his father and flees the family home, flying away into the sky.

Open up his case file and it's obvious that this changeling tale is a metaphor for his precocious queerness: Richie was a gifted kid, marked by his tendency to confect flamboyant tales ('he was a liar,' a disenchanted teacher claims), bullied *en masse* by his class and prone to playing around with another boy who shushes any attempt to divine what exactly the 'stupid junk' was that they did together.

Poison dwells on what it means to be a 'difficult' child and how that description can often allude to or forecast an otherness that parents are too scared to name. Father

slain, repression, homophobia, patriarchy (call it what you want) is overthrown and liberation awaits: another lost boy is off to Neverland. We experience his dawn flight into the sky for ourselves with a rush that's totally *Poppins*, the bedroom window growing smaller all the time as he achieves flight. 'He just jumped off the ledge and went up,' his mother says, 'like a wind or something had taken him up.' Going higher, the clouds modulate from snow white into dreamy pink.

A HOMOPHOBE ON *POPPINS*
'Mary Poppins is a fucking witch.'

WARDROBE
He said he wanted to create outfits that had 'something glamorous but also really horrifyingly twisted' about them. Hence the times he fixed a cracked skull to his head with the daintiest lace, transforming a memento mori into a piece of cake, or struck a curious pose in a midnight black ballet costume that any wannabe Odile would covet, the tutu puffing out like a fearsome thundercloud and the accompanying bodice covered with sparkly stars, his feet in white sneakers suitable for an astronaut, or the *nuit blanche* where he froze his face in a dumbstruck gawp by puncturing his cheeks with needles. He strutted around the tea room at Harrod's in London for *The Clothes Show* in 1988 wearing a faux-Dalmatian fur coat and mask like Cruella de Vil's mad son, claiming this was 'an après-ski outfit'.

Surveying Freud's portraits of Bowery, he doesn't look like a man so much as a relative of King Kong. Much like that movie's climax, these paintings accomplished near the end of Bowery's life encourage the stunned contemplation of a huge and monstrous mortal

body. So awesome are the scale and texture of those pictures, as if Freud had laid the flesh itself, raw, upon the canvas, that all their melancholia is shot through with a sense of marvellous spectacle: behold the dying beast. Cerith Wyn-Evans likened the experience of watching him at the D'Offay Gallery to studying a 'gorilla at the zoo'.

The costumes can be at once familiar and wholly peculiar, like in the credit sequence to Charles Atlas' film about the Michael Clark Company, *Hail the New Puritan* (1986) where he resembles a plump libertine from a misremembered Gainsborough painting: blue and orange stockings, breeches and choir boy wig but his face chequered with fiery spots and the flesh beneath painted frostbite blue. Many of Bowery's outfits can be best understood as elaborate spoofs of outfits.

KISS THE WHIP

Bowery told *Modern Painters* that by the end of the night 'quite spectacular' lacerations covered his chest, 'as if,' he noted, assuming the giddy diction of pulp erotica, 'I'd been whipped across my upper carriage with a riding crop.' He used fetishistic materials (especially latex) not to intensify any erotic sensation but to make himself fearsome, creating a force field of panic around his body. Nor was his favourite erotic mode anything close to *Venus in Furs*: he kept up that penchant for rough fucks in public toilets and claimed to have indulged in 'unprotected sex with over a thousand men'. (He admitted this was his 'biggest regret' in the course of a perky Q & A with the *Guardian* in 1992, hinting at his diagnosis.) Making the body suffer or subjecting it to sculptural deformations is always part of fashion's game. Lines spoken by the phantom personification of Fashion in

Giacomo Leopardi's swish 'Dialogue Between Fashion and Death' (1824) act as a prophetic commentary on Bowery's pursuits – and a warm-up act for the works of Alexander McQueen: 'Sometimes torture and mutilation, aye, and even death itself for the love they bear towards me,' Fashion tells the Grim Reaper,

> I say nothing of the headaches, and colds, and catarrhs, and fevers of all sorts ... which men contract through their worship of me, inasmuch as they are willing to shiver with cold or stifle with heat at my command, adopting the most preposterous kinds of clothing to please me, and perpetrating a thousand follies in my name, regardless of the consequences to themselves.

'WHAT HAVE I GIVEN BIRTH TO?'

For a long time even thinking about the whole 'fashion-death' thing was scary and the only way out was body-popping into a whole other dimension entirely by throwing down the video for Missy Elliot's 'The Rain' (1997) directed by Hype Williams with its home girl heroine in a baggy silver spacesuit and goggles that are totally Bowery. Like him, Missy favours a brand of science fiction couture that makes the body into a funky cube. Williams films her through a convex lens to endow her with additional it-came-from-outer-space otherness. 'I smoke my hydro on the d-low,' as she looms over and sneaks back from the camera.

If Bowery showed up here in this kinky reformulation of hip hop into an enigma, his influence was most obvious on the work of Alexander McQueen, who had high fashion loot that Bowery never obtained and an imaginative flair which remains unmatched. McQueen

brooded on alchemy manuals, Bosch and *The Hunger (1983)*, the glamorous vampire flick starring David Bowie and Catherine Deneuve; he dedicated a show to an ancestor burned as a witch in Salem (*In Memory of Elizabeth How*, 1692). He was a master of goth theatrics, sending his scarecrow-like figures to stalk runways, scoring *The Horn of Plenty* (2009) with Marilyn Manson's 'The Beautiful People' and, Edward Scissorhands-style, creating beauty through attacking his material. All the violence that Fashion speaks of in Leopardi's dialogue is visited upon the clothes which appear expertly scorched, torn or unstitched. He wished to make female glamour ferocious, he said, so that 'no man would dare lay a hand' on the women he dressed. *Savage Beauty* (his posthumous show at London's Victoria and Albert Museum in 2014) was crammed with macabre imaginative excesses, as if dressing some gore-soaked fairy tale: the mermaids, witches, swans, corpse brides; the vampire corsets, gold nests, bones. *Plato's Atlantis* (2010) showed its models as androgynous undersea creatures while on surrounding screens radiant lamias, natives to a computer-generated ocean, hungrily studied the audience.

For a shoot with *Dazed & Confused* in 1998, he supplied the American actress, model and Paralympian Aimee Mullins with two mahogany legs and a whalebone corset. In the accompanying pictures by Nick Knight she looks like a broken doll but together this trio made a much-needed declaration, proving that disability didn't preclude beauty or eroticism. In the 1990s, he was a textbook *enfant terrible*: early success, outrage, prodigious rate of invention, excess. (McQueen committed suicide, aged 40, in 2011.) During the 1997 documentary *Cutting Up Rough*, McQueen showed off his self-styled "ooligan'

charms from inside his fashion house's East London atelier. Cackling over his latest creation, laid out by the sewing machine like an animal on an operating table, the plump skinhead holds up a jacket stitched through with tresses of blonde hair – beauty devoured by a beast. He gasps, 'My mum's wondering, "What have I given birth to? A creature!"'

ARIA

Interviewed in 1991, Todd Haynes pointed out the monstrous logic running through *Poison* (and the collective imagination) when he said, 'The homosexual gets viewed very often as a person who is doomed to undo himself and thus serves as a warning: Look what happens if you deviate from the natural order.' Deviating from the natural order can be a thrill and twice as much fun precisely because it is forbidden: overthrow tired notions of taste, beauty or hideousness and indulge in all kinds of other spirited misbehaviour. Crack open a volume of Greek mythology – *Medea*, *The Odyssey*, *The Golden Ass* – and see the consequence for this violation: tragic happenings, incinerated estates, corpses everywhere. Punishment is frequently meted out from above in mean proportion to the intensity of intoxication or knowledge that this suffering daredevil discovered on the earth below. Believing that this rhythm of existence still holds means believing in a world invested with a 'natural' sense of drama. The catastrophe of AIDS manifests in a physical decline so brutal that it can seem like the work of a spiteful god. (Many homophobic religious groups claim that's exactly what it is.) After a long spell of relative splendour, health, the infernal fevers arrive, flesh is scalded all over with tumours, the body is left skeletal, demented, derelict.

Early in the virus' ascendance, infected bodies were frequently left untouched by undertakers. On 13 February 1987, the *New York Times* ran a report on these scandalous rejections:

> The indignities of acquired immune deficiency syndrome ... do not end with death ... Some funeral directors refuse to embalm AIDS cases or insist on such costly extra equipment as glass bubbles for viewing or dressing in protective clothing to pick up a body.

A communal stigma could metastasize from the corpse to the funeral home with an undertaker rehearsing this attitude for the reporter: 'Gee, Joe's brother-in-law was laid out there – he must have had AIDS.'

Bowery's body was his favourite material. There's a fable's wicked irony underpinning his life: no matter how fantastic the body becomes through his experiments, the same ugly fate awaits as a man is stripped down to the flesh, succumbing to disease. You can't throw glitter on that. These early deaths, ready to be interpreted as illustrations of martyrdom if all their magnificence and risk is taken into account, can also be seen as a tradition. A litany: Robert Mapplethorpe, Rainer Werner Fassbinder, Alexander McQueen, Arthur Rimbaud, Oscar Wilde. Not to forget all the other men who died (still are dying) from the virus who don't have quite such notoriety. Derek McCormack kisses off *The Well-Dressed Wound* (2015), his novel in the form of a séance meets-fashion show, with the acid proclamation: 'Faggots will die doing what they love: dying.'

And the truly radioactive line in Haynes' statement is this concept of the homosexual being 'doomed to undo himself', which reverberates through Bowery's project:

the costumes were a way to vanish and...

(HIS LAST PERFORMANCE, EARLY
WINTER, 1995
Bowery's coffin famously did not fit into his grave when
he was buried at Mount Macedon, back in Australia.)

GO BANG
... all this mournful choreography is a gross habit, as
if the only way to think about a concluded life was as a
crypt, offering little other than grief, scars, exquisitely
measured sorrow; old passions withered like specimens
on a mad scientist's shelf. Honey, fuck *that*: who says you
can't go *Party Monster* on it all, burst into song, cavort
through the graveyard, loop Macaulay Culkin dancing
in his Puck-on-Ecstasy costume? You can be dead way
before you're buried anyway, everybody knows that,
inside.

Bowery is someone who dedicated himself, inge-
niously, to making mischief, clowning, and proved that
didn't need to be just a dumb pursuit, thus the funeral
soliloquy and requisite attempts at blackening the page
with woe are neither hot nor wise moves. You could write
'*et in Arcadia ego*' in Liquid Gold and cum, that would be
a smart tribute. And there may be no adequate way to
mourn the queer paradise poisoned and lost long ago.
Like any great monster, Bowery shows what we could
be if we dared, bringing what's going on within to the
surface, mixing up inside or outside, dream or waking,
human and supernatural.

No use harping on his 'trademark impenetrability'
or 'the conundrum of his life' (attempted and rejected).
Picture him dancing with Anton Walbrook, that silver
fox, in *The Red Shoes* (1948) underneath a ruby moon,

picture him licking whipped cream off Divine's face or shaking booty to 'Seen and Not Seen' by Talking Heads ('He thought he might, by force of will, / Cause his face to approach those of his ideal') and 'Work It' by Missy Elliott. Picture him flashing his usual lunatic grin. He wanted to transfer exactly whatever insane notions were prancing around his mind into real life, without anybody else's interference or censorship, and he did it. Staying within the imagination is the most fitting tribute: it all came out of his head.

Heavy as it sounds, Bowery is sublime proof that the gloomy facts of life can be transcended, those dark feelings inside can be turned into something magical, bright and strange. Unrepeatable, and not an encore of anything, his life is also exemplary. He was his own muse. The whole explosion of fireworks that can be identified as his life from Sunshine boy to magic character in the Big Smoke, yes, all of that traces the transformation of life into art.

DANCE NUMBER

Anybody seeking a lesson in what a glorious, uh, disorientating 'thing' (sometimes you don't know what to call it) the greatest art can be should just fire up the footage of The Fall performing 'Big New Prinz' with the Michael Clark Company in 1988. Clark twirls around on a chessboard in black wig and jacket covered with Elvis patches as The Fall unleash this apocalyptic glam stomp – 'he is not appreciated!' – and the dancers throw shapes straight from a baroque masque, expressionless faces, bodies sinuous as spilt ink, all dressed in polka-dot underwear and little jackets frying with sparkly orange brocade. The inscrutability of the sequence is what makes it all so powerful. No knowing quite what's

afoot here, whether circus act or pageant, celebration, funeral game, or an unaccountable mixture of all four, and despite the surreal humour in play (several non sequiturs in motion at once), the performance is accomplished with iron discipline.

Dancers tumble over each other, limbs and glitter, boy or girl, writhing on the floor: they subvert whatever 'elegance' is supposed to be, creating a beautiful new kind of clumsiness. Clark has found a different way to dance by hobbling on crutches: an awkward lurch will turn into a dying kid's swoon; he makes jagged moves, turning the crutches, which ordinarily mark the body's infirmity into the source of rad experiment. This mixture of contrary signals transmitted by the choreography, score, costume seem as if they should overwhelm each other but combine into a beautiful new 'thing'. See, Michael Clark holds the crutch aloft, like a wand.

POEM
The two beauties (Magdalena Frackowiak and Sigrid Agren) are ready to hit the catwalk at Alexander McQueen's show *The Horn of Plenty* (2009). Photographed waiting in shadow by Anne Deniau, they appear in dresses spun from feathers, mouths painted blood red, one dressed in black and the other in white. The black swan stares as if seduced by a sudden beam of light or a song in the air, far-off, and the other studies us, a little scornful and sleepy, in a way that equals real glamour. There are no signs of documentary context: pin it to the wall and it could be a still from a cinematic retelling of 'Leda and the Swan' where our heroines, her daughters, have their sweet revenge and wicked old Zeus – a drunk with a thundercloud beard – ends up dead.

Dressed up, these two serious ladies belong in the

same monstrous taxonomy as Geryon from Carson's *Autobiography of Red*, a teenage boy marked with fiery red wings that mark his sexuality more dangerously than a rainbow flag would dare: freak, warped child, failed bird. Desire creates a monster. Geryon is scolded by his parents for wearing costume ('if you persist in wearing your mask at the supper table / Well Goodnight), he pulls on his brother's 'stick' in the dark and he falls in love with Herakles at the trailer park. In a 2008 interview with *The Paris Review*, Carson explained why she never wrote the novel about Medusa that she wanted to attempt before Geryon flew into her mind. (Medusa used to be beautiful, according to Ovid, until she was raped; she gave birth to her own winged beast, Pegasus.) 'There's something more narratable – is that a word? – and romantic and graspable about the monstrosity of being a gay man, now, for us, in this moment of culture.' Bowery revelled in that monstrosity, inventing an existence for himself that's gilded with the feel of some unbelievable fiction. Reality pulls off a costume change and turns into a dream.

TRANSFORMER

'This curious child was very fond of pretending to be two people.'
— Lewis Carroll

Once the story was over, I crawled back down the rabbit hole because reality was no match for Wonderland. Summer turned to autumn, frost growing on the pumpkins, and autumn died away into winter but still my sister hunted for me everywhere, calling out my name for days as if she believed yelling long and loud enough I'd be suddenly resurrected in whatever snow-covered field the police were stumbling through that afternoon. (They were searching for an outstretched arm, a foot or even a hair of a little blonde figure, somewhat bigger than a doll, bloodied and barnacled with ice.) There I would be at once, an angel in a nightdress, rubbing my eyes and shaking off another headful of freakish dreams. But I never came back home and she had a funeral for me, though there was nothing to bury, committing an empty coffin to the earth: ashes to ashes, dust to dust and all that other ghostly nonsense.

But I'm forgetting my manners, honey bunny, we haven't been introduced. When the supernatural Ms Carson resurrected *Antigone* in 2015, she had the mother from antiquity whose wickedness is legend proclaim, 'I'm a strange new kind of in-between thing aren't I / not at home with the dead not with the living'. If I hang out in a far more luscious and sunny space than that accursed suicide, I have the same curious condition. You see, I'm Alice, sprung from Mr Carroll's eccentric head and left alone to watch, read and dream for a long time now. (Hence my tendency to precocious razzle-dazzle

every so often but what did you think I was up to all this time, *mon petit*, tennis lessons?) I break hearts, I wolf uppers and downers like Skittles and I keep a hawkish eye on the activities of my various heiresses, amazing damsels that they are, living so-called life out there in the 'real' world, remarkable in their 'Alicious' nature. (I'll show you their pictures in a moment. And 'Alicious', in case you're wondering, is from *Finnegans Wake*, 1939, an exquisite blend of the 'scrumptious' and 'illicit' that I so dizzily incarnate.)

I still remember how the unicorn in the Looking-Glass Wood, that cute rascal with a wizardly beard who's since succumbed to moon blindness and lung disease, called me 'a fabulous monster' as we split cake with the lion. This dopey boy came and asked me to talk about what it means to be a monstrous girl and reminisce about all my adventures and perilous metamorphoses. I said yes in a lightning flash. He was shocked to find that, like all my goofy doppelgängers from the movies, I'm not a jittery little girl anymore but into my wicked teens, cavorting like a fuckin' punk. Duh, any good old story changes to mirror modern times and has the future hibernating inside it, too. A clever sorceress, I know Wonderland's magic inside-out: a few greedy tokes on the Caterpillar's pipe and there I was, ten years older at once. But Mr Carroll's story was always about 'the strange new kind of thing' a girl transforms into over the course of puberty: that should be obvious by now.

Conditions are weirder here now even than they were when he was alive: the skies are arctic summer blue all year round, slaughtered pigs still talk, wildflowers exploding from their rotten bellies, and the trash from lost weekends makes our forests smell like heaven. Please imagine me in fetching silver boots and a red polka-dot

132

dress (me and the Rabbit threw that shabby blue number on the bonfire last year: I loved to watch it burn), sprawling in grass that's a fantastic watermelon green and stroking the trusty Cheshire Puss as he purrs like a thundercloud. A stream may curve, serpentine, around me where I'll check my reflection. No curtseying for the perverted bros in the audience, that stuff makes me want to puke. The past is hard to purge. You should kneel down and kiss the mysterious imprint I've left in the grass, knowing in your filthy heart that I'm nothing like you. That wasn't a very kind thing to say. Oh, I have grown up.

The poor goth princess Francesca Woodman caught my ghostliness just right in plenty of her photographs, many of them self-portraits taken with preternatural elegance when she was still a teenager, too. To be a girl within Woodman's private dreams means being an enigmatic creature: she spends shadowy days indoors with her double, she appears as a blurry wraith, bones gone to light, as she nuzzles a stuffed badger in a vitrine. Her silhouette appears, snow angel-like, creepily spread-eagled in powder on the floor. I may be present in these pictures *in spirit* – allow the double meaning of those words to flicker for a moment – since I did plenty of vanishing myself. (Was I the first non-fairy girl to feel her body vanish and reappear? Twinkle-toed, I did it long before that dumb cunt, Tinkerbell.) But in her desolate New York studio and elsewhere, Woodman produced shots that are homages, ranging between the oblique and the obvious, to my original adventures.

Wearing a plastic toyshop version of the Rabbit's head, a naked dude, ripped as Mr Universe, waits for us at the door of a derelict house. This sinister pic, taken at an uncertain time between 1972 and 1975, is an

adolescent girl's erotic daydream, the Rabbit luring her into a (undead?) world of desires that lies darkly beyond the tangled weeds and filthy windows. She played around in a polka-dot dress, too, that picture from 1978, 'Polka Dots', shows her at nineteen, a Hanging Rock dame, bent in the gloom with a blurred hand to her ear as if listening to something buried, howling, in the wall. Strange to see myself so acutely embodied by a dead girl, even if it's no exaggeration to say evidence of my unshakeable presence is everywhere (a rare fate for a child star, except for Shirley Temple, obviously) from Balthus' enchanting vixens to the Looking-Glass Los Angeles surveyed in David Lynch's *Mulholland Drive* (2001): 'This is the girl'. Nor was Mr Carroll a stranger to these sensations himself, as he recorded in his essay 'Alice on Stage', writing about an actor who appeared in the first theatrical adaptation of my adventures: 'To see him enact the Hatter was a weird and uncanny thing, as though some grotesque monster seen last night in a dream should walk into a room in broad daylight and quietly say, "Good morning."' Good morning, indeed. I was the most troublesome ghost in his head: 'Still she haunts me phantomwise,' he wrote, and I get a tickle of that feeling myself when I look back to see all those copycats chasing my shadow.

For Woodman, turning herself into me was a way to brood on the precariousness of the body and being: she became the phantom in the attic or she merged with the walls of a decaying house to hint at her own *unheimlich* interior. She could've directed a grungy downtown adaptation of the story, switching the potions for opiates, and had Nastassja Kinski play me – well, she *had* transformed from ingénue to panther for *Cat People* (1982) – but Woodman, who always liked to play at

135

being a ghost, decided to become a spectre for real. In 1981, lovesick and still terribly depressed after a spell in a psychiatric hospital, she leapt from the top of her apartment building to her death, aged twenty-two. As I fell 'down, down, down' into Wonderland, I thought to myself, 'After such a fall as this, I shall think nothing of tumbling down stairs! ... I wouldn't say anything about it, even if I fell off the roof of the house...' One of my favourite photographs of Woodman is actually a monochrome snap taken by her dad when she was maybe thirteen with her back to the camera in a pinafore like the one I used to wear. Fir trees, mountains and smokestacks roll away under her dangling feet: it's all very *Twin Peaks*. Her slender arm stretches out, holding a straw hat with a flying saucer brim. She must know she's being watched: she sets the hat so carefully on the section of thin air at her side, she may be protecting an imaginary friend, some unseen Tweedledee, from the heat of the sun.

From time to time, the Cheshire Cat reminds me with a pink burst of laughter that a tale of puberty's troubles is so *not* what was afoot in my adventures. 'You're being sleepy and stupid again, babe,' he says, with his eyebrows all jazzy and velvet paws pinned on a dying bat, 'Remember I said, "We're all mad here." Wonderland is a nuthouse, no?' Many have found outrageous fruits by interpreting my adventures as an account of lunacy. True to all his old habits, the mischievous pussycat vanishes, tittering, before I can ask him to add a little more colour to the thought. Mr Carroll believed whatever we dreamed was real and thus that Wonderland lay somewhere on the map even if the cartographic particularities could be elusive when you were wide awake. Real schmeal, whatever the hot interpretation is,

the book always monitors existence as a never-ending riddle, making it a plainly factual account of life so far as I'm concerned. And I was acting all that out way before any of little Kafka's panicky moles, loquacious apes or bureaucrats, stammering, again in the style of Mr Carroll, hit the scene. Still, Franz is the only office boy to make me swoon.

In the 1950 Disney cartoon, 'Alice' looked very much like my sister, who was lying next to me on the riverbank that fateful May afternoon when I saw the Rabbit. She was a classic David Hamilton girl, slender and gentle as a fawn with her flesh the texture of white peach and that wasn't me: I was always a little too gawky and obstreperous. I want to write them a letter but I keep revising the fucking thing, ripping it to shreds every day:

> Dear Walt,
> You animated the Cat's loopy esprit to perfection
> but he isn't pink and purple. Nope, his coat changes
> hourly, making him look like one of those lunatic
> felines that the Victorian illustrator Louis Wain
> created when he was going cuckoo in Bedlam,
> therefore the fur is covered in multi-coloured
> lysergic patterns that shimmer and sparkle.
> Kisses,
> Alice.

When he conjured me up in his illustrations to accompany the book's first edition in 1865, John Tenniel gave me a mop of flaxen hair, tresses heavy as if I just had climbed from the bath, and the eyes of a little vampire, so dark and not a little bewildered: a flower girl for the bride of Dracula, the English Wednesday Addams. Immortal as his drawings are, I still think it's a little odd that Tenniel never caught in ink any 'little scream

137

of laughter' I produced on the page or the expressions of puzzlement, delight, and, yup, wonder I pulled when I was experiencing the fun here for the first time and had no actressy pretensions. My look, in all its unchanging moodiness, suggests the old curmudgeon could only picture girlhood as a state of constant perplexity. Transmogrification is really what my life is about and Tenniel did have a wicked time illustrating all that, whether it was my neck uncoiling, slithy as a jungle vine, when I was a giantess or me sneaking, Lilliputian, towards the Caterpillar's mushroom. My creator could never have me turn into a boy, somehow joining that gang of stinking jackals would be going too far, but neither of them, in their contrary attempts at drawing me, ever produced the portrait of a beautiful child: I always look sad and awkward as a mannequin.

Way earlier than the average child, I learned all about the joy of drugs ('Eat me! Drink me!') to deal with this trouble, along with the horror that sometimes jumps up, jack-in-the-box-like, when I think too much about what's happened to me, the divide between sense and nonsense, being myself or someone else. Or, actually, just thinking about being to begin with. How frightening all that change was at first and now I can't imagine a reality that isn't friskily syncopated every hour or so by fluctuations in scale, speed or feeling. I guess you would call it a compulsion, my desire to be something – *anything* – else.

You know *Legend* (1985), the big-budget fairy tale? (Those bargain basement unicorns! Tom Cruise as an elf!) I wanted to stalk around pretending to be the devil from that movie with his enormous horns and dragging around some ragged black wings I assembled myself from the corpses of dead crows and, yeah, I'd pitch my

voice down to the same sepulchral bass as him and tell all kinds of filthy jokes like a horrid comedian. I'd be a boy, all ruined and evil. That would be sick. 'Is this thing on?' A joke is just a riddle in a funny costume. And all those questions I had to answer in my interrogations from the Caterpillar, the Dormouse and the Mad Hatter, like an elaborate parody of education, were jokes stripped raw, turning knowledge into nonsense: 'Why is a raven like a writing desk?' I didn't know, I don't know.

A few bites of the fudge stashed, glowing, in the thicket and I could be a great big fiery tiger and eat up all the other animals here, painting my face with their blood. You probably remember that in Mr Carroll's books each new delirious episode's beginning was signalled by an outbreak of stars dancing trippily all over the page, the first hint of the awaiting fun.

```
    *          *          *          *
         *          *          *
    *          *          *          *
```

Now, what was I trying to say?

I was a girl who turned into a lunatic who turned into a ghost.

Sometimes just having a body is gross and I wish I could escape that. What's that Ryan Trecartin line again? (I think it was in *Sibling Topics*, 2009)... 'I don't want a body anymore. Fuck the body.' I could dwell on how 'virtuality' sets all Wonderland's tricks loose in the real world since you can mess with gender, appearance, the self and all its trappings at will. That's Trecartin's big wacked-out fantasia. But my enduring thought about computer life is how much I'd like to be reprogrammed so all this slime would come out of me until I ebbed

away and possessed, at last, no more substance than a hologram. I'd like there to be no noise at all. Trees, houses, a big grey wilderness. In this world, I could have a hunky centaur strut in here without the trouble of finessing any pixels, just by sculpting him, mahogany ass and all, with my overactive brain. CGI feels like the latest manifestation of the Victorian spook shows I used to know: apparitions materializing out of thin air, smoke and mirrors. You could tell me, Stop being so retro, so *Blair Witch*, you ghoul, and demand we green-screen out of here with various demons, aliens and cyborgs on our tails. I guess it was right, at last, that Tim Burton's *Alice* films were so artificial and had no real earthly air to them. They were programmes, all digital because Wonderland is supposed to be somewhere that only exists in the head. If green-screen technology in its pure state approximates anything truly, it's the inside of an empty head.

Sometimes I wish I was the stars. I mean, the really beguiling question my story asks is, where, or even *what* are you when you dream? Are you a creature or a thought? Mr Carroll entertained the idea that I was a figment in the snoozing Red King's head and left the answer uncertain, snakily waiting to be uncoiled by his readers. When my body stretched like liquorice, a pigeon, crazy with hunger, mistook me for a serpent ('Little girls are a kind of serpent,' he squawked quite reasonably). Which makes you wonder what happens when a girl decides to stop being, uh, girlish and becomes something else entirely, neither one thing nor another.

The photographer and model Claude Cahun wasn't scared of thinking about herself as a character who was somehow other than human, rejecting with futuristic daring all the attenuated notions of gender and sexuality

141

that were offered to her like a trunkful of suffocating corsets. Her biography could sustain an epic of *Orlando*'s proportions, all of it not some flamboyant entertainment but utterly real, tracking her psychotic mother's disappearance into a mental hospital when Cahun was a tiny girl, the long and fabulous romance she conducted with her stepsister Suzanne Malherbe (aka 'Marcel Moore'), her prankster resistance to occupying fascist forces on the humble isle of Jersey and concluding with her eventual death aged sixty, ravaged, in 1954. Yet it's her lifelong commitment to metamorphosis that's really captivating. She used photography as a space for solo performances, acting out moments of dandyish private play and exploring, like that marvellous daredevil and *poète maudit* Arthur Rimbaud, what happens when the self is somebody else. With electro-shock eyes, she appears in a picture sporting a sailor's suit and cap. Aged eighteen, she occupies a snapshot from 1912 as a lost odalisque, her head shawled with scarves and jewels, staring, spellbound, at her audience. The following year, Cahun was a skinhead starveling. Puffing on a cigarette in a velvet jacket, she – for there could be major doubts about her sex – looks like an aristocratic corpse.

Not feeling human meant she could transcend all the earthly limitations. She carried galaxies in her head, hawking up the sun like the sphinx ridding herself of a pesky fur ball. She wrote of herself as Eve, a lusty broad juggling 'suns, hedgehogs, moons, fruits, dead stars' with the whole cornucopia of creation at her command. She wrote, too, in conversation with another self, one of the many identities rough-and-tumbling giddily in her head, 'What would you like to do?' The other party replies, 'The impossible.' Like me, she was a chimera, tantalizing and magical, but she was also a product of

142

her own invention.

She knew the Surrealists. Andre Breton, that arrogant quack, sent her dizzy billets-doux declaring she was 'one of the four or five great minds of the time' but she was much too courageous to run with that crowd. They made me into a pin-up, too, with Breton scribbling overheated stuff about 'the profound contradiction between the acceptance of faith and the exercise of reason' (he always was a nice Catholic boy) in his *Anthology of Black Humour*, published, festively, on the edge of war in 1939. He also threw in one of my favourites, 'The Debutante' by Leonora Carrington, a ticklish little tale about a high-society adolescent who pals around with a frisky hyena. The beast goes to the ball after devouring the maid's face: eat your heart out, Cinderella. But Cahun's shenanigans really make demands distant from regular melting-clock Surrealism. Her entire project was a game of hide-and-seek with 'herself', whoever that was, so thorough and accomplished with such flash showmanship, anybody confronting her oeuvre might be dumbstruck, even a girl as schooled in the slippery nature of the self as me. 'Claude Cahun' was a boyish alias for 'Lucy Renee Mathilde Schwob' but every picture was an alias of one kind or another. Defying any imitators or pesky doubles, she parades her otherness for all to be startled by and to admire.

Circa 1929 when she was old, mid-thirties, here she is in one of her most voguish outfits. She sports a gold swimming cap over her shorn skull, a pair of sparkly homemade angel wings at full span and a Tiger Lily dress with a jagged hem. Her strange choreographic stance suggests she is as much a theatrical character as a real presence: a bloodthirsty Fury, ready for another night of mayhem. She eyeballs you with supreme

143

hauteur, her eyebrows lofty as her wings: 'No dope in slacks dare approach my angelic form and if you bore me with your slow-witted talk, I shall gobble you up, too.' She could have stepped from the pages of a fable: 'The Gorgeous Cannibal'.

'There ought to be a book written about me,' I swore when I was too enormous for the room, 'and when I grow I'll write one.' Maybe that's what this thing is, my woozy confessions, but writers are so boring and I never really wanted to join their gang. For a long time I thought that the book would be a tell-all memoir: *My Life in the Looking-Glass* was the title I toyed with for a few hours once I found out that *Blonde on Blonde* and *The Interpretation of Dreams* had been swiped by boys. I suppose I could still make a personal appearance on *Oprah* and set the record straight; I bet the audience would go nuts hearing me narrate the whole rainbow tale: 'There are no other kids in Wonderland and I'm ever so lonely.' Cue crocodile tears. Oprah, the goddess, could throw a big sticker on the front and make me 'Book of the Week' or whatever. But books are obviously hell to make and afterwards they have to be dragged around and explained to everyone for years, like your very own and extra-special deformed child.

Mary Shelley birthed her monstrous revelation *Frankenstein* when she was twenty and forever afterward felt a terrible ambivalence towards the story, calling it her 'hideous progeny'. But every mother has fears of bringing a monster into the world. She made that nightmare real and stitched it into shape limb by rotten limb, making its dark heart beat. Her Creature is a killer: he slaughters a little boy in the mountains and drowns a cheerful teenage girl in a lake. I still remember how that scene shook me to my bones when the movie came

146

out in 1931. Like every little girl, I thought for months afterwards that Karloff would wait for me at the river's edge, growling like a wounded bear, and pitch me into the water. Motherhood is for suckers: who wants to be at the beck and call of a shrieking pig? So tough just to look after myself.

This might be kinda remedial to note, too, but chronic pangs of anxiety lurked within any birth scene imagined by Shelley since her mother died from an infection three days after she was born – heavy with child, Miss Wollstonecraft wrote her husband, 'I expect to see the animal in a few days' – coupled with the trauma of her own little son's death and a near-fatal miscarriage. During this tragedy, her husband, the poet, lay his bride in a bath full of ice to slow her bleeding. Shelley was shocked to discover what terrors lay within her own imagination: even as her monster dashed across the arctic wastes, she knew he was just the ghost of her dead boy. I'd flirt with the Creature and kiss him all over his graveyard face. I only see boys in my sleep round here. Lascivious twentieth-century dudes claimed my adventures reeked like *Lolita* (1955), sniffing out subtexts that the Victorians, too anxious about carnal matters to imagine such happenings, never expressed. Yawn. I stay mute, too: meanings are there to be played with and, nymphet or not, who am I to spoil them? Much smarter to protect myself with the enigma like a suit of radiant armour than to spit out any secrets. The Red Queen used to quiz me tirelessly, 'What do you suppose is the use of a child without any meaning?' Nobody wants to be that, nothing more than an ugly scribble on the page. Maybe Mr Carroll was, much like Humbert Humbert, brooding hideously on the delectable nature of young girls and maybe he was truly preoccupied with nothing

more sinister than chess and rabbits: it's all still there to be dreamed over.

I'm a doppelgänger too, just like Lolita was the double of Humbert's first sweetheart, Annabel Leigh, herself named for a misty child bride conjured up by Edgar Allan Poe. There's the famous trove of photographs showing the other Alice, her hair chocolate, playing games with Mr Carroll. Aged six in one of his pictures, Miss Liddell looks unbelievably fierce, appearing wreathed in a 'beggar girl' costume on a backdrop of luxuriant ivy. He photographed her bright-eyed and wearing a headdress of summertime flowers; a scowling teenage girl, bored royalty, wore a crown like I did when I was Queen. His love for her makes everyone nervous but even a little detective work – no deerstalker and opium pipe required – reveals they shared an eccentric but innocent kind of affection that nobody knows what to call. All his biographers concur on this fact, nodding like Professor Yaffle. A virgin to his death at sixty-five in the twilight of the Victorian era, Mr Carroll struggled with his own peculiar case of arrested development. If darker shades of feeling or meaning do lurk within this relationship, they might never be known because he threw all their correspondence into the furnace like a boy who'd just got dumped for the first time and the other Alice never said anything. Mr Carroll was so lonely he had to caress another girl into being, deep in the undergrowth of his imagination, as the other Alice grew up, so he assembled my skeleton, unspooled my veins and sewed up my flesh. In all its confusions and delights, his tale may be at its most touching as an allegory about not feeling at home, a continual misfit, whether within the body, mind or in the world: 'I'm afraid I can't explain myself, Sir', he had me mumble, 'for I'm not myself,

148

you see.'

I had marvelled at the oddity of being inside a fairy tale when I first came here and even an airhead like Snow White can tell you that's not the safest place for a girl to be. Cindy Sherman did a wicked job illuminating that in the 1980s. All of her work makes my insides glow with delight from her *Centerfolds* (1981), glamour pusses in their bedrooms in varying states of distress and terror – they were rejected by the editors at *Artforum*, the title made you think of porn magazines and then made you shudder, to her gooey series *Clowns* (2004-5) where the artist (and multiple rubber-faced doppelgängers created by digital manipulation, fudging the difference between 'clone' or 'clown') gurn and lurk in a candy-coloured computer simulation of a big top.

Her *Fairy Tales* sequence rules. 'Untitled 140' (1985) sees her lying, ravished, on her flank in some lurid thicket, an ugly neon glow irradiating her wig's Harpo-like mass of curls. She sports a hog snout freckled with blemishes and catches your eye like a naughty coquette. (Is the background glow from dumped plutonium?) Flirting, the swine has her hand to her mouth, as if she's trying to smother the laughter caused by a dirty joke. Last night I watched the old BBC documentary about Cindy again, *Nobody Here But Me* (1994). The film proved what the cinematographic textures of her pictures had always suggested: she was a horror film devotee. The crew follow her to a video rental place in SoHo where she checks out the stocks with the giddy air of Belle browsing in the Beast's library, pausing to ogle copies of *Halloween* (1978) and *The Texas Chainsaw Massacre* (1974) – the dopey boy told me he used to do exactly the same thing in Blockbuster or whatever as a cub, scanning the racks hour after hour for the ghastliest tapes he could

find, daydreaming over the artwork on their covers: severed heads, shrieking girls, beast men— horror's full arsenal. But the most bewitching intimation happens early on when she thinks back to childhood. 'I was always into the more perverse side of dressing up,' she says,

> Becoming old or a monster, somebody else, not being some pretty role model ... I don't even recognize what's there in the mirror ... Maybe it's like a possession, suddenly this apparition is there.

Her photographs allow her to charm herself into an imaginary character's skin. And, at the same time, the whole game orbits around the thrill of disappearance: now you see her, now you don't. The Cat flashed me a little disembodied grin a moment ago to underscore this point.

For *Fairy Tales* she becomes a bunch of monsters again just like she loved to be when she was a child. She moons the camera with a doll's plastic rump in 'Untitled 155' and by not hiding how fake the ass is, she makes the shot all the creepier as if she was abandoned in a workshop halfway between being a Hans Bellmer puppet and becoming a real girl. No ignoring, kids, how rad it is that she takes on fairy tales as a woman and rather than acting the innocent, the damsel in distress, revels in their grotesquerie: now that's owning it.

No broad has caught the monstrousness of just about everything right now, in ways both funny and scary, quite like Alex Bag. Much of pop culture's cheer makes her want to puke. She parodies commercials in her video *Coven Services* (2004), playing a zombie in goth wig and fishnets who perkily endorses tampons from a cemetery

while drooling blood and a witch who promotes anti-depressants for children. (A chorus of those she calls her 'test subjects' with Child Catcher creakiness pop up in skeleton suits yelling 'In the midst of life we are in death!' suggesting zombification is afoot.) So *not* the kind of heiress I had in mind at the beginning, Paris Hilton cameos as a glow-in-the-dark minx, slurping on a dick in footage swiped from a pirate copy of her sex tape *1 Night in Paris* and evidently way more into the attention of the camera than the actual coitus. It's still so now (by which I mean, so WTF) that the erotic ideal could be a commodity and a porn flick could be an advertisement. Bag also G. I. Janes it up as real-life soldier Jessica Lynch, 'a famous war hero for watching her best friend bleed to death in Iraq,' cheerleading for the military-industrial complex with all the glee of an unhinged Mouseketeer. It's a critique of the collusion between capital, fantasies, sex and abjection, not to mention government cabals, that's way more accurate than any future drone. Not that 'critique' is where I get off, actually – that makes me retch, too. I'm into watching girls get lost in the funhouse. On her public access TV show *Cash from Chaos / Unicorns and Rainbows* (1994-97), Bag and her pal Patterson Beckwith rolled up to the drive-in in freaky alien masks with heavy metal mullets; she dreamed up a chat show for vampires and conducted what she called 'drugumentaries' on air where she and her impish co-host roiled on this or that illicit substance and tried to make peanut butter sandwiches. Looking ill as a junk fiend gone cold turkey (such a hot look: I love you, Christiane F.) one wannabe Dracula on Ricki Lake says, 'I'm not a blood drinker because AIDS is going round.

The boy was cool with me killing all this by

remembering Jim Henson's *Labyrinth* (1986), which is the only homage to my exploits that really comprehends the uproarious implications of the tale with its assortment of fuzzy ogres, riddle-me-this puppets and antic hands: girlhood is a maze. The movie catches the scariness of desire with Jennifer Connelly's wayward maiden battling her wish to become a heroine against the mad allure of David Bowie's Goblin King: 'The question is – which is to be master – that's all,' as Humpty Dumpty once told me. B-but that proposition doesn't seem quite so tasty to me now as I stammer like Mr Carroll.

<pre>
 * * * *
 * * *
 * * * *
</pre>

Now reality might have to interfere, at last.

Wonderland is where I hid and nobody has ever found me. When you're young, sometimes it seems like all you know how to do is hide.

When I dream now the scenes are switched and, contrariwise, I'm not here but back home. There's no potion for the longing that visits me in the dark and eats away at my stomach like a big electric animal. Before I drift off I want you to remember a story about a girl who doesn't find any solace at home or any refuge in fantasy: no quantity of drugs or dreaming can bring her out of the wasteland. Bruising as it is for me or anyone to contemplate, this story may be the toughest account of being a girl, especially a lonely girl in a nowhere place, that there is.

Starring the mesmerizing hellcat Linda Manz in its lead role as troubled teenager Cebe, *Out of the Blue* (1980) is a punk tragedy shot by the rather devilish

Dennis Hopper when he was obliterating himself with narcotics. Stark in a way that few other American movies dare to be (except for Barbara Loden's *Wanda*, 1970), *Out of the Blue* is also a total masterpiece. Shaking like a ghost through the raw Vancouver autumn, Hopper plays Linda's convict father, a genuinely psychopathic character straight out of jail. The movie's prologue sees him blotto at the wheel of a truck, kissing his little daughter on the mouth – she's dressed up like a clown, it's all very creepy – and thundering into a school bus packed with eager kids in Halloween costumes. There's a shrieking that sounds like a hundred little mice on fire, the scene explodes and Linda wakes up, suddenly a teenager, from a dream that's also an unyielding real memory. Childhood should be dreamtime, wild green space full of daring and possibility; *Out of the Blue* shows you the ruins of that hope. Childhood is a garbage dump where the same ugly grey winter day loops over and over again, the depression beyond any economic or pharmaceutical remedy.

Linda runs away and gets dragged back by the authorities. Hopper rolls up to the playing fields on a sunless afternoon in a convertible like a red shark scabbed with rust and knocks back more liquor. (When he was a kid in 1940s Kansas, Hopper used to lie on the roof of his Pop's truck, huffing a rag soaked in gasoline and hallucinating clowns running wild across the starry sky.) Home is hell. Linda still sucks her thumb and holds her bear tight – 'see the moon?' – as her father's drunken barking comes through the wall. Later in the same bedroom, he gets lost in her knickers after she demands, 'Take a good whiff!', re-enacting some incestuous horror-show from their past. Knees gone to slush, he waits between her legs and she stabs him in

the neck with scissors. Almost every wild child ends up in an early grave: remember Bresson's Mouchette? Bullied, raped, beaten and dejected, she tumbles down a hill to her death. Our heroine was a showbiz found-ling, 'discovered' at a New York laundromat at fifteen and duly cast in Terrence Malick's transcendent *Days of Heaven* (1978) on the power of her lost urchin charisma. Linda also narrated this American epic in the style of a spellbound Little Rascal with her New York drawl guid-ing us through the golden pictures that Malick seems to have retrieved from America at the start of the last cen-tury. Hellfire roars through a field; snow falls on tired lovers at dusk: 'You just got half-angel and half-devil in you,' she mumbles.

Hopper had serious history with the youth mov-ie, co-starring with dead legend James Dean in *Rebel Without A Cause* (1955) and *Giant* (1956) along with di-recting *Easy Rider* (1969). He was also one of the great American photographers, fleet-footed, precise, and able to capture potent moments inside quicksilver scenes. His pix of little black girls outside a ramshackle Harlem carnival make something inside me crack every time I see them. When *Easy Rider* was a countercultural smash, the rascal quickly hightailed it to New Mexico and, with all the maniacal verve that his era demanded, he went on to feed his head and satisfy his lusts until he didn't really know who he was anymore. He was still grooving on a chemical regime that would paralyze a griffin a decade later when *Out of the Blue* was on limited release, snorting mountains of cocaine in between drenching himself with beer and rum from sunrise to the end of the night. Dynamite snakes through the movie and, by way of cryptic tribute, he decided to nearly kill himself before a slack-jawed audience at a Houston speedway,

155

re-enacting 'a Russian dynamite trick' he'd seen as a child: 'Just keep your head down!' He survived and lived high for a while until his mind finally shattered. He spent time, catatonic, in several psychiatric wards and would be retrieved by his parents looking haggard as a piece of old taxidermy.

All that's my wandering, wondrous ('wanderous'?) way of saying that *Out of the Blue* is a movie reckoning with loss, trauma, and the burial of various ambitions, ranging from a damaged little girl's desire for a happy family to the utopian promise of the psychedelic 1960s. But the movie is also a ferocious meditation on what it means to be blown away, whether by dynamite, heroin, booze or music. Hopper scores the story with almost nothing but Neil Young's 'Hey Hey My My (Out of the Blue)', a track torn between celebration of rock music's power ('the king is gone but he's not forgotten') and desolate elegy, to signal this world occupies a never-ending state of mourning ('once you're gone / you can't come back.') There will be plenty more to grieve by the time the movie's over. Meanwhile, the director makes a self-lacerating attempt to confront all the bad stuff he's done in the pursuit of getting high – mad rages, wrecked promises – and still acknowledges his demons are far from calmed, closing on a cathartic blast of self-destruction as the movie goes out with a suicidal bang. To say there is no solace or value in dreaming is the most tragic thing I can imagine. So much of waking life's excitement, rapture, magic – whatever you want to call it – is lost if dreaming is abandoned.

The movie played to meagre crowds upon release in the States but would be a shock for anyone who watched. Hopper remembered a distressed little girl tiptoeing up to him after an early showing, asking over and over

again as she sobbed, 'Tell me it was a dream, tell me it was a dream.' Trying to console her he responded, 'No, darling, it was a movie.' That doesn't sound so much like solace as a desperate man's prevarication, admitting there wasn't a huge difference between them in the end.

In August 1979, following her debut in *Days of Heaven* but before *Out of the Blue* exploded, Linda had her first and maybe solitary taste of how big time fame feels when she was the subject of a profile in *People*. She had won a supporting role in the ill-fated sitcom *Dorothy* that first aired that autumn and ceased transmission by Christmas but the reporter was more eager to alternately marvel at Linda's ragamuffin charms and contemplate with bougie panic how this Chaplinesque little character had charmed her way into Movieland. To catch the inner-city horror of her life before stardom beckoned, the journalist even kicked off with a cold opening mimicking the tone of a caseworker's file, ready to be quoted in a B-movie about life on the all-girl wing of juvenile hall.

> Father: whereabouts unknown. Mother: troubled, prone to violent arguments. Home: New York City tenements, frequent evictions. Traumatic experiences: seeing a girl's breast slashed in a knife fight; being splashed with boiling water.

None of these troubles or their melodramatic disclosure in the story, including yet more on surviving 'the worst of a Manhattan slum youth', stopped Linda from being as voluble or vulnerable as ever. 'Once,' she said, 'someone gave me some brown stuff to stick in my nose. It made me so sick I think I practically died.' She also confides, 'For a long time, I was always asking people to adopt me.' Despite the happy-go-lucky goofiness

that shades the piece, such as the photographs of Linda chilling with a surfboard in homage to the Fonz, sadness rolls off almost every sentence.

And yet, and yet... honey bunny, I don't know. Maybe Linda never really wanted to be in movies when she grew up. What we wonder about when we're children often seems too funny and weird to tell anyone, only a few years later. What does it really mean to *know* who you are? I don't think that can ever happen, not for me. Manz's career waned after a few more years, climaxing in 1982 when she was nineteen with a role on *Faerie Tale Theatre*'s adaptation of 'The Snow Queen' as 'Robber Girl'. The dream was left in the refrigerator and forgotten. But 'acting's in my blood,' she said in August 1979, 'I hope it lasts forever.'

THE DEAD-END KIDS

'I love you, Satan.'
— Ricky Kasso

'Sometimes when I'm watching television
And I think that most of the people in the movie
Are probably dead,
It's spooky.'
— Daniel Johnston

He saw the boy on TV. Larry Clark saw tons of his fa-
vourite boys on TV – Matt Dillon, Corey Haim, River
Phoenix – but the unknown kid, maybe seventeen
at max, in this episode of the talk show *Donahue* (you
know the kind of garbage banquets they have on those
shows: Sixteen and Obsessed... With Satan! Yes, I Am A
Vampire, My Father Hates Me) had a jittery thing about
him that was just great. If Clark was making a movie of
the book in which this kid appears, *The Perfect Childhood*
(1993), he would be the hero, skinny, shaggy hair hang-
ing all over his face and eyes glowing like he's ripped on
speed. The boy could be classified as a 'brat', 'punk' or
a 'juvenile delinquent' if you need to be all '50s bureau-
crat about such magnificent creatures. Clark recorded
the show, freeze-framed the picture on his TV and took
a photograph. The kid must have done something bad to
be on the show. Nothing beats being bad.

Rewind the videotape.

·

OK, play: this scruffy and kinda gorgeous drop-out ap-
pears on the cover of Larry Clark's book of photographs

dedicated to delinquent youth, *The Perfect Childhood*.
Notorious for the hedonistic adventures, never-ending
drinking, drugging, fucking all the time, to which his
beautiful photographs testify, Larry Clark is a former
juvenile delinquent – an unrepentant and major league
rascal – himself: needles, fun with guns, robbery, jail
time, the whole shebang. Clark's project is so obviously
about boys, all their devilish antics and special energy,
it's there in your face, you can't escape it. Boys getting
high, boys and their confused fathers, famous boys,
dead boys, naked boys, sleepy boys in Polaroids, boys
with a thing for Satan; most of them are white boys but
he will sometimes throw in a Mexican kid on trial sport-
ing a borrowed suit, just for kicks. The boy seen at the
start of *The Perfect Childhood* in a handful of pictures has
history whether he knows it or not: he could be the little
brother of Joe Dallesandro in Andy Warhol's hustler
odyssey *Flesh* (1968). (With the dum-dum insouciance
of a hunk on shore leave, Joe had his own name tattooed
on his arm.)

Homoerotic action is everywhere in Clark's work
but never offered to you in any comprehensibly fruity
form: only the hot fact of a nude body, a dumbstruck
revelation with its eyes closed and its dick hanging out.
Clark enjoys shooting boys like that for the sheer jolt,
the don't-give-a-fuck excitement of it all, even if he is a
straight dude whose lusts don't exactly revolve around
them. (Lou Reed's record *Transformer*, 1972, is a more
sparkly example of what happens when queer ambiance
and proclivities are channelled through a heterosexual
kid.) If he gets an ambiguous high from being around
boys, Clark's real predilection is tracking desire's woo-
zy lacunae, the moments that are not exactly hetero- or
homoerotic according to any usual programme. For

162

an exquisite primer on these mind-fucking properties of Clark's art, check out the undulant go-go boy scene from his teen murder flick *Bully* (2001). What was that first Sonic Youth record from 1983 called, the one with the scrawly drawing of a boy's head, getting X-rayed or falling apart? Oh, yeah, *Confusion Is Sex*.

.

'I was the last guy in Oklahoma to go through puberty', Clark told the *New York Times* in 1995. 'I stuttered very badly. I could hardly speak. My father stopped speaking to me ... So I started taking drugs. I did amphetamines every day from the time I was sixteen to eighteen. My parents never even noticed.'

.

Matt Dillon's not-so-hunky little brother Kevin, who is also an actor, shows up in a faded snap collected in *The Perfect Childhood* as a gap-toothed and pumpkin-headed little hoodlum. Ripe for a special guest role on a 1980s kids TV show as the archetypal kid from 'the wrong side of the tracks' who leads a plucky young hero astray, maybe with the assistance of a raggedy hound, Kevin has gone on to have his own perfectly respectable acting career, though he exudes little of his brother's lethargic charm or rough-trade mesmerism. But he reckoned with the trouble of being 'Matt Dillon's brother' or disappointing agents by 'not being Matt Dillon' or the trouble of being repeatedly confused with 'Matt Dillon', which would be, to use the vernacular of his youth, like really heavy, psychologically speaking.

Adding to Kevin's perplexity, Matt had provided

such a potent performance of all the doubt and strife that comes with being a little brother in Francis Ford Coppola's fantastic *Rumble Fish* (1983). Time is on the nod: *Rumble Fish* speedballs cinematography and atmospheres from German Expressionism with the humid mood of a juvenile delinquent flick from the 1950s. Dear bro Mickey Rourke appears as The Motorcycle Boy, a philosophical spectre, and Dennis Hopper plays their father, a crumpled drunk in a dead man's tweeds. Clouds do a REM sleep to-and-fro across the sky, junkyard music explodes on the soundtrack and the shadow of a teenager swoops down the empty streets.

The last picture in Clark's *Teenage Lust* (1982) is a snapshot of three boys lined up by height in sharp suits. Eaten away by the light of an flashbulb in places, the picture looks as if it was retrieved from behind a fridge. Even if *Teenage Lust* is subtitled 'An autobiography', none of the boys is obviously a young Larry Clark – they look like a trio of apprentice loan-sharks, too similar for easy identification – but there is a chronic sense of sadness radiated by concluding a book on a picture of fraternal happiness once rejected and remorsefully (too late?) smoothed out: family in ruins. Another childhood memory: Daffy Duck (no brother to Donald Duck) shows up in *The Perfect Childhood* eager for fun. 'I guess I could use a thmidgeon more!' lisps Bugs Bunny's nemesis, spraying hungry saliva from his speech bubble. Calling for a 'thmidgeon more' in Clark's world makes Daffy sound like he's wasted, tongue numb from shoving too much cocaine up that handsome orange bill.

·

'Kevin, Former Satanist' shows up in another sequence

of TV snapshots from *The Perfect Childhood*, identified by his on-screen tag and staring at the audience like he's on a bad trip. Satan hadn't been so popular among American teenagers since the Salem witch trials almost three hundred years earlier, a far from coincidental situation hinting that folktale superstition had returned from the dead under President Reagan. *The Perfect Childhood* is as much about the media's contradictory and overheated thinking on youth as it is any messily 'realistic' exploration of teenage wasteland: these crazed boys who are embracing Satan every night cohabit pages with pin-ups torn from teen girl magazines. Clark was plainly fascinated by this drift towards magical thinking where juveniles were suddenly depicted as demons in thrall to the powers of darkness. 'The devil,' the Bible says, 'worketh in children of disobedience,' and according to Pentecostal wisdom circulating in the 1980s, he frequently did so to a heavy metal soundtrack.

In 1989, the music of Judas Priest was sent to trial after a teenage boy, disfigured beyond recognition by a shotgun blast, claimed he was commanded to kill himself by subliminal messages concealed in the band's records. *Dream Deceivers* (1992), David Van Taylor's documentary about the trial, is one of the most unsettling films you can find about music, religion and fan worship as a form of mania. Owing to reconstructive surgery, the surviving boy has a collection of roughly butchered meat for a face. (Van Taylor studies him blowing smoke out the hole that used to be his mouth.) Courtroom testimony reveals the boys' ghastly private world where lyrics were an occult substitute for scripture, apocalyptic theology was ingested in the morning and all the narcotics they could stomach were slugged down at night. Relentlessly taking drugs didn't provide

166

any excitement so much as a much-needed escape from the unstoppable horror of being alive. And there's the brute irony that he survived, in more gruesome shape than anybody wants to imagine, with the consciousness he wanted to obliterate intact.

Not that such a situation can be called 'survival', exactly: the mind and body, unspeakably ravaged, are nothing like what they were before but the heart still beats. When the kid woke up and looked in the mirror, there was no boy looking back at him, only this creature from a Poe tale. Thinking about that irresistibly stimulates a sick little feeling: being monstrous is no longer a dressing-up game or a shock in a movie but a reality escaped only in sleep. He wanted to abandon his body and, in some macabre sense, that's exactly what happened. A smiling girl in *Teenage Lust* holds a sign reading, 'I am one of God's mistakes / And he is going to erase me.'

.

For kids in the 1980s, horror cinema and heavy metal music offered an escape from the repressive atmosphere of the Reagan era, each feeding teen fascinations with gore, death and all things occult or apocalyptic. Fearful of their popularity – heavy metal acts sold out arenas while *Halloween*, *A Nightmare on Elm Street* and *Texas Chainsaw Massacre* mutated into ugly franchises – Christian ideologues attacked them as a sinful influence on young minds, only drawing the target audience closer to the powers of darkness. Stephen King's books sold in enormous quantities and were routinely transformed into films – *The Shining* (1980), *Cujo* (1983), *The Dead Zone* (1983) *Children of the Corn* (1984), *Pet Sematary* (1989) – proving there was a huge collective appetite for

167

tales of supernatural creatures hounding small-town innocents. And if King is a dreadful writer, he's attuned to the feelings of displacement and difference that preoccupy many teenagers, incarnating them through the monstrous metaphors of telekinesis, possession or vampirism, conditions that frequently originate in some mortifying childhood trauma.

.

When two boys from Columbine High School killed twelve classmates and a teacher in 1999, *Time* had them on the cover. Little portraits laid out like a cascade of playful photo booth snapshots represented the awful roll call of victims. The horror tagline called the killers, who wore big grins, 'The Monsters Next Door', as if the only answer for such unfathomable brutality was an invocation of the supernatural. Art's few memorable confrontations with the plague of high school slayings are those that don't proffer any reasons for how a child could become so cold but court instead grief-stricken numbness, silence and bewilderment. Tempo opiated, Gus Van Sant's film *Elephant* (2003) moves back and forth at a trance-like pace, skirting the periphery of a massacre before observing its awful heart.

Meanwhile, the prophetic *Heathers* (1988) wickedly couples the twin cataclysms of teen suicide and the high school massacre together, making them into occasions for an acid comedy of manners: 'Did you have a brain tumour for breakfast?' Winona Ryder narrates and leads in her favourite mode (sly and kinda fragile with noir starlet hair) as the movie conjures a high school with a social system as elaborate as Dante's *Inferno*, the titular clique of popular girls reigning over the scene

and the fat girls left, like Satan in his icy cave, to endure the deepest solitude. There's an outbreak of suicides (murders, actually) among the students and, impeccably arch, the movie surveys the rancid ways in which the media confects the facts of these tragedies into tear-jerking hokum. Unsettling in its acuity, *Heathers* trashes its more earnest contemporaries ('Bite me, John Hughes') as it attends to the realities of teen angst, parental incomprehension and the awfulness of school. Like the Columbine massacre, the movie's finale involves the failed detonation of a bomb: school's out forever.

Karen Kilimnik's *Heathers* (1994) is a copycat replay of the original, taking its name and doubling its duration. Much as *Elephant* replays scenes from multiple perspectives like survivors attempting to piece the sequence of events together in baffled retrospect, Kilimnik loops or rewinds various scenes, perplexing their chronology and transfiguring the high school into a labyrinth – a formal move comprehensible to anybody who went through the education system. Playing truant from all her narrative responsibilities, Kilimnik creates a videotape that could be the possession of an obsessive fan trying to commit the film to heart. Signalling the premonitory forces in play, the video was installed in a recreation of the movie's funeral chapel, complete with flickering neon crucifix. Like her paintings, Kilimnik's *Heathers* allows her to think about fame ('Winona forever') and to dwell on girlhood as a time of starry-eyed fan worship and sinister daydreams. Rewriting fiction, her *Heathers* ends on a monstrous note: Ryder writes in her diary, likening her former friend to 'some mythological creature my eighth grade boyfriend would have known about' before wondering about herself and her sociopathic beloved J. D., 'Are we going to prom or to Hell?'

At the trial of the Manson Family killers in 1970, prosecutor Vincent Bugliosi referred to the defendants, all maniacal girls under the spell of Midwestern hippie pimp Charles Manson, as 'human monsters, human mutants,' stripping away any chance of sympathy or plausible identification with the suspects, not to mention encouraging that the death penalty be meted out. According to all available folk wisdom, to be a child who kills is to be powered by a unique intensity of evil.

.

In Clark's book *Tulsa* (1971), there's a picture of three nude kids (two boys and a girl) shooting up in a bedroom. The girl is just boosting off, needle to the vein, as the others watch – the boy's rubber banana dick hangs there – and feel Oklahoma amphetamine rocketing through their bloodstream. They were all part of Clark's druggy circle of friends. Over their shoulders on the wall is a poster showing Lon Chaney Jr. in *The Wolf Man* (1941): face thick with fur, showing his fangs, he looms out of the artificial fog in a point-of-view shot, ready to ravish an unseen damsel. The werewolf is a hot mascot for a junkie, just as hungry for an illicit substance – flesh and blood rather than dope or coke.

When he was eight years old, William S. Burroughs wrote a little book called *Autobiography of a Wolf* pretending to be a lone critter that dies when toxic fumes drift into his creek. Little Burroughs switched into wolf consciousness to escape the trouble of being a boy (as he writes in the prologue to *Junky*, 1953) subject to an intense 'fear of nightmares' and recurrent hallucinations

170

of 'animals in the walls'. In his teens, a neighbour obviously disturbed his air of preternatural otherness, dubbed him 'the walking corpse'. His imagination crammed with vampires, ghosts and Mugwumps (a sinister brand of organism discovered in *Naked Lunch* (1959), which 'licks warm honey from a crystal goblet with a long black tongue [and] has no liver') Burroughs is always sensitive to the monstrous consequences of devouring drugs. In his books, vampires frequently act as spectral metaphors embodying the effects of heroin addiction. The trick is most ghoulishly accomplished in *The Western Lands* (1987):

> a certain species of vampire which can take male or female form sneaks into the rooms of youths. The pleasures they offer are irresistible, and the victim is hopelessly captivated by these visits which no charm or lock can forestall. The victim loses all interest in human contact. He lives only for the visits of the vampire, which leave him always weaker and more wasted.

·

In horror films, there are dead teenagers everywhere. The slasher genre depends on their corpses stacking up.

·

In a note at the start of *Tulsa*, Clark writes 'once the needle goes in it never comes out.' Track marks, like the holes left in the neck by a vampire's bite, mark that the body is under a spell.

·

172

The most brutal autobiographical statement in *The Perfect Childhood* is a crumpled document written upon Clark's admission to a rehabilitation clinic in 1990 or 1991 – facts are hard to obtain. Call the thing 'Self-Portrait as a Bunch of Drugs (c.1965-1990)'. In his own spidery hand, Clark dates and enumerates his experience with a huge smorgasbord of substances ranging from the ferocious psychedelic DMT to 'herion' [sic]. Between 1967 and 1980, he remembers spiking up approximately three hundred times. A surprise that his recall isn't hazier since decades were also devoured by his eager consumption of 'codiene [sic]', PCP, opium, morphine and a solitary dalliance with a brain-frying quantity of crack. All of which hints that Clark had a more hardcore constitution than the average character drawn into such a whirlwind but also makes for a talk show-like confession – 'How I Obliterated Every Day on Narcotics' – thrown down for voyeuristic perusal and encouraging any viewer to imagine a procession of flashbacks.

'Alex on Ludes, OK, 1973' is written in the gutter of a picture from *Teenage Lust* by the same agitated hand. The photograph shows a mysterious boy, half-silvered with light and riding on a sweet high. Making the scene out of focus enough so the boy glows is Clark's sympathetic method for capturing the fuzzy-headed mellowness supplied by ill-gotten prescription tranks and a few cold beers. 'Paint Sniffers, Tulsa, 1972' shows two little punks stalking through a gothic forest at noon with paint-soaked cloths obscuring their faces. Brains gone to ice cream, one of the kids shoves a tree trunk, maybe thinking it will topple over just like him. No pictures survive from the lone afternoon in 1975 when Clark huffed a 'rag-full' of spray paint himself – presumably

he swore it off after the glitter faded from the rush and the next few hours were spent struggling against dissociative static.

The concept of autobiography happens to go a little fuzzy, too, when the figure responsible for its existence is frequently a ghost skulking outside the frame and his everyday life is experienced through a magic veil of mind-altering chemicals. 'Self-Portrait as a Bunch of Drugs' obliquely represents friends vanished, hours smoked and days melted away. Such prodigious drug consumption totally banjaxes anybody's sense of time along with who or what they're supposed to be when they regain their senses. The self, scratching its head, needs to figure out everything all over again: reality is such a drag.

·

Clark's pictures are obviously silent but they could be soundtracked by Royal Trux's *Twin Infinitives* (1990) or shivers of feedback mimicking the electrical rush of a drug through the body, just like the noise that creeps in when the vampires get high on blood in Jim Jarmusch's *Only Lovers Left Alive* (2013) or junkie testimonials and gunshots or the sound of dogs barking in the rain.

·

This whole party is haunted by the spectre of Genie. Frequently remembered as a 'feral child', this California girl never actually knew the wilderness or anything approaching 'nature' in her early life. The journalist Russ Rymer's account of her discovery and its aftermath, *Genie: A Scientific Tragedy* (1994), describes how she was

174

condemned from shortly before her second birthday until her discovery by local authorities at the age of twelve in 1970 to spend every moment alone in the house's garage with nothing for stimulation other than a handful of defaced magazines and a plastic raincoat. Mistakenly believing his daughter was mentally disabled and fearing she would be damaged by the venomous attentions of the outside world, Genie's father had kept her locked in the dark. Any account of her early life sounds like material from a reading primer set in hell: Daddy grew his nails out extra-long so they would make the noise of claws against the door and keep her quiet; Daddy growled like a beast to stop her moaning; Daddy went to sleep with a shotgun in his arms. 'Genie' (a pseudonym bestowed on the girl by scientists to honour her sudden arrival in the outside world and her unearthly appearance) emerged frozen in earliest girlhood, speechless and stunned. She walked like a rabbit, her hands nervously testing the air as she walked; her voice came out a high-pitched squeak and she never fully mastered language, becoming a terrifying example of how solitude can accelerate the mind's decay. Photographs showed her in a plaid coat next to a doctor: a ghost holding tight to a friend's hand.

Hollywood was only fifteen miles west of the suburb where she was found, and on a subliminal frequency tales of neglected or truly feral children reverberate through many depictions of wayward kids. Think about Judy Garland in *The Wizard of Oz* (1939) barking 'I'll bite you myself!' at an old crone; the spell in Terrence Malick's *Badlands* (1973) where Sissy Spacek and her killer boyfriend Martin Sheen go *Crusoe*, living in their own fort in the wilderness, or the fact that Jodie Foster's tearaway heroine in the bittersweet all-girl high school flick *Foxes* (1980) is nicknamed 'Jeanie'. Shot by Adrian

Lyne (who went on to indulge his fascination with girlish flesh – Humbert Humbert called the condition 'nympholepsy' – further with that soft-focus adaptation of *Lolita*, 1997), *Foxes* ends with the future looking desolate. Foster smokes through an afternoon's reverie at the graveyard, hanging out with her friend's handsome tombstone (1964-1979), another summer gone to Hell.

.

The teens who shot themselves after listening to Judas Priest were especially thrilled by the band's song 'Dreamer Deceiver'. A tale of intergalactic escape, the track's lyrics evoke a Peter Pan-like sprite who waits underneath children's windows 'breathing summer breeze' and spirits them away to another world. Soon 'we are lost above' as 'hazy purple clouds' swirl like so much cough syrup. It's all schlocky like a star-gate trip done on a '50s backlot but weirdly moving if you think of the two boys listening to it over and over, enthralled by its offer of an alternate world. 'We obviously thought,' the surviving kid mumbles, toothless, 'there was something better.'

.

Clark's book *1992* (published that year) is as fat as the September issue of *Vogue*. A jailbait teenager appears, looking like a younger version of Keanu Reeves in *Speed* (1994), strung-out in heaven with his head knocked back and the surrounding world a blur he'll never remember. Boys are playing dead on almost every page: some are hanged in their bedrooms, others deep-throat guns in their underwear. The feel of these scenes could be fuzzy

and diaristic, collecting encounters with runaways to create a hustler's catalogue of half-remembered flesh but they have the same lustrous chrome surface as Bruce Weber's contemporaneous shoots for Calvin Klein. His imitators in fashion were legion and the following year, Clark indeed occupied major space in *Vogue*, his photographs juxtaposed with snapshots by Corinne Day, one of his greatest devotees. Much of *1992* dwells with ghostly fascination on the subject of teenage suicide but now it seems like a dead-eyed and darkly ironic example of the decade's most notorious aesthetic, heroin chic.

These are kids numb to desire, eyes rolling back in their heads with delight or disconnection. So heavy is everything with analgesia that actual spiking up never needs to manifest in the pictures. There are hints of real life's mess, fire and energy like in all the other books, but the prevailing mood is one of doped inertia. Attempting to run away, the kids find themselves becalmed.

.

Mind fried by a dose of acid taken just before registration, angelic blonde kid Claude from Jonathan Kaplan's *Over the Edge* (1979) sneaks into art class. It was supposed to be speed; no more than thirteen, he tells his pal, 'I'm flashin'...' The soundtrack is all sinister woodwinds and horns as if we've wandered into an evil forest from *Bambi* (1942), that is until he clocks the slide of a detail from Bosch's triptych *Garden of Earthly Delights* (c. 1490-1510), glowing on the blackboard: devils and imps cavort in a cross-section of a sinner's ass, then the noise gets psychedelic. He sits in assembly, rubbing at his face, eyes wide, his whole body looks like it's melting. Claude's brother, a cherub in a Kiss t-shirt, never speaks at all.

Gummo (1997), written and directed by the American malcontent Harmony Korine when he was twenty-three years old, is also a mind-addling trip. Not since Dorothy awoke in Oz has a tornado offered audiences such riotous transport to a region that doesn't make much earthly sense. Korine's tale of an Ohio town ravaged by a twister signals that we're touching down in some otherworldly nowhere by commencing with a gang of kids singing the filthy tongue-twister 'peanut butter, motherfucker!' and naming relatives, male and female, who have a 'pussy', before a dog appears skewered on a satellite antenna. A whispering narrator confesses, 'I saw a girl flyin' through the sky' – Dorothy? – 'and I looked up her skirt'; cue the snarl of a chainsaw: waking logic is getting obliterated.

Gummo is often as scuzzy as a rotting animal carcass but who could ignore the addled poetry of it all? So much of Korine's work occupies an atmosphere pitched weirdly between the scary and intoxicated: picture the scene where Chloë Sevigny (once the director's heart-stopping muse) appears on a couch, a strung-out jezebel licking her lips and throwing back her silver mane in slo-mo. Removing a family portrait from the wall, a boy scarcely older than a toddler with teeth the colour of burnt-out cars stares at the cockroaches swirling underneath; meanwhile, three wasted teens get high on the couch huffing fumes from aerosol cans, the scene scored by the rhythm of their spacey respirations. Or consider the tenderness of the attention paid to a girl with Down's Syndrome as she recites the alphabet, the letters happily cartwheeling over each other. And being awed at their beauty doesn't mean forgetting the

symbolic consequences of depicting America like that: spellbound and strung-out to the max, dirt poor and depraved. In an interview with *Purple* almost twenty years later, Korine called the movie 'a love letter'.

·

Curiouser and curiouser how *Gummo* always has us, like Alice, chasing a rabbit. Unlike Lewis Carroll's bewhiskered official with his checked coat and pocket watch, Korine's Bunny Boy is a mute with knuckle tattoos and frisky pink ears: he messes around with an accordion and skateboards through the mayhem. 'He looks like a queer rabbit!' hollers a pre-teen cowboy in a junkyard. With its repertory of eccentrics suggesting out-of-work carnival folk, weird swerves, and a mood of trippy disorientation, the garbage-strewn world seen in *Gummo* is like a Southern Gothic renovation of Wonderland. Bacon, fried to bark, is glued to bathroom walls and lynched Barbies hang from the ceiling. Korine gets high on the derelict freak scene surrounding him. There's a black dwarf and two cute albino sisters; here's a redneck tweaker destroying a chair. The town is under a malign spell: Korine's films always happen in a magical environment. Lunacy breaks out; warped beauties run amok. The Disney Channel babes in *Spring Breakers* (2012) go on their robbing spree believing everything will be dope so long as they pretend they're in a 'fuckin' video game'; night-time in dead regions of the Deep South comes ghosted with the wizened vandals seen in *Trash Humpers* (2009). *Mister Lonely* (2007) is set on a Scottish commune occupied by celebrity impersonators: Little Red Riding Hood sings the song of a hangman's daughter and a boy who believes he's Buckwheat, the

black imp from The Little Rascals, rides a pony. *Act Da Fool* (2010), a short film produced on the dime of *haute* fashion house Proenza Schouler, dreamily follows a crew of girls around a wild landscape where trashed cars are overgrown with swamp grass, stray balloons float in the trees and the ghetto babe narrator hears the stars call out, 'We love you, girls, we really love you.'

.

Amazing, still, how rich *Oz* remains almost eighty years later: the flying monkeys, the grumpy trees, kaleidoscopic poppy fields dusted with knockout snow, the multicoloured horse, 'lions, tigers, and bears, oh, my!': all vivid and magical enough for a merriment overdose. And yet *Oz* is about loneliness. Remember the pathos of the Tin Man's description of himself as 'no heart, all hollow', or the unwittingly tragic implications of the orphan Dorothy, still shaking the phantasmagorical land from her mind at the movie's end, declaring she will stray 'no further than my own backyard'. Judy Garland was seventeen at the time of the movie's production and very little of her performance has any hints of being childlike: she really seems to be acting out an *impression*, heartrending in its sincerity, of the quintessential good girl.*

* On 10 February 1976, long before she reappeared as an aged version of the Wicked Witch of the West in Warhol's *Polaroids*, Margaret Hamilton assumed her most famous role again for a special guest role on *Sesame Street* (1969-). She crash-landed on set, lost her magical broom and threatened to turn a boy into a basketball. In a rare instance of trans-species infatuation airing on TV, Oscar the Grouch announced his crush on her from his trash can. The programme received numerous letters of complaint from parents claiming their children were terrified of

Gummo is assembled from fragments like a scrapbook or mixtape, two lo-fi forms where teens can honour their obsessions. Korine plays around with what a film is supposed to be, mixing fuzzy Polaroids, photographs and found VHS footage of heavy metal kids mid-satanic conversation ('we're giving you the greatest honour: to sit by the right hand of Arioch in Hell') into his tales about deranged teenage wildlife. The outraged critical response claimed the young provocateur was ditching narrative and having fun showing off the nihilistic thrills available to kids living in a desolate place – to which the obvious answer was mad cheering. Korine was a kid mixing all his oddball passions together. *Gummo*'s wonky structure owed more to the rhythm of skateboarding videos than Hollywood; and time spent as a skate rat was also responsible for Korine's use of the drop-out zones where kids congregate, including supermarket parking lots or under bridges, troll-like. He scored the movie with black metal, which he proudly called 'music from the pits of death', created by Nordic teens who burned down churches and swore allegiance to the devil, whether in the form of far-right ideology or presenting the traditional horns and pitchfork. It was all for kids, to scare them, fuck them up, enchant them. And maybe a hyperactive juncture had been reached where the rules of storytelling couldn't really apply (an

... the Witch. Further test screenings showed a group of kids were 'exceptionally attentive during the Margaret Hamilton segments' and especially fascinated by her green face. However, the research department of the Children's Television Workshop, the production company responsible for *Sesame Street*, recommended that the episode never be shown again.

interlude showed a sleepy-headed boy talking about attention deficit disorder and hymning the powers of Ritalin): the most accurate way of conveying the present was a work where the story was comprehensively *wrecked*.

.

A snap of Harm n' Chloë kissing on the basketball court on a bright summer day in 1998 by Terry Richardson. Pink tongues exploring each other: young love. *Kids* (1995), which Korine famously wrote at the age of nineteen after a chance meeting with Clark in Washington Square Park, commences with some feverish smooching between a runt boy in his boxer shorts and a girl young enough to be fresh from an Easter egg hunt. (Unknowingly infected with HIV, he convinces the poor straw doll to lose her virginity to him.) Korine has always chronicled the adventures of delinquent youth. His own movies are the works most wholly dedicated to lunacy, the wonders and troubles that come with making mischief, since the Marx Brothers broke up their act.

Kids wasn't the raw verité picture many claimed it to be. Clark was working his major obsessions: drugs, teenage flesh, lawlessness and empty-headed white boys with the carnal energy of wild dogs. But a documentary does reverberate through the lurid summer day seen in that film. Mary Ellen Mark and Martin Bell's ode to Seattle's homeless children *Streetwise* (1984) follows its subjects without a hint of after-school-special morality. A self-styled 'playboy' called Shadow rolls up, pimping out lost girls and slicking back his hair like a psychotic crooner. There's also Tiny, a fourteen-year-old hooker ('I wanna be really rich, diamonds, jewels, all that stuff...', she

squeaks) and Rat, a spaced-out urchin who inaugurates the film by diving from the Washington Bridge by the light of a summer dawn. He tumbles eighty feet into the river and hits the water. His narration sounds like the lyrics of a druggy seduction song: 'The only bad part about flying is having to come back down to the fuckin' world...'

.

Coming down sucks. An eccentric mixture of hoodlum and wunderkind, the young Korine dashed around New York in the 1990s behaving with the same 'strange insanity' that he found radiating from the carnival folk he watched as a boy. Prone to outlandish confabulations, he showed up on *Letterman* looking like a young Harpo Marx and announcing how he had seen Snoop Dogg in a theatrical production of James Joyce's *Ulysses* (1922); he performed an unhinged tap-dance at the Patrick Painter Gallery in Los Angeles whilst wearing a shock-haired wig suitable for a woodland sprite, his face covered in corpse paint. (Frequent appearances in blackface, too, like Al Jolson risen from the grave, were Korine's way of communing with some of America's most notorious ghouls whilst also paying his respects to his beloved and long-dead world of vaudeville.) He cast the lead actor in *Gummo* after watching him mumble, drugged, through questioning on an episode of the daytime talk show *Sally Jesse Raphael* called 'My Child Died From Sniffing Paint'. He was making a hellacious slapstick movie ('a Buster Keaton snuff film', according to him) called Fight Harm in which he wandered around New York, getting into real brawls with random characters on the street: he broke ribs, he got concussion, a bouncer outside Stringfellow's

snapped his ankle like a candy cane. 'People will roar with laughter,' he claimed on TV, 'at my pain.'

But at some point towards the decade's end, his energy waned. Having lived so high, so fast, he suddenly wanted, he said, 'to disappear'. He was sick of the whole game and almost fatally disenchanted with his art. His multiple addictions (heroin, crack) grew incapacitating. With the darkness beckoning to him, Korine's film *Julien Donkey-boy* (1999) ends on a scene of chilling withdrawal as its schizophrenic protagonist fades, like a figure in a nightmare, into the claustrophobic den under his bedspread. Korine's houses went up in flames but somehow he came back. Upon recovery he explained, 'the drugs were a way for me to slow things down ... to make things quiet.'

·

Whatever happened to Macaulay Culkin? When he was asked to direct the video for Sonic Youth's woozy serenade 'Sunday' in 1998, Korine responded by luring the former child star out of early retirement and producing an unsettling study of him that feels like a piece of junkie erotica. He shoots Culkin brooding darkly on his own reflection in a mirror or has the kid play the wrecked seducer, puckering up to kiss the audience, his blood-red lips blossoming. For a few breathless moments, Culkin removes his raffish top hat – Fred Astaire with a headful of downers – as the guitars go through an interstellar freak out, conjuring all the distortion and garbage that rage around his mind. Accompanying the video was a chill book of soft-core photography shot by Korine that same year called *The Bad Son* where Culkin appeared as a sickly prince, half-nude, spectral and

cavorting with pubescent ballerinas. A deadpan con-
fession preceding the pictures, written by Korine but
gamely signed by Culkin, casts the boy as a fun-loving
sociopath who spoke with God while climbing trees and
set his brother 'on fire when he was asleep'. The waggish
queer film-maker Bruce LaBruce called the volume 'a
remarkable modern artefact: has-been child star kiddie
porn' while Korine later claimed that Michael Jackson
scored multiple copies.

Still a teenager, Culkin had famously retired at four-
teen to be left in peace with the millions he made from his
lead roles in the two *Home Alone* movies (1990-92) and
Richie Rich (1994), ditching any relationship with his con-
trol freak father in the process. (All three movies trade,
on the wicked fun a boy can have when his parents are
gone.) He used to be America's favourite mouthy angel,
a cross between Shirley Temple and Bart Simpson in
terms of perky rapscallion charisma. Unseen for years
and the object of fantastic rumour, like a drug-addled
unicorn, Culkin was variously believed to be hardcore
for narcotics, a recluse or dead. Child stars have trou-
bled afterlives, which seem to be cosmic recompense
for their early success. The video for 'Sunday' subverts
Culkin's childhood image and manifests grisly fears
about what happens to child stars once they quit the
spotlight. Peter Robbins, who voiced Charlie Brown for
six *Peanuts* cartoon specials and a feature film during
his childhood, lost the role when his voice broke. Later
diagnosed as a paranoid schizophrenic, he was jailed for
five years in 2015 after writing threatening letters to his
estranged wife and the owner of the trailer park where
he lived in California. To make a fortune as a child
and never work again, owing to preternatural talents,
seraphic good looks or mere presence, often proves to

be a terrible fate.

.

If they need cash, some kids go queer: 'He wanted to get his dick sucked. I was pretty broke and he offered me like sixty bucks and a bunch of speed so...' That's a hustler talking, his verité testimony is patchworked into the anarchic weave of Gus Van Sant's *My Own Private Idaho* (1991). *Idaho* really got what was at stake in desire, gay or straight, with that early shot of River Phoenix, a *Tiger Beat* dreamboat on the ecstatic receiving end of a great blow job. As he reaches the shivery brink of coming hard, cut to a farmhouse falling from the sky and shattering with an explosive racket in the heartland fields that supply a pretty (and pretty lonesome) picture of his interior world. Home is wrecked: fuck you, family! 'At home,' as the critic and poet Wayne Koestenbaum has remarked, 'we are supposed to learn to be straight.' As a reminder of the money that always lurks within any bodily pleasure in the film, including rich kid Keanu Reeves' wander around America's gnarliest quarters (a fun-and-games prelude to inheriting a fortune from his old man), River finagles ten dollars out of his customer, a morose gargoyle hiding in the bathroom. Clark exhibited huge collages of Phoenix assembled from pictures ripped out of magazines after the star died, mimicking the cult worship that surrounds celebrities who meet an early death. The thing looks uncannily like an artefact snuck from the bedroom of a psychotic fan.

.

Something like the confused state of the family relations

188

in *Idaho* is hinted at by the moment around the campfire where River, close to sobbing, suggestively slurs together 'a normal dad' and 'a normal dog' so that Keanu can't really understand him. With the glow from the flames playing over his face, Keanu's amused to wonder what a normal mutt would be, whilst his friend pines for him in secret and the 'normal' family he never knew. So earnest was young River that he owned a dog, as a fanzine page reproduced in *The Perfect Childhood* reveals, named Justice. But as the writer and critic Hilton Als smartly claimed upon the film's release, all conversation about the absent dad or the phantom dog is inconsequential once it's weighed against the few explosive memories of his mother. 'If *Idaho* is about anything,' Als writes, 'it's about "Mom" as the figure who provides eternal longing, the empty space of desire we attempt to fill with this beloved or another.' Lovesick River chases his mother all over the map, only to end up alone and unconscious by the roadside yet again. As the story's never-ending loop hints, his mother has only set him up for a future of abandonment and unrequited love. But if only he could find 'Mom' in whatever chimerical form she suggests herself (girl, boy, house) everything would be OK – love is the drug.

·

(I can't even begin getting into the chaotic personal ramifications of watching *Idaho* for the first time on my fifteenth birthday: seeing the lonesome Phoenix crawling around trashed on a street corner after laughing at the sky, watching him howl at that startled rabbit, or the heartbreak of the film's closing moments: flatland breeze, big rust-brown field, thieves sweeping over the

189

poor boy's sleeping body. The full psychological turmoil of orphanhood is desperately caught in the scene where Phoenix sprawls, sobbing beyond solace, in his friend's lap, unable to remember the colour of his mother's faraway house, a home that has disintegrated somewhere over the rainbow years before: was it green or blue?)

.

Dude, don't forget Ryan McGinley. Naked teenagers on road trips, fireworks, puffs of clouds strewn like bubble bath across the blushing sky, Levi's; an Audrey Hepburn moppet with a happy coyote, tongue lolling out, claws sharp, strung over her shoulder: this American photographer's pictures are supreme examples of the dreamy and dumb. Many of McGinley's best photographs (the pictures full of real summertime wonder) are funded with the loot from work for major brands and skilfully purvey the fantasy of being a crazed youth without allowing any hint of worry or trouble up ahead to interfere. Sex is a happy rumour in many of these pictures; all the kids look like bright-eyed foals. A queer kid from New Jersey, McGinley chronicled the sensory derangements of his own fucked-up heyday: he appeared in a Polaroid snorting a comet of cocaine off a pal's dick, and photographed pals variously glittering on acid or blasted by PCP. Once he swore off these excesses, he began remaking them as a hallucinogenic ideal, amping up the lyric Huck Finn vibe as he went. His lush photographs from 2004 of the crowds at Morrissey concerts, fans aching to touch their idol, radiate solar pinks or blues, the scene blissfully lost somewhere between a disco and an aquarium's seabed. For his book *Moonmilk* (2009), kids cavort in a sci-fi landscape of deliquescent caves

and hollows bathed in fluorescent light.

In the first decade of the 2000s, after what happened in New York, Washington D.C., Madrid, London, the terror threat levels glowing darkly all the while, not to mention the retaliatory strikes which obliterated expanses of the Middle East conducted by various military regimes in the name of 'justice', cities didn't feel like such fun places to wander. There was a psychic flight into the wilderness, evident in everything from the arrival of New Weird American music (also known as 'freak folk') to Gus Van Sant's *Gerry* (2004). One of the perks of imagining Paradise is that it never changes: fruit, eager flesh, earthly disconnection, and the sun playing peek-a-boo between the trees. To sing it back in the vernacular: 'There is a light and it never goes out.'

·

Boys and girls falling apart; boys and girls with their teeth knocked out; boys and girls dreaming...

·

But *Idaho* is so much fun! A road movie about a queer sleepyhead mixed with fragments from Shakespeare's *Henry IV* (1596-1599), Van Sant's odyssey is so dense with allusions, contrary energies and quotations that the entire trip is irresistible and difficult to fathom. Dwell on the Cocteau-like wonder at play when the noise within a seashell brings memories crashing back into Phoenix's head on its phantom waves, or the mannequin boys lined up after dark in the style of figures from Philip-Lorca diCorcia's imminent *Hustlers* (1993), or the jazzed-up sunflower, collected from some Pop

191

Art Eden, that Phoenix kittenishly plays with at a funeral. (Even or especially at its screwiest, the movie opens up several worlds to explore.) And there are the monstrous complications that come with all the boys likening the switch from paid-up hustler to real queer as the metamorphosis into a swishy Tinkerbell: 'When you start doing things for free, you grow wings and become a fairy.' Or Keanu throwing last night's Slush Puppie from a rooftop onto Bob (the hobo Falstaff to his sly Prince Hal) several storeys below, signalling the fat man's arrival by yelling 'Here comes Santa Claus!' and crowing joyously for good measure, like Peter Pan back in Neverland. Or, amid such unruliness, representing the sex scenes through a breathless combination of choreographed freeze frames, the boys' impulsive ménage à trois with Hans in Portland running to the musical hullaballoo from a distant circus while Keanu's tryst with the Italian babe happens as the Pasolini country outside hums with the hushed activity of birds, horses, the wind in the trees. There's such power in *Idaho* ditching the supposed responsibility to occupy a settled form, which could be readily equated with its similarly complicated responses (scared refusal versus desolate acceptance) to the problem of becoming a man. 'Queerness', as the theorist Eve Kosofsky Sedgwick stated in 1992, is 'the refusal to signify monolithically,' a definition which resonates with *Idaho*'s mad pursuit of numerous cinematic possibilities at once – Shakespearean saga, white trash melodrama, hustler exposé, psychoanalytic portrait. The consequences are cerebral, aesthetic, and erotic. And always at the end, the sensation that you've watched a whole life slowly disintegrate.

.

Phoenix died when he was twenty-three years old, overdosing on a combination of heroin and cocaine on Halloween night, 1993. His myth remains invulnerable, like an embalmed corpse. His character is narcoleptic, which may be another not-so-oblique way of alluding to heroin addiction. Junkie recognition has to tingle at the thought of a character who lives according to a fateful rhythm of reveries, vanished time and gloomy returns to consciousness. Sunny oblivion, a desire to be disembodied, is suddenly way more attractive than, say, the spiky fire from amphetamine or the synaesthetic delights offered by hallucinogens, let alone the routines of sober life. Such stuporous pursuits, an all-consuming need to escape – 'to slow things down' – beat all other forms of excitement.

.

'I wish I was debris', the girl in *Act Da Fool* says, 'and I could just fly away.'

.

One of the 'peanut butter motherfucker' kids in *Gummo* can't say 'funeral': 'I went to his *fune-yall*', he mumbles, 'I went to his grave...' The voice loops, echoes playing hide-and-seek in the mix thanks to lo-fi reverb, the ghost of a goblin in a Black Sabbath T-shirt whispering in your ear.

.

If they don't have fangs, wings or any other fancy prostheses to brag about, these teenage punks and runaways

193

are another breed of monstrous child, the rough young punk out of control who has no supernatural defences to hand other than youth. But a juvenile hero who effectively disconnects himself from the world at moments of panic, stress or trauma hints, too, at how monsters can be tamed or vanquished. As you age, youthful wickedness is rejected but crazed fantasies fade, too. According to any rational school of thought that's a happy ending, or something like one.

Dream on.

Like, what kind of monstrous production cops out by invoking 'rational' anything at the last gasp? A 'private Idaho' can only be an ideal world inside his mind, somewhere he can be alone with his mother for all time and endlessly dream; a world known dimly once and chased ever after. Like J. M. Barrie wrote of Neverland long ago: 'We too have been there, we can still hear the surf, though we can land no more.' Youth itself becomes a lost place, never to be regained. Any clever kid can tell you that's what 'utopia' – paradise – really means.

Nowhere near Paradise, *Gummo* concludes with the cloudburst of Roy Orbison's swoony ballad 'Crying' set to a rapturous montage of tornados blowing everything to smithereens:

> For you don't love me
> And I'll always be
> Crying over you.

So full of longing it hurts.

Houses go whirling through the sky again.

'Life is great', the narrator mumbles, 'without it, you'd be dead'.

SPOOK HOUSE

CAST:

KLAUS, an intoxicated young skinhead vampire with
sharp fangs, waxy bat-like prosthetic ears, spectral
pallor and blood around his mouth wearing the classic
Bela Lugosi costume (black cloak with red interior,
white shirt) with the ensemble only unsettled by his
footwear, a pair of red Converse sneakers. A learned
character, he speaks in a heavy German accent, much
like his doppelgänger, namesake and star of Werner
Herzog's *Nosferatu the Vampyre* (1979), Klaus Kinski.

HERMIONE, a teen sorceress with green skin and
jet-black hair, all dressed in black and sporting a
pointed hat, exactly like The Wicked Witch (Margaret
Hamilton) in *The Wizard of Oz* (1939). She speaks
with the same exquisitely refined English accent as
Emma Watson who played the brainy witch Hermione
Granger in the *Harry Potter* films (2001-11). Like
Watson, she's not beyond the occasional cute lapse into,
like, *Clueless* (1994) intonation. The two leads are close
pals, prone to the playful flirtation that characterises
the 'will-they-won't-they?' interactions on plenty of
sitcoms so their talk always simmers with a certain
erotic heat.

MICHAEL JACKSON, the dead singer, aged
eleven, in his scarecrow costume from *The Wiz* (1979).

RAVEN, a bird puppet.

RABBIT, the shabby pink cuddly toy from Mike Kelley's photograph *Ahh, Youth...* (1991).

TRICK-OR-TREATERS, a ghostly troupe of twelve children in various costumes, including the Wolf Man, Batman, Dracula, devils, skeletons, Red Riding Hood.

.

A haunted house in the suburbs on Halloween night. Hermione's bedroom is huge and full of enviable things: shelves crammed with LPs, framed Edward Gorey poster for the New York City Ballet's production of Dracula *from 1978 on the wall, fashion magazines and books stacked and scattered everywhere, luxe hi-fi, turntable and TV. But the room is also a flimsy set, approximating the dollhouse feel of the interiors seen in studio-shot sitcoms. Through the bedroom window and illuminated by a full moon, Klaus can be seen sneaking along a tree limb. Hermione sits on her bed, mixing pink cake batter in a bowl.*

A skeleton boy from the band of TRICK-OR-TREAT-ERS *appears and holds up a board with the chapter's epigraph spelt out in phosphorescent plastic letters:*

> *'Boo, you're through!'*
> *— James Joyce.*

He drops the glowing board, throws devil horns with his left hand and vanishes.

KLAUS (*taps at the window*): Trick or treat?

HERMIONE (*jumps*): Fuck, Klaus, you scared me to death.

KLAUS: Sorry, I was going for a big dramatic entrance, you know that's how we revenants like to conduct ourselves.

HERMIONE: Like you're training for the circus?

KLAUS: I was going for flair. Maybe it is a hangover from my acrobatic nights with Herr Barnum but it's also very *Salem's Lot*.

HERMIONE: I know, we watched it last year with the dead kid floating in mid-air: spine-tingling.

KLAUS: And I'm somewhat high, too, since I just slurped majorly on three kids in zombie costumes down the street.

HERMIONE: Wow, what a feast.

KLAUS: They were total morons but what am I supposed to do, not gorge on the one night of the year where I don't need to sneak around graveyards? Now, *bitte*, let me in, I've got a ghost story to tell you.

HERMIONE *lays down the bowl, lifts up the window and beckons* KLAUS *inside. Shivering, he climbs off the tree limb, over the window frame and into the room.*

KLAUS Oooowwww! (*howling like a werewolf*): I should've given you the old lycanthropic serenade. I was out there for ages freezing my nuts off, talking to that psychotic raven.

HERMIONE: Oh, he *is* a nutcase. (*Mimicking Raven's depressive squawk*) 'Nevermore! Nevermore!'

KLAUS (*straightening up*): So how's the greatest night of the year gone for you, my favourite sassy enchantress?

HERMIONE: Traditional: spooked some poultry, caused a power-cut. I thought you'd be in Transylvania

tonight.

KLAUS: You were expecting a backwards-talking dwarf or succubus?

HERMIONE: Yawn. I'm in no mood for sucking anything, fang boy, nor any of your soliloquies about *Party Monster*, the joys of ketamine or the impossibility of finding a good cloak retailer – I'm making a cake.

KLAUS (*mixing them cocktails with supplies from his cloak*): I've got a whole fright night extravaganza for us tonight, Hermione. Art, records, narcotics: it's going to be huge fun. (*He hands her a cocktail.*)

HERMIONE: How does a rough trade vampire know so much about art anyway?

KLAUS: Centuries of hanging out at mausolea – (*catching himself*) – I mean, museums.

HERMIONE (*eyebrow arched*): Uh-huh.

KLAUS (*toasts, mimicking Frankenstein's Creature*) Alone – bad, friend – good!

HERMIONE (*toasts*): Good!

They knock back their cocktails together.

KLAUS (*licking batter off the wooden spoon, eyes glittering*): Ach, du Lieber...

HERMIONE: This is straight from the witch's handbook, a cake temptation act to snare the foolish: they did this in Salem in 16-whatever.

KLAUS: 1692, kitten. I was there, an apprentice bloodsucker getting loaded on that psychoactive mould in the parson's barn.

HERMIONE: Those girls knew flora and fauna, I don't. Their puddings had, like, witch piss in them, but I'm not at that level yet so mine's just spiked with good old-fashioned opium.

KLAUS: Who's it for?

HERMIONE (*grins*): Oh, just a boy. So, what's this ghost story you wanted to tell me?

KLAUS (*falling back on the bed*): It's a hoot and a horror show, your flesh's going to crawl.

HERMIONE: Where are we going, a lonesome mansion? (*Excited*) Oh, can we act out *The Turn of the Screw* in funny voices? I want to be the boy who gets smothered.

KLAUS: Ditch those Victorian ambitions: our haunt's L.A.

HERMIONE (*getting close to him on the bed*): Is it in one of those amazing celebrity graveyards? 'Night of the Undead Child Stars'... *The light in the room dims and* KLAUS's *face is suddenly illuminated by torchlight.*

HERMIONE: Hope this cures my insomnia, cupcake.

KLAUS (*dark narrative tone*): According to the report, at some point in 2000, long after midnight, Dracula materialized in the suburbs of the San Fernando Valley, riding a white stallion. The phantom was the artist Cameron Jamie throwing a hex on the sites where he endured a hellish youth. Later, he was seen at a local Burger King with his plastic fangs covered in gore, alongside an accomplice spangled on LSD and riding around Sunset Boulevard in a taxi with a transvestite hustler he found on a street corner. He showed up at a local bikini bar, shaking his undead rump to 'Back in Black' by AC/DC – (*Hermione whistles the riff to 'Back in Black'*) – and puking a neon jet of fake blood in front of various bewildered patrons, only to quit the scene after supposedly 'pissing in his pants'.

HERMIONE: Zoinks, necromantic mischief.

KLAUS: He was terrorizing the suburbs where he

grew up, making these morbid sorties in the name of revenge, just like Quint in your beloved *Screw*.

HERMIONE: 'Cause growing up in the Valley would be (*assumes uncanny Valley Girl voice*) grody to the max and so make you wanna barf?

KLAUS: Certainly. He called the suburbs a 'small, dead world'.

Ordinary light returns.

HERMIONE: How accurate, I can't wait to move into the haunted castle... (*thinks*) Rewind: you said 'according to reports', were ghostbusters involved? Bill Murray and Slimer?

KLAUS: None of the stories can be verified because live documentation was *verboten*: only one witness was allowed at each performance and their testimony relayed to a cartoonist who created comic book drawings of each scene. (*He pulls a picture from his cloak and shows her.*)

HERMIONE: He looks like Keanu in *The Matrix*. Nope, actually he looks like that purple vampire from *Sesame Street*, uh, Count Von Count...

KLAUS: Ja, if the Count was an urban legend. Since there's no evidence, Jamie gets transmogrified from an artist into late night Hollywood's equivalent of – yikes! – Sasquatch.

HERMIONE: I saw a bunch of masks he did in *Artforum*, a party of Chewbacca heads, all severed, all on stakes, with the faces covered in gnarled wood: evil trophies.

KLAUS: Even he's killed them, his work's like fearsome evidence that somewhere all the monsters are real: they've escaped from bad dreams, ready to

raise hell.

HERMIONE (*sing-song*): But if he's the vampire, it's all pretend, Poindexter.

KLAUS: Bingo. That *Scooby Doo* kind of failed scariness galumphs through Jamie's stuff. Think of Dracula at a fast food joint spilling milkshake on his sneakers or trying to suck blood with those plastic fangs.

HERMIONE (*mimicking* Scooby Doo *villain*): 'I would've gotten away with it if it wasn't for you meddling kids!'

KLAUS: But that doesn't stop the dissociative freakiness involved in becoming a monster: what happens to the self if you're pretending to be a vampire or a Krampus?

HERMIONE: It gets erased or it gets eaten – wait, a what?

KLAUS: *Kranky Klaus*, his movie from 2003, he tails the mischief on a traditional *Krampuslauf* in an Austrian mountain town: soused local men dress up as furry beasts with big Satanic horns and cause chaos. (*He dons a terrifying Krampus mask and growls.*) Children must behave or they will be carried off to Hell on the Krampus' back. (*Removes the mask.*) Tough kids end up with snow in their underwear and blood all over their faces. *Kranky Klaus* double-bills wickedly with *Spook House* – that's all about Halloween festivities in Detroit suburbia: zombies everywhere, Krampus descendants waving prosthetic severed heads, staged car crashes in the woods and the Grim Reaper roaming the parking lot. He makes those masks and toxic drawings; he mapped the Valley on the intestines of a vampire bat. (*He unfolds the poster for Jamie's show at Galerie Chantal Crousel in 2002 from his cloak to show the drawing.*)

HERMIONE: An airbrushed heavy metal

vampire bat.

KLAUS: Depicting the Valley like that, Jamie's on the same wavelength as Antonin Artaud who said –

The TRICK-OR-TREATERS *appear with a flash, their recitation is soaked in reverb.*

TRICK-OR-TREATERS: 'No one has ever written, painted, sculpted, modelled, built, or invented except literally to get out of hell.'

KLAUS (salutes): Thanks kids!

The TRICK-OR-TREATERS *bow and vanish.*

KLAUS: Jamie's work is trippy and terrifying. It's about the monstrous stuff we do for fun. (*Picks up the copy of* Dazed & Confused *from December 2003.*) He said, 'Some artists create worlds they want to exist. In my world, everything's dead and brought back to life in a zombie-like state.' (*Nodding*) Hells yeah, we're going into that world. We're going Mulder and Scully on it.

HERMIONE: But where did you get the Gashlycrumb Tinies from?

KLAUS: I have my ways.

HERMIONE (*sweetly*): Can we eat their hearts, please, two or three, like toffee apples?

KLAUS: No way, they're our chorus.

HERMIONE: Rats. But Jamie's not the only artist to feast on the carcass of, like, 'horror', is he?

KLAUS: Nope, he arrives at a time when the pop mythology of horror movies, monsters and the gothic are all the rage as ways of dealing with psychic detritus that comes with adolescence. He roams the Valley around the same time that Buffy battles the Master over

the Hellmouth in Sunnydale and *Scream 3* hits cinemas.

HERMIONE: Oh, when kids got *Goosebumps*; and even the disenchanted went to Hogwarts.

KLAUS: Richtig. In 1997, a blockbuster show *Gothic: Transmutations of Horror in the Late 20th Century* at ICA Boston collects Jamie and Mike Kelley's pix of the denizens at LA's goth clubs with gore-hound shots by Cindy Sherman, those deformed mannequins by the Brothers Chapman and a bunch of other treats in a mood of fin-de-siècle decadence. One of the catalogue essays in the accompanying volume is a story by Herr Dennis Cooper about two teens who summon the Dark Lord (*quoting in stoned American voice*) 'Satan, we're calling on you...'

HERMIONE (*in stoned American voice*): 'We love you, Satan, you're the coolest.'

KLAUS: 'Uh, shit, I think he's screwing me.'

HERMIONE: 'Relax, let him, it's his thing, man.'

KLAUS (*normal voice*): Cooper knew the Devil was screwing the minds of kids everywhere as goth aesthetics achieved mainstream acceptance thanks to Tim Burton, Nine Inch Nails and *The Crow*.

HERMIONE (*holding up her bloody arm with the word 'Sorrow' carved into it by a razor blade and quoting The Smiths in deadend monotone*): 'I wear black on the outside/ Because black is how I feel on the inside.'

She licks blood away from the wound swiftly, like a cat.

KLAUS: Meanwhile, MTV feeds off teen angst. (*Sings in booming voice*): 'Despite all my rage/I am still just a rat in a cage!'

HERMIONE (*makes a wry face and* KLAUS *straightens up*). By the time of *Scream* at Anton Kern in

New York in 2004, which trumpets the fact that all the works were inspired by movies, horror means something else completely... Homeland Security, black sites, psy ops, post-9/11 dread.

KLAUS (*surprised*): Ms I-Gobble-Hearts actually paid attention in my chat about *Dogville* last week. (*Regaining himself*) Jamie's ghostly drawings of masks – Krampus lost in a snowstorm – hang out with Sue de Beer's film on teen girl anomie, *Disappear Here*...

HERMIONE: ...As if the horror is just living itself.

KLAUS: Her films are the best: she imagines teen life as a horror movie on downers – everybody is too strung-out to scream. She broods on the interior lives of teenage spree killers, filmed a witch dancing with a werewolf, made a photograph alluding to a blood-spurting bed from *A Nightmare on Elm Street* and retouched a picture to create a self-portrait as a cadaver split in two. David Altmejd's werewolves with orange mullets appeared, grinning, and Banks Violette was showing his memento mori.

HERMIONE: Skulls in X-ray, skulls on paper, all obsessive, as if he was a teenager hearing Slayer for the first time.

KLAUS: Ah! Matthew Barney is a huge Slayer fan. He was transmogrifying into a satyr and a Manx giant for various instalments in *The Cremaster Cycle*, conducting a spaced-out mating dance with Aimee Mullins in *Cremaster 3*. Ms Mullins turned into a cheetah for the occasion, chequered with orange spots.

HERMIONE: Mullins is a babe!

KLAUS: Old Barn-meister became a faun for *Drawing Restraint 7* in '93. (*He pulls a picture from his cloak.*)

HERMIONE: Grrr, faunography! Look at those 'roid rage veins in his arms. Barney throws my brain

into the deep-freeze and my puke reflex into overdrive, darling: it all stinks, epically, of Mammon and locker rooms and dead Joseph Beuys.

KLAUS: Chill, please, I'm just mapping out Jamie's ecosystem for you. Certain imps you can't avoid.

HERMIONE: Like, Matthew, I know a dick is a dick. Can't you say a dick is a wand, shooting sparks everywhere?

KLAUS: Barney never thinks about what fun or disorientation a beast can get their filthy paws into but Jamie knows it inside out.

The TRICK-OR-TREATERS *appear, playing 'Funtime' from* The Idiot *(1977) by Iggy Pop from a boombox and dancing wildly.*

TRICK-OR-TREATERS (*singing along*): 'Last night I was down in the lab / Hanging with Dracula and his crew! Fun-fun-fun fun-time!'

KLAUS: OK, flashback! *Komm, meine Kinder*! (*Whistles.*)

The TRICK-OR-TREATERS *form a line and all hold puppets: some clutch famous Hollywood monsters such as The Creature from the Black Lagoon, others have puppets representing little punks with mohawks and leather jackets. An overturned lamp throws its beam onto the wall and the shadows of the monsters appear in the spotlight. One of the* TRICK-OR-TREATERS *operates a little puppet representing the young Cameron Jamie. The act is scored by the theme to Dario Argento's* Suspiria *(1977) with celeste and xylophone prancing along, darkly.*

HERMIONE (*eyeballing the scene*): I must be (*in falsetto*)

fucked up. Shadow puppets? What is this, 1890?
KLAUS: 1976, actually. OK, 'based on a true story':
aged seven, Jamie goes to the cinema in the Valley
to see a revival of an old monster movie but before
the lights go down, there's a warm-up act...

The shadow of King Kong staggers into the spotlight.

KLAUS: Some dummkopf in management has enlist-
ed a local actor to dress up as King Kong, come onstage
and do a dance routine for the kids.
HERMIONE: Throw some moves, my pretty!

*Kong's shadow performs a drunken backflip and returns
to swaying on the spot like he's shot full of tranquillizers.*

KLAUS: Bravo. The kids figure at once that the
Eighth Wonder of the World has been usurped by
the worst tribute act in all of L.A. (*Quoting* Time Out
*interview from 2003. When quoting Jamie he always slips into
a flawless American accent*) Jamie knows it's just 'a guy
in a crappy old gorilla suit'. The audience goes ape on
his behalf.

*Noise of someone fumbling with a cassette machine – clatter,
punching buttons, rewind squeal – followed by a tinny
recording of a crowd in uproar: yells, whistles, stomping.
The shadows of the punk kids loom over Kong.*

KLAUS: According to Jamie, 'They start bombarding
him with him with food, ice cream, whatever we had.'

*Various projectiles hit the Kong impersonator like meteorites.
He staggers in and out of the spotlight; a trick-or-treater plays*

the funeral march on the kazoo.

KLAUS: And the whole gang of other monsters rush up on stage, coming to their friend's aid...

Shadows of the Wolf Man, the Mummy and the Creature from the Black Lagoon dash into the spotlight as the uproar continues; a trio of punk shadows jitter, awaiting further instructions.

KLAUS: But the cinema was in a gang area so all the kids 'had razor blades, knives, the monsters were getting the shit kicked out of them.'

The punk shadows bring out little blades and chaos ensues as they battle with the monsters. Noise of bike chain whipping through the air, B-movie screams, the Wolf Man bites a punk's face, the Creature from the Black Lagoon gets KO'd, breaking glass, sirens wailing.

KLAUS: The riot tumbled out into the streets...

Helicopter noise, dogs barking, the punks continue to beat the Mummy.

HERMIONE: Bring the ruckus!
KLAUS: Jamie said, 'I saw this Mummy being hoisted into an ambulance and at the same time he's being stabbed with an ice pick.'

The Mummy lies on a stretcher as a lone punk slashes wildly at him with a blade. The young Jamie's shadow is left alone in the spotlight, accompanied by the sound of late night breeze and sirens receding.

HERMIONE (*doom-laden Orson Welles voice*): 'And he was never the same again.'
KLAUS: He said, 'That was just another night in my adolescence.'

Lights back on. The TRICK-OR-TREATERS *bow and vanish with their puppets.*

HERMIONE: Yikes. L.A sounds like the world's scariest amusement park.
KLAUS: Eerie, nein? That's the night when most of Jamie's big obsessions jump up in his head.
HERMIONE: Jack-in-the-box.
KLAUS: A transformative moment. Let's bag and tag them: monsters, obviously, violence, imitation...
HERMIONE: *Failed* imitation. Götterdämmerung.
KLAUS: Boom, five points. The critic Gary Indiana claims Jamie's mischief-making for the *Goat Project* was conducted in 'Dracula drag', hinting at the comic and kinky ambiguity at stake (*shudders*) in his performance. Reality and fantasy getting hideously mixed up. Like, the madness going on in *Spook House* has Walpurgisnacht ambience even if it's happening in twenty-first century Detroit. Did Goethe ever scarf a bunch of mushrooms?
HERMIONE: Hmm, plausible. Maybe rambling over Mount Brocken with his friend Eckermann he ate some wonderful shrooms, chewy as ears, stinking of dirt. (*Quoting* Faust): 'While the trees and rocks pull faces/And the bloated burping mazy/Jack o' lanterns multiply.' Can't get into the coven without a little *Faust*.
KLAUS: That sounds like a real bad trip to me. One of the most amazing things about *Spook House* is that towards the end the monsters don't seem pretend at all,

211

as if we've gone straight into the cauldron of an intox-icated brain. The beasts and zombies totally inhabit their macabre creatureliness.

HERMIONE: Potions are my favourite. Don't wanna sound too la-di-da but drugs are a means of sensory enchantment, just like pictures. The world on a mush-room trip can get all grotesque and *wet*. When I'm high, I see ghosts.

She waves her hand which suddenly becomes a huge black paw, glitter exploding from it as the fuzzy crunch of distorted electric guitar sounds from somewhere. She grins and her hand returns to normal.

KLAUS: Is that what Bram Stoker meant when he was describing 'brain fever'? Not a problem for me, I stay loaded all the time: blood is my coke, blood is my Moët.

HERMIONE: Are you channelling Ol' Dirty Bastard now? Dead rapper séance.

KLAUS: Au contraire, bae, it's just a fact. Weird but not extraordinary for an artist to keep up that continu-ity between their childhood obsessions and adult work, to always be in tune with their inner devil. By the time he was a teen in the 1980s, Jamie was dumpster diving with a certain Matt Groening at local high schools.

HERMIONE: Matt Groening as in *The Simpsons*?

KLAUS: *Natürlich*, though this was pre-*The Simpsons*, pre-Homer meeting that 'space coyote' after eating insanity peppers, pre-Bart claiming the soul was a hoax created 'to scare little kids, like the bogeyman or Michael Jackson', pre-'D'oh!', if you can imagine that.

HERMIONE: No way, Springfield's a model of the world. What were they looking for in these archaeolog-ical excavations of the high school dumpster – porn?

Ludes?

KLAUS: According to Mike Kelley, they wanted more extreme stuff: textbooks crammed with ultra-violent fantasies, psychotic rants written in the margins, lewd cartoons.

HERMIONE: R.I.P. Mike.

KLAUS: And they collected them as hometown examples of *art brut*: rabid productions created by losers in between ducking Science and wandering stoned into History. Jamie began photographing Halloween festivities in the neighbourhood around the same time.

HERMIONE (*pointing to a picture in Jamie's eponymous monograph from 2003*): This pic from '88 is so 'Hansel and Gretel', legs stuck in the oven, Nikes airborne.

KLAUS: On the subject of influence, Jamie's story about watching Mexican wrestlers fight Dracula and 'a host of mutant dwarfs' on TV as a kid matters as much as Paul McCarthy's mid-70s video *Experimental Dancer*.

HERMIONE: That's the one where he dances around, naked, with his dick hidden between his legs, like Buffalo Bill in a clown mask, grunting.

KLAUS: Nobody forgets *that*. Jamie definitely learned tons from McCarthy's bestial goofiness, perverting clown into creep.

HERMIONE: The John Wayne Gacey tradition.

KLAUS: Amen. Back home, Jamie stayed close to the VCR, locked into the madhouse of Los Angeles' public access TV stations, hoarding footage for what would become *The Neotoma Tape*, compiled between 1983 and 1995.

HERMIONE: 'Neotoma' being, like, what, a new tumour?

KLAUS: Latin for – how would you say? – 'pack rat', Circe. Among the attractions, a nerdy character

telling of his search for 'the dog-rabbit' in Vermont, Satanist teens puking in a mall, a symposium for mothers scared by heavy metal. Fast-forward to the turn-of-the-millennium and Jamie's making pilgrimages to various eerie sites such as the ramshackle house where Captain Beefheart recorded *Trout Mask Replica* in 1968 and Aleister Crowley's lair in Cefalù where the Great Beast held occult rituals until panicky fascists chased him out.

HERMIONE: His mother called him 'The Great Beast' when he was a little boy because he was so wild: he's the definition of 'young monster'.

KLAUS: He always beat me at chess. On these adventures, Jamie's still playing around with *Goat Project*'s experiments in haunting space whilst making plans for his next ghoulish environmental inquiry, *Spook House*.

HERMIONE: Ghouls just wanna have fun.

KLAUS: Stay tuned.

He takes out a packet of cigarettes, passing one to
HERMIONE *and taking out another for himself.*
They smoke quietly throughout this interlude.

RABBIT (*pops up and speaks in a high-pitched squeak to the beat and pop of a drum machine*): Hey kids, did you know the first trick-or-treaters were ghosts? In *The Golden Bough* from 1890, James George Frazer says Halloween is 'an ancient pagan festival of the dead'. According to folklore, on the last night of October, the door between the worlds of the living and the dead opened just a crack, meaning regular people could expect visitors from the graveyard. Frazer says, 'It was, perhaps, a natural thought that the approach of winter should drive the poor shivering hungry ghosts from the bare

fields and the leafless woods to the shelter of the cottage with its familiar fireside.' Jeepers creepers, huh?

The TRICK-OR-TREATERS *appear. The Wolf Man holds aloft a boombox playing the insistent ice-pick tingle of John Carpenter's* Halloween *theme.*

KLAUS: Let's call *Goat Project* and *Spook House* 'suburban gothic': art where home sweet home's full of supernatural beasts and nightmare troubles. *A Nightmare on Elm Street* is suburban gothic but way more bloodthirsty, *Blue Velvet* festers on the same turf. (*He opens his hand to reveal a severed ear crawling with ants*) Jeffrey learns all about the body as the movie goes on, his education begins when he finds the ear in the field near his house. At the start of *Spook House*, we crash land in the shadow of a derelict mansion, scene in grungy monochrome, *Vampyr*-ish, a fat double of Frankenstein's Creature shambling down the street with his werewolf pals. The soundtrack's feedback from The Melvins, like a sick wolf howling.

The TRICK-OR-TREATERS *throw back their heads and howl like a wolf pack.*

HERMIONE (*head-banging*): Stoner rock rules!
KLAUS: There are kids dressed up for a black mass at the door. The scene disintegrates and we fall into Technicolor. Cue tracking shot through the graveyard alternating with tracking shot of the suburban houses –
HERMIONE: Like that line in *The Virgin Suicides* about the house –
TRICK-OR-TREATERS: '– Becoming one big coffin.'
KLAUS: An old house looks like a rotten head.

HERMIONE: The windows are the eyes.

KLAUS: A house that eats children for breakfast. And soon the monsters arrive and it's all chaos, clowns, blood drooling down the screen, covens in the basement, serial killer lairs, lynched dummies in the trees. The Melvins fry your skull with drone and zombies run through the night. The mood is always tranced-out, *creepy*.

HERMIONE: We're in the undead world. Is it dumb to think of Michael Jackson's *Thriller* video with the dancing zombies?

KLAUS: No way. 350 million YouTube hits and counting: #zombielife. But also think about Mike Kelley's 1992 essay 'Playing With Dead Things: On the Uncanny', where he visits the home of Forest J. Ackerman, the editor of *Famous Monsters of Filmland*, in the Hollywood Hills. The space was crammed with horror and sci-fi props. Kelley said –

RABBIT (*pops up*): 'Touring it is like walking through a rubber cast of Jane Fonda's breasts from *Barbarella* and a wall of life masks including those of Bela Lugosi and Vincent Price.' (*Vanishes.*)

KLAUS: Welcome to the land of the dead. Remember the movie was shot in 2002, only a year after 9/11. There was plenty to mourn.

HERMIONE: I was reading that Southern Gothic writer, Harry Crews, describing his childhood. When he was a little boy he thought existence was –

TRICK-OR-TREATERS: '– Scary as a nightmare, just like being awake in a nightmare.'

KLAUS (*grins*): *Fantastich*! (*Pulling handwritten notes from his cloak*) I asked Dave Markey who was assistant cameraman on *Spook House* and he can't remember today exactly how he and Jamie became acquainted.

Maybe a teenage Sofia Coppola introduced them in the early nineties or maybe they met late in the previous decade via the McDonald brothers from the hardcore punk band Red Kross who wrote an ode to Linda Blair, the girl from *The Exorcist*. Wandering from house to house, they found (*in American voice*) 'these pre-teen kids that had a haunted backyard set up' and they pulled off 'an impromptu lip-synch performance of the Insane Clown Posse from a boombox' for their audience –

The TRICK-OR-TREATERS *all body-pop to the music.*

KLAUS: The Posse's one of Detroit's cult exports: horrorcore rappers with their own mythology in which purgatory is represented as a carnival. On *Spook House*, Jamie said, 'Everybody thinks about Hell, nobody thinks about Purgatory.'
HERMIONE: Dummy, the suburbs are Purgatory: another undead world, another re-animated myth. And I don't know why you're ignoring the eye-of-newt power of Princess Coppola and Jamie's hook-up since her movie *The Virgin Suicides* is all about the ghost world of the suburbs and – that music's going to make me hex you.

Noise of tape rewinding. 'Clouds Up' by Air from the score for The Virgin Suicides *comes on.*

HERMIONE: Detroit. Four dead girls. 'Cecilia was the first to go.'
TRICK-OR-TREATERS (*quoting Cecilia Lisbon*): 'Obviously, Doctor, you've never been a thirteen-

year-old girl.'

HERMIONE: Five blonde Ophelias – hanging, over-dose, head in the oven, carbon monoxide poisoning, leaping from the window – become erotic ideals for a bunch of pimply teenage masturbators. Even if it isn't so gnarly as *Spook House*, it's still perfumed all over with the stink of death. All of the spaced-out happenings in the book and the movie, which is tops, by the way –

KLAUS (*daydreamy*): I remember sunbeams drifting through silky autumn leaves.

HERMIONE: – Play out against the backdrop of a strike at the cemetery so the dead stay unburied, increasing the spooky ambience. The suburbs turn into what the Ancient Greeks called a necropolis. And I haven't even sunk my pearly gnashers into the fact that the Lisbon girls' swank lair is a spook house, too, haunted by their ghosts.

KLAUS: They've such pretty teeth. And I remember sick elms, like the whole environment is dying, too. And that graduation party at the end where the house is shrouded in fog, toxic waste green.

HERMIONE: Ghoulish shit, darling... Whilst we're mapping the suburbs, remember the kind of clownish fiend in *Blue Velvet* who sings 'In Dreams'? That could be Freddy Kruger's theme tune, too.

TRICK-OR-TREATERS (*singing*): 'In dreams you're mine / All of the time...'

HERMIONE: He stalks them in their sleep. Oh, and *Twin Peaks*! *Peaks* so obviously belongs on the same map.

She claps and suddenly the room is full of fir trees and mid-night sky. Hermione is in Twin Peaks *chic: plaid shirt, dark jumper, skirt and red shoes. She has a Dictaphone in one hand*

and an eagle owl on her shoulder. 'Laura Palmer's Theme'
from the soundtrack to Twin Peaks *by Angelo Badalamenti*
hums through the dark.

HERMIONE (*mimicking Agent Cooper*): Diane, it's 2.13
a.m, I'm on an unrealistic patch of woodland with a
handsome vampire. The owls enjoy a witch's touch.
KLAUS (*recoils, hissing and baring his fangs*):
HERMIONE! Please banish this fancy disease bag.
He has the eyes of a priest!
HERMIONE (to the owl): 666, Ozzy!

The owl flies away.

HERMIONE: Bob's the killer in *Peaks* and he creeps
through dreams in order to make the unwary do
his bidding, which is a psychic assault spelled out in
Malleus Maleficarum.
KLAUS: I am not following.
HERMIONE (*sighs*): How-to-spot-a-witch, medie-
val-style, boy. Thousands of girls burned alive thanks
to the wisdom of this little volume. (*She puts a hand inside
his cloak, draws out a weighty tome and reads aloud*) 'For
Satan himself ... in dreams, deluding the mind that
he holds captive, leads it through devious ways.' Like
when Leland Palmer admits he killed Laura, he says: 'I
was just a boy. I saw him in my dreams. And he opened
me and he came inside me.'
KLAUS: The vampire's dark art and Satan's, too.
HERMIONE: But Bob's a metaphor to conjure up a
father possessed by monstrous urges. Bob's his cos-
tume consisting of skin and teeth and hair but Daddy
still rapes and murders his own daughter.
KLAUS: Daddy is the Big Bad Wolf.

TRICK-OR-TREATERS: 'Let me come in or I'll huff and I'll puff and I'll blow your house in!'

The music stops, the trees fold into the floor and we return to the bedroom with HERMIONE *and* KLAUS *laid on the bed in their usual attire. The* TRICK-OR-TREATERS *have vanished.*

KLAUS: Not to ignore some Bob-like propensities on Lynch's part.
HERMIONE: Ah, their silver hair...
KLAUS: Uh, *nein*, his demonic possession of various favourite teen genres like high school drama, soap, horror flick.
HERMIONE (*mimicking* Twin Peaks' *backwards-talking dwarf*): 'Let's rock!'
KLAUS: In 1990, it really was freaky to see Lynch on the same turf as the kids in *The Breakfast Club*, roaming the corridors and checking into detention.
HERMIONE: (*flawlessly impersonating Molly Ringwald in* The Breakfast Club): 'Excuse me, sir, I think there's been a mistake. I know it's detention but I don't think I belong in here. (*Normal voice*) Goat Project, Spook House* and *Twin Peaks* are about the body horror and psychological upheaval of being a teen, growing up and all that. The same goes for *Buffy*, or even stuff like *Charmed* and *The Craft* that besmirches the good name 'witch'. Magic is a metaphor. Hocus pocus is the only way to stake the trouble of youth.
KLAUS: Should we sneak towards Freud's essay about 'The Uncanny' or do you wanna go for a confession?
HERMIONE: Oh, confession would be way more fun.

The light switches to a giallo combination of purple and green, just like in Sue de Beer's Disappear Here. HERMIONE *lies back on the bed and gazes up at the ceiling.* KLAUS *vanishes. The* TRICK-OR-TREATER *in the wolf mask holds up a reproduction of Mike Kelley and Cameron Jamie's photograph,* Thursday's Goth *(1996) as she speaks. The picture shows a teenage girl in full goth coven drag at a club, eyes ablaze, ecstatic.*

HERMIONE (*suddenly sounding drugged and sleepy*): A Halloween dream: I may be wasted – what else is new? – but Klaus asked me to think about my teens and, well, the whole experience makes me feel sick. That's when I actually have thoughts because I'm certain what's in my mind is... garbage, like plutonium making my body sick. I don't know. I guess I was just born like this: a bad girl, a black heart. But I was a scaredy cat when I was little. I was frightened of things under my bed, strange, sewn-together bloody animals that crept over me in the dark. Normal childhood stuff, I guess. I mean, in the right circumstances, a sheet thrown over a chair can be a ghost. But kids like to be frightened. Scary stories thrill them, they love to hear about how cruel the world can be, all the malevolent birds pecking out the ugly stepsisters' eyes. They fall into the magic world and they really believe there is a wolf out there beyond the house... hungry. (*She snarls*) 'All the better to eat you with, my dear!' And I have these... urges.

She conjures a bird from thin air and bites ravenously into its chest as the creature shrieks and pounds its wings.

BIRD: My heart! My poor heart!

223

Mouth covered in gore, she breaks its neck, throws away the carcass and coughs up blood.

HERMIONE (*in evil pitch-shifted growl*): I don't know what's going on inside. (*Normal voice*) Samantha in *Bewitched* can disappear. I can't. And my body gives me the creeps. Puberty's like your own special episode of *The X-Files*: the creature you used to be falls apart, all these chemicals alter what you want... who you crave. No opting out of the programme. Ready or not, here they come. Dot. Dot. Dot. Puke or starve: reach target weight. Let some ogre or vampire fuck you so you're not too lonely. But you're the alien, you're the monster... within (*Singing to herself in a whisper*) My mother said I never should/Greet the creatures in the deep, dark wood...

The TRICK-OR-TREATER *holding the photograph vanishes, ordinary light returns and* KLAUS *reappears.*

KLAUS: Alles klar? See, everybody's head is a haunted house. But a 3D spook house turns all that horror inside out, manifesting the trauma that troubles the concept of 'home'.
HERMIONE (*counting on her fingers*): Fears of slaughter, family secrets, children hungry for parental blood, evil transmissions through the TV.
KLAUS: In the late 50s, moguls at Universal Studios sold a package of their classic horror films to American TV stations, bringing the Wolf Man and all his pals onto the airwaves and into your home.
HERMIONE: Boom! Old monster movies are another graveyard to be raided; more rubbish to be sold. See the movie, buy the costume.

KLAUS (*checking* The Wire's *January 2004 issue*): Jamie said Halloween is 'a form of performance art' whilst claiming his work was about how 'people become inspired by popular media but to the extent that they somehow become damaged by it'. Throw them together and you get 'Dracula drag'.

KLAUS *produces a junk food cup from within his voluminous cloak and slurps on the straw producing a great squelching noise.*

HERMIONE: Excuse me, I have to go and vomit.
KLAUS: It's blood and ice cream mixed together, to keep me sharp between the ears.
HERMIONE: Oh, midnight feast.
(*She takes the cup and slurps.*)
KLAUS: Now, if I can be the Giles to your Buffy, most of the critical stuff scrawled in the margins of Jamie's work gets all fevered about anthropology, its subversive deployment on the fucked-up and brain-dead tribes of contemporary American suburbia.
HERMIONE (*drawls*): Trailer park runts burnin' cats, eatin' cookie dough and watchin' *Cops*. (*Normal voice*) Like, if you go to goth clubs and get high in corpse paint on Friday nights, that's a ritual.
KLAUS: But Jamie's works might be viddied best as anthropology's evil twin because of that bad trip texture. Rub your eyes but none of it feels real. If you want something with the same brain-melt energy, try *Titicut Follies*, shot on the mental ward, or *Heavy Metal Parking Lot* – (*impersonating a yokel*) 'Judas Priest, motherfucker!' Back in 2008 when he was asked to programme a selection at the International Film Festival in Rotterdam his 'small taste of American

surrealism' included that video of The Cramps rocking
out at a California mental institution –
HERMIONE (*sings*): 'I was a teenage werewolf /
Braces on my fangs!'
KLAUS: – *Death Wish III* and one-reelers starring
The Little Rascals. He loves the madness in the
American imagination and pays it scholarly attention.
But he also likes innocent things that are actually
warped, like when you think of Halloween, how odd
is it to have all these children dressed up as if they're
dead?
HERMIONE: Oh, that sounds heartwarming to me.
KLAUS: And the video for 'Welcome to My
Nightmare' by Alice Cooper is anthropology, too: kids
going nuts for the spectacle of a dude getting chased by
Jason from *Friday the 13th*, Michael Myers and Nurse
Ratchet. Tales from the crypt are resurrected and
turned into metaphors for drug addiction.
HERMIONE: I always thought the nightmare was
the show, like, Alice bringing us into his head?
KLAUS: Jamie likes showmen: he was obsessed with
that Michael Jackson impersonator he saw dancing
outside the Hollywood Wax Museum in the mid-90s.
HERMIONE: If you're wrestling Michael is that
wrestling a ghost?
KLAUS: Jamie told an interviewer in 1999, 'The
Hollywood Wax Museum is one of my favourite places
in Los Angeles because they never turn on the air con-
ditioning system so all the wax figures are so distorted.
They all look slightly melted... The Judy Garland as
Dorothy from *Wizard of Oz* looks like a severe burn
victim.'
HERMIONE (*imitating Wicked Witch*): 'Melting!
I'm melting!' Don't tell me you're not thinking about

Michael's face, too. Maybe he would've felt at home with that gang.

KLAUS: He liked to make himself into a monster: that werewolf-into-ghetto-zombie transformation from *Thriller*, the self-obliterating drug regime, and all that cosmetic surgery until he looked *sehr* alien.

HERMIONE (*melancholy*): The loneliest boy in the world.

KLAUS: I think he wanted solitude: chemical oblivion, deep sleep, dreamtime never to be disturbed.

HERMIONE: If he was so spaced-out, maybe he believed he was inside a Disney movie, like he really was Pinocchio by the end.

KLAUS: Or Voldemort.

HERMIONE: *Heavy*

KLAUS: Jamie said of his favourite impersonator and former wrestling opponent, 'I became fascinated with the psychology of a person like that, the idea of wanting to be somebody else.' The poison irony being Michael obviously wanted to be someone else, too. There's some weird on-set footage in *The Making of Thriller* documentary from 1983 where Michael appears in his full werewolf jock costume, all fanged, furry and slumped in the make-up chair as Rick Baker –

HERMIONE: Oh, the bearded man who did the transformation effects on *An American Werewolf in London*.

KLAUS: – says in a voice-over, 'He wanted to change into a monster. He wants to go through that. I don't know why.' Carve that on his grave in fancy letters.

Suddenly, a shivery breeze can be heard, sending a vortex of dead leaves spinning past the window, making the fences creak and causing a commotion in the big tree.

HERMIONE: Look!

On the tree limb sits MICHAEL JACKSON, *eleven years old, afro'd and cherubic in a child-sized version of his Scarecrow costume from* The Wiz. *Perched next to him is the* RAVEN.

RAVEN: Little Michael, you're back from the dead!

An explosion of canned applause from somewhere, mixed with cheers and whoops.

MICHAEL: I know that, brainiac. And I still don't have nobody to talk to about how I feel inside. I feel more like one of those magical characters than a boy. I guess I never was a real boy.

RAVEN: Nevermore! Nevermore!

MICHAEL: It was fun to be scary. I didn't have to be frightened about being cute or not anymore. No girls came to bother me.

RAVEN (*puffing out his feathered chest*): That horrid costume doesn't frighten me. I've pecked out a scarecrow's brain before.

MICHAEL: I love my scarecrow suit. (*He produces a copy of his autobiography,* Moonwalk, 1988, *from his pocket and reads aloud. He's a slow reader.*) 'When I was transformed into the Scarecrow, it was the most wonderful thing in the world. I got to be somebody else and escape through my character.'

RAVEN: But what was wrong with being yourself, Mike?

MICHAEL: 'Sometimes I imagine that my life experience is like an image in one of those trick mirrors

in the circus, fat in one part and thin to the point
of disappearing in another.'
RAVEN (*squawks*): Self-portrait in a trick mirror!
A telltale sign of body dysmorphia!
MICHAEL: 'I'm especially fond of the scene where
Diana asks, What am I afraid of? Don't know what
I'm made of, because I've felt that way many times...'
RAVEN: But it's Halloween, Mike, we can have fun!
MICHAEL (*closing the book*): I'd like to go and hide
now.
RAVEN (*bowing his head*): Such a sad story.
MICHAEL: Big trouble came and got me in its jaws,
like Pop did a long time ago.

Huge gale of audience laughter from somewhere.

RAVEN: Nevermore! Nevermore!

*Michael rummages around in his head and pulls out a clump
of straw.*

MICHAEL: Nothing up there.

*Michael bows and vanishes. Raven flies away into the night.
Wild applause.*

HERMIONE: Poor Michael.
KLAUS: The Scarecrow's an all-singing, all-dancing
doll – that means we can bring back the F word!
HERMIONE: What, 'fornication', 'fairy',
'fin-de-siècle'?
KLAUS: *Nein*! *Frankenstein*.
HERMIONE: Oh, book club!
KLAUS: You can't ignore the *Frankenstein*-ish

implications of Jamie claiming, 'In my world, every-thing is dead and brought back to life in a zombielike state.'

HERMIONE: You can't school me on *Frankenstein*. I know the birth scene off by heart, it was on the curriculum.

KLAUS: The Gothic for kids. Take it away.

HERMIONE (*drawing herself up in actorly fashion*): 'It breathed hard, and a convulsive motion agitated its limbs ... I had selected his features as beautiful. Beautiful! Great God! His yellow skin scarcely covered the work of muscles and arteries beneath; his hair was of a lustrous black and flowing; his teeth –'

KLAUS: Ah, let's sink our fangs into that: 'the demoniacal corpse to which I had so miserably given life'.

HERMIONE: Obvs, Victor's gone against nature to make his deranged golem – as in magical clay golem, not *Lord of the Rings* golem – he's borne a child so these convulsions ravage the whole notion of what it means to be a man. Mary Shelley didn't call it 'the modern Prometheus' for nothing: violated nature, hubris, occult science.

KLAUS: Go on, throw a few more bat wings in the cauldron.

HERMIONE: And she runs volts through all our fears and thrills roiling around technology: we all want to experiment but the consequences can be... (*she looks dreamy*) so *dark*.

KLAUS (*rolling his eyes*): 'Beauty will be convulsive or it will not be at all.'

HERMIONE: Who said that?

KLAUS: I think it was Debbie Harry on that talk show in *Videodrome*.

HERMIONE: Cronenberg in the house! And his

mad scientists are always the heroes, even when their ambitions are totally whacked-out which is... always?

KLAUS: Which is why the cautionary tale, 'careful-with-that-alembic, Victor' thing makes me want to puke. He's an artist creating work.

HERMIONE: Like the lab is his studio?

KLAUS: Yup, he's a sculptor making a devilish assemblage. Shelley has him all wild-eyed, talking about this fantasy of making 'an animal as complete and wonderful as man', trapping the 'spark of being' and 'collecting and arranging my materials'. Perhaps it's a sick quest but those are an artist's labours and ambitions, Victor's transmuting art into life, hunting the sublime...

HERMIONE: OK, bats in the belfry: a) he fails, hideously, and b) it's not like he invents *Pegasus and the Hydra*, he's a body snatcher.

KLAUS (quoting *Frankenstein*): 'I dabbled among the unhallowed damp of the grave or tortured the living animal to animate the lifeless clay.'

HERMIONE: Necrophilia and psychosis, that's what the book exhumes.

KLAUS: In Victorian times we used to call grave robbers 'resurrection men'. Brood on that.

HERMIONE: Wow, fascinating trivia.

KLAUS: Putting the 'fact' back into 'putrefaction'. But even if it's all so mortifying, it's obviously an allegory for making art and how that can power a smart kid to confront all the abject muck in her brain. Nobody said it would be a picnic. *Frankenstein*'s about the energy of the imagination plus Prometheus, CGI, *Videodrome* and so much more. 'Long live the new flesh!'

HERMIONE (*pensive*): Funny how in the movies, Karloff growls but in the book, the Creature talks like

he's in *Paradise Lost*. The monster being 'reasonable' messes with a threshold – the 'self and other' thing, I'd guess you'd call it – that needs to be kept intact so we can feel superior.

KLAUS (*points to self, groaning like Karloff*): I monster... you human.

HERMIONE: That's why there's more cat-and-mouse in the book. Victor calls the Creature 'My own vampire' when he's trying to escape him.

KLAUS: Monster consciousness can be kind of dumb.

HERMIONE: The lights are on, nobody's home.

KLAUS: Which is maybe the scariest thought of all: an empty head.

HERMIONE: Or the attraction. What's a monster thought anyway? Any thought that's bad or any thought you don't want to have? Killer thoughts... (*thinks*) Which you know all about, Klaus. We've pussyfooted around why everybody has a crush on the vampire. Tell me, please.

KLAUS: I could talk about the joy of cruising for new flesh, devouring it like wild strawberries, but if you're not feeling rhapsodic... well, the Greeks depicting Death as a beautiful youth would be one of the oldest reasons. James Dean or the iconography of punk rock would also be contenders: live-fast-die-young and show off a gorgeous corpse.

HERMIONE: (*reciting Kurt Cobain's vow from MTV interview in December 1993 in his strung-out mumble*): 'If I'm gonna die, if I'm gonna kill myself, I should take some drugs, I may as well become a junkie...'

KLAUS: Primal anxieties about blood flamed up by AIDS are in the mix, too. A spike in heroin use between the late '80s and mid-'90s is also responsible: grunge, heroin chic: *The Lost Boys*, Coppola's *Dracula*,

Interview With A Vampire. There's a metaphorical continuity between hunger for dope and lust for blood. And in the era of the zombie apocalypse, heroin use is riding high again in the ghettos, trailer parks and tower blocks.

HERMIONE: In Hammer Horror's *Dracula*, Van Helsing says vampirism is 'similar to addiction to drugs'.

KLAUS: And mortals like to fantasise about eternal life, not thinking how grim it is, or how a vampire sells their heart and becomes a beast.

KLAUS *sweeps the cloak across his face, revealing a terrifying wolf head: sharp fangs, grey fur, wicked red eyes.*

HERMIONE: Oh, what big teeth you have.

Klaus-as-Werewolf growls, hungry. Hermione sweeps the cloak across his face again and he reappears with the face of the demon that flashes through The Exorcist *(1973), bone-white, baring yellow teeth and his eyeballs ringed with gore.*

HERMIONE: Oh, what big eyes you have.

She sweeps the cloak across his face again and he returns to his old self.

KLAUS: Like Jonathan Harker asks in *Dracula* –

The TRICK-OR-TREATERS *reappear.*

TRICK-OR-TREATERS: 'What manner of man is this or what manner of creature is it in the semblance of man?'

HERMIONE: A conundrum never to be solved.

They kiss, the bed shakes wildly and all the lights in the room strobe, making the skull beneath KLAUS' *flesh evident. They come apart, he whispers into her ear and the* TRICK-OR-TREATERS *appear – some holding dimly glowing pumpkins – and howl like wolves again.*

KLAUS (*leaping up, imitating Heather O'Rourke in* Poltergeist): They're here! (*Normal voice*) The children of the night, what music they make! It's burial time!

The trick-or-treater dressed as Dracula runs forward eagerly, a box under his arm. RAVEN *swoops in through the window.* HERMIONE *claps: malevolent winter trees shoot through the floor and a thick layer of dead leaves lie underfoot.*

HERMIONE (*quoting* Faust): 'We have entered, so it seems / Zones of magic, zones of dreams.'
KLAUS: We've reached the end of the night. Permit me to leech some energy from the poet and critic Bruce Hainley. In 2013, very much seeing the monster as a sign of the times, he asked, 'Why are we so overrun with superheroes, lycanthropes, werebeings of all sorts ... the undead? (*Grins*) Endless vampires and zombies. Monstrous beings, not just on TV shows, in movies and books but even in commercials – ' *Twilight, X Men, Game of Thrones, The Walking Dead, Stranger Things* ' – such hauntings tally as the mainstream's way of figuring that, on the level of the imaginary, life as life is pretty much not worth living and one must be supernatural just to get by, just to deal or exist at all.' Arriving in 2003 with the Iraq War in full swing, *Spook House* is a super-prescient account

of this supernatural world. Ordinary humans have gone into the sepulchre; 'monstrous beings', zombified or not, allow you to imagine transcending earthly horrors. What was once a wicked end-of-the-century aesthetic now ghosts through much of our entertainment. Hainley claims it's a manifestation of mourning displaced onto our dreams...

TRICK-OR-TREATERS: 'It's all a return of the repressed, figurative P.T.S.Ds re: almost a decade, courtesy of various Patriot Acts, of not even being able to show the *coffins* of war dead returned home. A decade of brutal memorial censoring causes corpses to appear everywhere.'

HERMIONE: 'In my world, everything's dead and brought back to life in a zombielike state.'

KLAUS: This might just be our black comedy, our dark way of dealing with life right now through fantasy, or proof that we all want to be something bigger, wilder, something... *other*. Monsters reign. Now let's hit the crypt, kitten.

HERMIONE: What did you have in mind?

KLAUS: Über-fun.

KLAUS *produces a book of spells and a dead black cat from his cloak.* HERMIONE *eyes them, licks her lips and throws her arms around his neck.*

HERMIONE (*purring*): Delicious.

Noise of the audience whooping and cheering.
RED RIDING HOOD *steps forward and as she reads the final lines in the voice of Jenny Agutter from* An American Werewolf in London, *the young Dracula madly digs a hole in the earth with his hands, shoving in*

235

the box at the last moment.

RED RIDING HOOD: For the last *Goat Project* performance, shortly before sunrise, Jamie took many of the negatives documenting his wrestling matches along with the costumes and buried them in a box somewhere in the Hollywood Hills so they would go on haunting the city. The witness said, 'he was laughing the whole time.'

All the TRICK-OR-TREATERS *bow,* HERMIONE *and* KLAUS *kiss and Vincent Price's insane laughter from 'Thriller' by Michael Jackson loops over and over again.*

FOR ARTHUR AND ALL THE
OTHER MUTTS

'I'm really beyond the grave and no more assignments
please.'
—— Arthur Rimbaud

Dear Diary,
Now that the show is over, I guess I should slink off with
a few words of wisdom – ha! – but I can't because I'm oh-
so-scared right here in my bedroom, just after midnight,
and there are monsters I want to dream about for a while
longer. Nothing is ever complete, obviously. (Can't send
another letter to my old pal, the Beast, he's been hiber-
nating forever.) I feel like Max from the illustration on
the last page of *Where the Wild Things Are* stumbling back
from the jungle, still in his wolf suit, a little dazed with
the magic spell not quite broken. (In the picture, his
fuzzy lupine paw still scratches at his human head– I
always thought that was funny.) All my masks – witch,
vampire, Krampus, Alice – are lying on the floor.

 Uh, but about 'right here' and now and being 'oh-so-
scared': the feeling of living within a freak show and/
or dystopia is difficult to escape, not just because of
Trump, though he's the most hideous candidate. Zoning
out, distorting my own voice until (hopefully) 'I' kind
of vanished was sometimes just a strategy for dealing
with this brand of beastliness in ascendance and the
wretched inevitability of its triumph. Rampant greed,
virulent racism (which is being treated like something
too long repressed), somebody's astronomical bank
balance being invoked to prove their personal 'value',
wisdom and cunning –
 I just can't.

It all makes me want to scream into a hole.

And what I wanted to write in conclusion about *Satan in His Former Glory* (c. 1805), that painting by William Blake where the devil appears as a beautiful youth, wings at full span, surrounded by illuminated harps and fairies, Beastie, the magic toyshop gothic scenes in the video for 'Lullaby' by The Cure ('The spider-man is having me for dinner tonight!') or *The Secret Diary of Laura Palmer* (1990) by Jennifer Lynch (still unacknowledged as one of the most scarifying books about adolescence) now seems kind of... *far away.*

When I began thinking about monsters seriously, I didn't have this other kind of hideousness or horror (which the present moment supplies in abundance, natch) on my mind. I was thinking about the liberations that come with transforming into an animal, gobbling hallucinogens or getting deranged in the name of art in the name of art. I saw this German tabloid nicknamed Trump the 'Horror-Clown' on the eve of his election which is an acute description for a figure who's simultaneously direct from a nightmare and just a repulsive fucking goon. As more than a few pundits have pointed out, the outbreak of 'killer clown' pranks plaguing cities in the USA around election season was just preparation for Trump's reign. And there is the so-called 'Halloween mask theory', that scary factoid proving that whoever sells more fright masks of their likeness to trick-or-treaters that night eventually wins the election, verifiable ever since Ronald Reagan (the monster daddy to the ogres in charge today) beat Jimmy Carter in 1980. But what do you do when a 'horror-clown', a bogeyman, occupies a role of supreme power? Difficult to think of a response that won't somehow involve everybody turning more cold-hearted, like when the little

240

girl's being tested by the doctor in *The Exorcist* and she snarls, 'I don't feel anything.' (I still love the moment in that Nirvana track from *In Utero* – I must have been eleven or something when I first heard it – where Kurt Cobain tests out the phrase 'cold heart' over and over again, screaming it at first but at last merely whimpering it. That still makes me shiver.)

What I wanted to celebrate instead is that my monsters, like some radical opposition force, are embodiments of everything such toxic ideologies wish to exclude: they embody otherness and make into art, ripping any conventional idea of beauty to shreds and replacing it with something weird and troubling of their own invention – *that's* heroic. And, yup, no little amount of 'zoning out' or trying to invent some other private world where the imagination can go wild is also crucial to their art. That's how they rebel against a reality that's too cruel or boring for them to inhabit. I mean, I really think of them as an antidote to all this ghastliness and bullshit, even if sometimes I feel guilty for wanting to be left in peace inside my imagination and not reckoning enough with all the horror going on outside. What's it like inside a monster's head? That's the other question I kept on asking myself.

.

Dear Diary,
Towards the end I was thinking a lot about that moment at the climax of *Under the Skin* where the alien played by Scarlett Johansson strips off her human suit – 'girl' turned inside out– to reveal the vulnerable creature beneath and stares, numb, at the scared face she holds in her hands. That pinpoints 'right here' and now: watching

241

the self from outside, sick of being human, nature degraded, gender undone, mind reeling.

.

Dear Diary,

I suppose all my daydreaming about Rimbaud is irresponsible too but... whatever, for a long time I really thought he was the mascot (no, he'd hate that), the *heart* of the book: he's the archetypal enfant terrible, the legendary hellion who produced volumes of bewitching verse while still in his teens, ditched his art to become a gun runner in Abyssinia and died, aged 37, rotten with cancer, in 1891. Like all my monsters, he tested his body and his mind, he caused trouble (he started fires in attics, he stabbed his lover Verlaine, he jerked off in a friend's glass of milk) and he conjured this wild imaginary world through his work. A demon jumps up in his suite of poems, *A Season in Hell*, and howls, 'You will never stop being a hyena!' The same demon – Dionysus on a ferocious comedown – 'once wreathed such lovely poppies round my head'. But Rimbaud's also gorgeous and he's a ghost. I wanted to test the definition of 'monster' and mess it up and feed it different substances. I think Alfred Jarry was imagining Rimbaud, way more than his *Ubu Roi*, when he wrote those lines about the monster as 'an original, inexhaustible beauty'.

.

Dear Diary,

I watched *Total Eclipse* a few days ago, the biopic of Rimbaud from 1995, starring Leonardo DiCaprio. Rimbaud was just one of the sweet and tender hooligans

Leo played in this early phase of his career. Roll call: Richard the troubled wannabe writer from *This Boy's Life* (1993) who grows to loathe his hayseed stepfather, Robert de Niro; a teenage version of the poet Jim Carroll in *The Basketball Diaries* (1995), a dreamy Catholic boy who combines his passion for shooting hoops with huffing glue and ends up a junkie hustler, howling for his mother in the middle of a New York snowstorm. (It was Rimbaud's tale re-staged with skyscrapers and dirty spoons.) And he was Arnie in *What's Eating Gilbert Grape* (1993), a mentally disabled teenager who hides in trees, laughing, flicks at his nose to fire up his brain and tugs awkwardly on Johnny's Depp's sleeve. Leo had spent research time at a California institute for similar kids and he doesn't so much perform as become this wild boy, responding to the simple things of the world with manic glee. (Rimbaud routinely casts himself as 'the troublesome / Child, that so stupid creature' or brags 'I am a brute / I have no moral sense' in between roaming springtime forests that echo with 'idiot laughter'.) Arnie slouches on his father's grave, accidentally dissing the old man, family and the notion of respect for the dead.

A Season in Hell would be a good name for a film about teen life. Hell, as Rimbaud understood, can be enormous fun. Hell can be Wonderland...

'His mother called him "Wild Thing!" / and Max said, 'I'll eat you up!'/so he was sent to bed without eating anything.'

And his bedroom turns into a jungle and he sails through night and day to the land of the Wild Things.

Not far-fetched, not for a moment, to hear an echo of Max's unseen mother yelling 'Wild Thing!' in Rimbaud's cry of 'Enfant monstre!' from *Illuminations*, which John Ashbery's luminous translation renders as

'monstrous child!' That's Rimbaud's moment of defiant self-identification. I can see him, face filthy, bellowing the line in the woods at sundown. For a while, Rimbaud played the monstrous child with mad-eyed verve before hanging up his own wolf suit and departing for Africa and riding a ship of his own across the big green sea: a boy, a monster riding by the tide, just like Max.

There's that sequence of paintings by Mike Kelley, *Pay For Your Pleasure*, where Rimbaud's face is kind of warped and plutonium green to endow him with extra hazmat riskiness, that ferocious quotation, 'I am a brute, I have no moral sense' hanging over his head. Repeatedly the boy thinks of himself in this savage form, 'leaping on every human joy like a wild beast', kicking off *A Season in Hell* with an invocation of his 'bad blood' or bragging, 'I belong to a race that sang at the gallows'. This time what really shook me was the moment where Leo's scribbling furiously in a weatherbeaten barn with that black velvet donkey, watchful, over his shoulder. I was thinking that if somebody wanted to accurately capture the strange weather of Rimbaud's poetry on film, we'd have suddenly to tumble into the donkey's mind ('hee-haw!') in the middle of that scene, the poor animal staring at himself in a barn puddle and not knowing it was his face in the water, upside-down, dizzy.

Leo (or his likeness) would soon become art objects, too. Karen Kilimnik painted him at his most goblin in 1998, dirty blonde and pre-pubescent with a look of stoned but amiable stupor in his little puppet eyes for the picture *Prince Albrecht at Home at the Castle on A School Break*. She casts him in this fantasy, spiking Warhol's clinical obsession with celebrity with the love-struck air of teen girl portraiture, historical re-enactment and stalker scrapbooks.

244

During that interview with *Detour* conducted by Dennis Cooper in 1996, Leo thought again about why he wanted to play the poet and said, 'Rimbaud's a badass. Rimbaud's like James Dean.' One teen idol laid over another: total eclipse.

.

Dear Diary,
Here are some questions I would have asked Leo if I was interviewing him in the 1990s:

a) When you were a boy in Echo Park what was your best Halloween costume: wolf-boy, non-specific TV mutant or comic book superhero?
b) Who's your favourite rapper in the Wu-Tang Clan? (He revealed his love of hip hop in the course of that chat with Cooper.)
c) What's your favourite Rimbaud line? 'Hymns don't carry on the air of Hell!' or 'I stretched out in the muck'?

.

Dear Diary,
I still have all these notes on Rimbaud. I'm still eager to go down that rabbit hole. Look...

By the time he was twenty in 1874, Rimbaud wanted to abandon poetry like so much boring homework: his masterpieces were complete and his energies were spent. Numerous copies of *Illuminations*, his final suite of poems, were ditched at the printer's in Belgium. There he is as the pensive boy at the margins of the famous painting by Henri Fantin-Latour (*By the Table, Rimbaud, Verlaine and the Bad Men*, 1872) or in Etienne Carjat's

245

photograph, outlined against a blizzard, Orpheus reborn as a hoodlum. (By Fantin-Latour's hand, Rimbaud appears all misty, as if his existence was, even then, difficult to believe.) Reportedly the first time he got stoned on hashish he was disappointed that the drug only unveiled hazy pictures of the blue moon to him. A caricature by a close pal shows him 'drinking with a white polar bear' during travels to Scandinavia, or perhaps it was at the zoo in Copenhagen or when he was the cashier of the travelling circus. The ringmaster had 'two beautiful daughters,' Starkie claims, 'one of them eventually married a Russian prince and the other died of an accident during her equestrian turn.'

In *Total Eclipse*, Leo knocks back wine at noon down rainswept boulevards, growls in imitation of a mutt and dandyishly pins dead butterflies to his pyjamas. To the delight of teen girls everywhere, he appears on the rooftops, nude, body licked by a fire below, shouting at Verlaine. 'Suck on this, Parnassus!' is the feel of Leo's performance, assisted by a devilish sneer. River Phoenix had the role until that Halloween speedball intervened, guaranteeing him his own legend, and he would have been awfully miscast, too spacey, too lacking in all the cunning that Leo can hint at just by smoking his pipe.

But, yeah, I think it's a sensible movie when the 'sensible' doesn't really exist in Rimbaud's world: if hyenas appear, there are also jungles, clowns, urchins, blue feathers, 'magic flowers, droning' and various 'amazing beasts', horses, the poet in the form of a bear, 'fur turned hoary with grief'. If anybody's life required a full bombardment of fauns, tigers, dream sequences, not to mention the aurora borealis rioting in his mind, or, contrariwise, the bruising realist treatment in order to be believed, it's little Arthur's. His existence takes the

246

form of a meteor. He wondered, 'What witch will rise up on the white sunset?' and wrote of boys with 'green apple flesh'.

What I really like about Enid Starkie's biography, *Arthur Rimbaud* from 1947, other than its wise alchemical slant that casts the poet as something like the Sorcerer's Apprentice, destroyed by the supernatural forces he invoked, is that the author doesn't insist on verification for every footprint or close encounter. In Starkie's telling, Rimbaud is a magician and a rascal. She notes that the prodigious sixteen-year-old who wrote 'The Drunken Boat' had to invent the sea within his own mind, depending on a maelstrom of quotations, gothic lore, disquisitions on the submarine life, Poe, Baudelaire and Michelet (who also wrote a fine history of witchcraft, *La Sorcière*, in 1862 – Rimbaud is always summoning witches) because he never saw the sea in reality until he was taken on a trip to the coast by Verlaine. Awestruck Parnassians encountering the boy for the first time in Paris referred to him as 'Satan' and Verlaine, who always struggled with his contrary urges towards wickedness or virtue, similarly represented him in letters as an angel and a snake demanding he consume fatal delights from the Tree of Knowledge.

They reached the shore together. Sea breeze, aquatic light, beach wrack, green foam: to be submerged in the water, all noise reduced to a warm mumble, not having many thoughts at all, was to be at peace. No one else would comprehend that sensation of being inexplicable. There were all these wild songs in his head that nothing in his background could explain, other than a heap of devoured books: scary to have such magic inside yourself and knowing it needs to be expelled. The banquet of the imagination, glimpsed in the prologue to *A Season*

in Hell, can suddenly turn rancid: one moment, the poet takes Beauty on his knee – intoxicated kisses, murmurs in his ear – and the next they are brawling: 'I found her bitter, and I insulted her.' To drown this singing creature may have been a self-protective measure, another means of escape. He returned to the waking world: quantifiable luxuries, changing tides, sunshine drooling through the trees.

Long before, in the famous letter where he insists on 'a reasonable derangement of the senses', he also claimed a poet's task is to 'make the soul monstrous' (limits razed, virtues violated) and writes with all the flair of modern Prometheus about 'stealing fire' in order to succeed. The scamp never pauses to wonder what curses might be unleashed by such reckless moves. Prometheus, Anne Carson says, must endure 'sawing, hammering, harvesting, slaughtering, scrubbing' inflicted upon his body once he goes against the gods. All the loss, physical dereliction and inertia that Rimbaud experienced after completing *Illuminations* is just comeuppance for the glories he knew in his youth.

His old self was left on the jetty at Marseilles in 1875, disintegrated, like a vampire in sunlight. Much as he always imagined his poetry in the form of a journey – that wander through the forest in *Illuminations* where he sees the troupe of lost clowns; a summer spent, dead, surveying the marvels of hell – the shape of his life could be split between those two clandestine journeys, one to Paris in late August 1871 attempted as his gifts were coming into focus and this other to Africa four years later when poetry was abjured. (Starkie reports, 'At eleven o' clock, he left his friends and none of them was ever to see him again.') Following that first impulsive trip to Paris, he ran away from home repeatedly. No

matter that he was immediately conveyed to jail upon arrival, penniless, some layer of ice keeping him quiet melted away afterwards. These escapes, too, acted as mere practice runs for his eventual departure to another continent.

At school, the other boys eyed him warily: such were his talents, along with his strange, nervous silence, they wouldn't have been surprised if sometimes he spat roses from his mouth.

.

Dear Diary,

Confession: there are things I'd like to have in my own private Rimbaud film, if I could make one. When the book was half-dead or just stream-of-consciousness raving, I kept imagining it. I know Todd Haynes made that short film, too, when he was a student that he's shown a handful of times in like three decades, *Assassins: A Film Concerning Rimbaud* (1985) and, duh, I was intrigued by the fact of that movie being split into eight stylistically promiscuous chapters (didn't even remember that until I was halfway through the book) and the vow by one theorist that '*Assassins* is less about Arthur Rimbaud the real boy-poet than it is about 'Rimbaud', a character we have largely constructed from his writings and the myths and legends that have grown up around him.'

In my film, Rimbaud in childhood would be played by a stray dog but Rimbaud in his teens would be played by Linda Manz or maybe one of Larry Clark's hoodlums. In freaky sequences, the morning after writing in his poem 'The Deserts of Love' (c. 1871-2) about 'longing to die' in the attic of his mother's farmhouse, he appears at the breakfast table and proudly shows off his new gold

wings and pointed tail. A sheaf of Rimbaud's rediscovered childhood drawings is displayed to the camera, including pictures slick with crayon gore that depict him riding a lion. Photographs show him in Abyssinia, smoking opium. I figured there would be a big musical number where he sang 'I Put A Spell On You' by Screamin' Jay Hawkins to a band of London pickpockets – he wrote *Illuminations* in the capital – leading them along a rooftop by night, and dancing wildly when all the horns erupt like rowdy drunks. There would be a picture of the teenage Rimbaud, arm around his older brother, stiff as a scarecrow, and both of them grinning happily even though Jean appears just as Rimbaud imagined him in *A Season in Hell*, 'mouth rotten, eyes gouged out'. Out roaming in the big empty field beyond the farmhouse, a teenage Rimbaud would discover the corpse of a dog, melted by the caresses of the sun, and howl in sympathy, garlanding the carcass with dead flowers and weeds. There would be a shot of the dog's senseless white eyeball, recalling the full moon.

Using Rat and another kid from *Streetwise*, I'd re-enact the scene described in Starkie's biography where he visits the jetty by the river in Charleville with his brother when he was a small boy: 'Sometimes,' Starkie writes,

> Arthur would stand up in the boat and sway it from side to side as if it were being buffeted by a violent storm and then he would cry out to his brother to look at the immense waves beating against the stern of the vessel.

And sometimes,

he would gaze down into the depths, seeing the weeds beneath him tropical vegetation and strange oceanic monsters. But inevitably the school bell rang and he was obliged, reluctantly, to tear himself away from his dreaming.

His last letter, dictated to his sister Isabelle on 9 November 1891, the day before his death, addresses the owner of a steamship company (twelve tusks will be shipped in five boxes) and yet strikes a tone of self-flagellating candour usually reserved for intimates. Propped up in bed, a leg gone and his fever raging, he claims, 'I am helpless and unhappy, I can find nothing, the first dog in the street will tell you that ... I am completely paralyzed ... Tell me what time I need to be carried on board.' It would be amazing to have a woman (maybe Charlotte Gainsbourg) read those lines in voice-over, just to make things a little stranger. Fade out on the waves; no sound but the noise of the sea growing fainter all the time.

.

Dear Diary,
He was buried in November, which is to say 225 years ago this month. The coffin was shrouded in velvet and led through the streets of Charleville to the cemetery, accompanied by black horses, priests, 'choirboys in their surplices and cassocks and twenty orphans, each holding a lighted candle.' A chill morning: nobody speaks at the graveside and the coffin is committed to the earth in silence. He buried the shameful child he used to be long before that but occasionally, in the mirror, he must have caught an old flash of the youthful daring in his eyes

and felt a glow inside his stomach: 'A little secret', his re-flection imparted, 'between you and me'. His body was changed almost beyond recognition: tough, all the old vulnerability outgrown, his skin cooked by the African sun. 'Rimbaud' died when he was twenty years old.

In the film, there would be a scene that showed him at fifteen slipping away from the house in the moonlight as a storm whips the trees. Rimbaud would sneak through the woods, his shadow looming against the gaunt barn. We'd chase him as he ran faster and faster. Between the trees he'd hallucinate wolves lying in the bloody sun and he'd fetch a snake, hissing, from the water's edge, sticking out his tongue in parody of a kiss. The future will be a huge bright carnival. He will sink his teeth into whatever black fruits he's offered. We'd see the birds take off in waves against the sky, fleeing the boy on fire.

APPENDIX

Illustrations

89 Udo Kier as Count Dracula in *Blood for Dracula*, (1974).
 Directed by Paul Morrissey.
 Film still.

90 Andy Warhol's poster for Rainer Werner Fassbinder's *Querelle*,
 (1982). Copyright © 2016 The Andy Warhol Foundation for the
 Visual Arts, Inc. / Artists Rights Society (ARS), New York and
 DACS, London.
 Film poster.

98 Leigh Bowery in *Teach*, (1992-98)
 Directed by Charles Atlas.
 Film still.

110 Leigh Bowery with assistant Nicola Bateman, Fergus Greer, (1988).
 Photograph.
 Copyright © Fergus Greer. Courtesy Fergus Greer.

113 Divine as Dawn Davenport in *Female Trouble* (1974).
 Directed by John Waters.
 Film still.

133 *Alice and the Caterpillar*, illustration for *Alice in Wonderland*,
 John Tenniel, (1865).
 Illustration.

139 Tim Curry as Darkness in *Legend*, (1985).
 Directed by Ridley Scott.
 Film still.

144 *Self-Portrait*, Claude Cahun, (1928).
 Photograph.
 Courtesy © Jersey Heritage Collections. Courtesy Jersey
 Heritage Collections.

145 *Le Mystère d'Adam*, Claude Cahun and Marcel Moore, (1929).
 Gelatin silver print; 4 x 3 in. (10,16 x 7,62 cm).
 San Francisco Museum of Modern Art, fractional and
 promised gift of Carla Emil and Rich Silverstein.
 Copyright © Estate of Claude Cahun. Photograph: Don Ross.

152 Dennis Hopper and Linda Manz in *Out of the Blue*, (1980).
 Directed by Dennis Hopper.
 Film still.

156 Dennis Hopper as Billy in *Easy Rider*, (1969).
 Directed by Dennis Hopper.
 Film still.

160 Court photograph of Ricky 'The Acid King' Kasso, (1984).
 Photograph.

163 Cover image from *The Perfect Childhood*, Larry Clark, (1993).
 Copyright © Larry Clark. Courtesy Larry Clark
 and Simon Lee Gallery.

171 *Untitled*, from the *Tulsa* series, Larry Clark, (1971).
 Black and white photograph.
 35,56 x 27,94 cm (14 x 11 in.)
 © Larry Clark, image courtesy of the artist, Luhring Augustine,
 New York, and Simon Lee Gallery, London / Hong Kong.

179 Jacob Sewell as Bunny Boy in *Gummo*, (1997).
 Directed by Harmony Korine.
 Film still.
 Courtesy Harmony Korine.

186 Macaulay Culkin in the music video for *Sunday* (1998)
 by Sonic Youth.
 Directed by Harmony Korine.
 Film still.
 Courtesy Harmony Korine.

196 Isabelle Adjani and Klaus Kinski in *Nosferatu the Vampyre*, (1979).
 Directed by Werner Herzog.
 Film still.

206 *Black Sun*, Sue de Beer, (2006).
 Film still.
 Copyright © Sue de Beer. Courtesy Sue de Beer.

Monster Materials

Reading, Watching, Looking, Listening

SELF-PORTRAIT AS A WEREWOLF

Books and essays

Nina Auerbach, *Our Vampires, Ourselves* (1995)
J. M. Barrie, *Peter Pan* (1911)
Ossian Brown, *Haunted Air* (2010)
Angela Carter, *The Bloody Chamber* (1979)
Emilie Friedlander, Daniel Lopatin interview, *Thump* (November 2015)
Vladimir Nabokov, 'Scenes from the Life of a Double Monster', *Nabokov's Dozen* (1958)
Ovid, *Metamorphoses* (8 AD)
Chis Randle, Derek McCormack interview, *Hazlitt* (October 2015)
Mary Shelley, *Frankenstein* (1818)
Bram Stoker, *Dracula* (1897)
Frederick Treves, *The Elephant Man and Other Reminiscences* (1923)
John Waters, *Shock Value* (1981)

Film and television

A Clockwork Orange (Stanley Kubrick, 1971)
A Family Finds Entertainment (Ryan Trecartin, 2004)
An American Werewolf in London (John Landis, 1981)
Beauty and the Beast (Jean Cocteau, 1946)
Beauty and the Beast (Gary Trousdale and Kirk Wise, 1991)
Black Swan (Darren Aronofsky, 2010)
Buffy the Vampire Slayer (TV series, 1997-2003)
Come to Daddy (Chris Cunningham, 1997)
Divine Waters (Vito Zagarrio, 1985)
Edward Scissorhands (Tim Burton, 1990)
Eraserhead (David Lynch, 1977)
The NeverEnding Story (Wolfgang Petersen, 1984)
A Nightmare on Elm Street (Wes Craven, 1984)
A Nightmare on Elm Street (Samuel Bayer, 2010)
Nosferatu (F. W. Murnau, 1922)
The Phantom of the Opera (Lon Chaney, Rupert Julian,

Edward Sedgwick, Ernst Laemmle, 1925)
Poltergeist (Tobe Hooper, 1982)
Snow White and the Seven Dwarfs (David Hand, 1937)
Stranger Things (TV series, 2016)
Thriller (John Landis, 1983)
Twin Peaks (TV series, 1990-91)
Water Me (Jesse Kanda, 2014)

Music

Captain Beefheart, *Shiny Beast (Bat Chain Puller)* (1978)
David Bowie, *Diamond Dogs* (1974)
My Bloody Valentine, *Loveless* (1991)
Oneohtrix Point Never, *Garden of Delete* (2015)

'THE LITTLE BOY WHO CAN'T BE DAMAGED!'

Books and essays

James Agee, *Let Us Now Praise Famous Men* (1941)
Buster Keaton, *My Wonderful World of Slapstick* (1960)

Film and television

The General (Buster Keaton, Clyde Bruckman, 1926)
The Playhouse (Buster Keaton, Edward F. Cline, 1921)
Sherlock Jr. (Buster Keaton, 1924)

UNTITLED (FREAK)

Books and essays

Diane Arbus, *Diane Arbus: An Aperture Monograph* (1972)
Diane Arbus, *Untitled: Diane Arbus* (1995)
Diane Arbus, *Revelations* (2003)
Georges Bataille, 'On Deviations from Nature', *Visions of Excess: Selected Writings, 1927-1939* (1985)
Patricia Bosworth, *Diane Arbus: A Life* (1982)
Franz Kafka, 'Investigations of a Dog' (1922)

Leslie Fielder, *Freaks: Myths and Images of the Secret Self* (1980)
Rhonda Lieberman, 'Diane Arbus: Revelations', *Artforum*
(September 2003)
Arthur Lubow, *Diane Arbus: Portrait of a Photographer* (2016)
Flannery O'Connor 'A Temple of the Holy Ghost', *A Good Man Is Hard to Find and Other Stories* (1955)
Edgar Allan Poe 'Hop-Frog' (1849) from *Complete Tales and Poems* (2014)
Avital Ronell, *Stupidity* (2002)
August Sander, *Face of Our Time* (1929)
Gloria Steinem, 'After Black Power, Women's Liberation', *New York Magazine* (April 1969)
Susan Sontag, 'America, Seen Through A Glass, Darkly', *On Photography* (1977)

Film and television

The Brain that Wouldn't Die (Joseph Green, 1962)
Even Dwarfs Started Small (Werner Herzog, 1970)
Female Trouble (John Waters, 1974)
Freaks (Tod Browning, 1932)
It's A Wonderful Life (Frank Capra, 1946)
Los Olvidados (Luis Buñuel, 1950)
Satyricon (Federico Fellini, 1969)
Wild at Heart (David Lynch, 1990)

Music

The Stooges, *Fun House* (1970)
New York Dolls, *New York Dolls* (1973)

HERR FASSBINDER'S TRIP TO HEAVEN

Books and Essays

Robert Katz, *Love is Colder Than Death* (1987)
Madonna, *Sex* (1992)
Ian Penman, 'R.W. Fassbinder: Love is Colder than Death',
Vital Signs (1998)
Andy Warhol, *The Andy Warhol Diaries* (1989)

Film and television

Ali: Fear Eats the Soul (Rainer Werner Fassbinder, 1974)
Blood for Dracula (Paul Morrissey, 1974)
Berlin Alexanderplatz (Rainer Werner Fassbinder, 1980)
The Bitter Tears of Petra Von Kant (Rainer Werner Fassbinder, 1972)
Chinese Roulette (Rainer Werner Fassbinder, 1976)
The Devil, Probably (Robert Bresson, 1977)
Effi Briest (Rainer Werner Fassbinder, 1974)
Empire (Andy Warhol, 1964)
Fox and His Friends (Rainer Werner Fassbinder, 1975)
Germany in Autumn (Rainer Werner Fassbinder, et al, 1978)
Hairspray (John Waters, 1988)
I Don't Just Want You to Love Me (Hans Günther Pflaum, 1992)
In a Year of 13 Moons (Rainer Werner Fassbinder, 1978)
Lebensläufe (*Life Stories*) (Rainer Werner Fassbinder, 1978)
Lili Marleen (Rainer Werner Fassbinder, 1981)
Lola (Rainer Werner Fassbinder, 1981)
Love is Colder than Death (Rainer Werner Fassbinder, 1969)
The Magick Lantern Cycle (Kenneth Anger, 1947-1981)
The Merchant of Four Seasons (Rainer Werner Fassbinder, 1972)
Mother Küsters' Trip to Heaven (Rainer Werner Fassbinder, 1975)
Querelle (Rainer Werner Fassbinder 1982)
Rio das Mortes (Rainer Werner Fassbinder, 1971)
Satan's Brew (Rainer Werner Fassbinder, 1976)
The Third Generation (Rainer Werner Fassbinder, 1979)
Veronika Voss (Rainer Werner Fassbinder, 1982)
World on a Wire (Rainer Werner Fassbinder, 1973)

'I JUST ADORE EXTREMES'

Books and Essays

Hilton Als, 'Life As A Look' *The New Yorker* (1998)
Anne Carson, *Autobiography of Red* (1998)
Bob Colacello, *Andy Warhol's Exposures* (1979)
Suzanne Cotter, Michael Bracewell, Stephanie Jordan, *Michael Clark* (2011)
Anne Deniau, *Love Looks Not With The Eyes: Ten Years with Lee Alexander McQueen* (2012)
Fergus Greer, *Leigh Bowery Looks* (2002)

Giacomo Leopardi, *Dialogue Between Fashion and Death* (1824)
Derek McCormack, *The Well-Dressed Wound* (2015)
Sue Tilley, *Leigh Bowery: The Life and Times of an Icon* (1997)
Robert Violette (ed.), *Leigh Bowery* (1998)
Andy Warhol, *Andy Warhol's Diaries* (1989)
Claire Wilcox (ed.), *Alexander McQueen* (2015)
Oscar Wilde, *The Picture of Dorian Gray* (1890)

Film and television

The Clothes Show (1988)
Cutting Up Rough (TV documentary, 1997)
Desperate Living (John Waters, 1977)
Hail the New Puritan (Charles Atlas, 1986)
The Hunger (Tony Scott, 1983)
The Legend of Leigh Bowery (Charles Atlas, 2002)
Living Inside (Sadie Benning, 1989)
Party Monster (Fenton Bailey, Randy Barbato, 2003)
Pink Flamingos (John Waters, 1972)
Poison (Todd Haynes, 1991)
The Rain (Hype Williams, 1997)
The Red Shoes (Michael Powell, Emeric Pressburger, 1948)

Art

Jerome Caja, *Bozo Fucks Death* (1988)
Michael Clark Company, *No Fire Escape in Hell* (1986)
Alexander McQueen, *Savage Beauty* (V&A, London, 2015)

Music

Marilyn Manson, *Mechanical Animals* (1998)

TRANSFORMER

Books and essays
André Breton, *Anthology of Black Humour* (1940)
Claude Cahun, *Disavowals* (1930)
Lewis Carroll, *Alice's Adventures in Wonderland* (1865)
Lewis Carroll, *Through the Looking-Glass, and What Alice Found There* (1871)

James Joyce, *Finnegans Wake* (1939)
Vladimir Nabokov, *Lolita* (1955)
Sophocles, *Antigone* trans. by Anne Carson (2015)

Film and television

Cash from Chaos/Unicorns and Rainbows (Alex Bag, TV series, 1994-97)
Cat People (Paul Schrader, 1982)
Cindy Sherman: Nobody's Here But Me (Mark Stokes, 1994)
Days of Heaven (Terrence Malick, 1978)
Easy Rider (Dennis Hopper, 1969)
Halloween (John Carpenter, 1978)
Labyrinth (Jim Henson, 1986)
Legend (Ridley Scott, 1985)
Mouchette (Robert Bresson, 1967)
Mulholland Drive (David Lynch, 2001)
Out of the Blue (Dennis Hopper, 1980)
Sibling Topics (Ryan Trecartin, 2009)
The Texas Chainsaw Massacre (Tobe Hooper, 1974)
Wanda, (Barbara Loden, 1970)

Art

Coven Services (Alex Bag, 2004)
Fairy Tales (Cindy Sherman, 1985-89)
Clowns (Cindy Sherman, 2004-05)
Polka Dots (Francesca Woodman, 1975-76)

THE DEAD END KIDS

Books and essays

Hilton Als,'Gus Van Sant's *My Own Private Idaho*', *Artforum* (October 1991)
William S. Burroughs, *Junky* (1953)
William S. Burroughs, *Naked Lunch* (1959)
William S. Burroughs, *The Western Lands* (1987)
Larry Clark, *1992* (1992)
Larry Clark, *The Perfect Childhood* (1993)
Larry Clark, *Tulsa* (1971)
Harmony Korine, *The Bad Son* (1998)

Ryan McGinley, *Moonmilk* (2009)
Russ Reymer, *Genie: A Scientific Tragedy* (1993)

Films and television

Act Da Fool (Harmony Korine, 2010)
Badlands (Terrence Malick, 1973)
Blue Velvet (David Lynch, 1986)
The Breakfast Club (John Hughes, 1985)
Bully (Larry Clark, 2001)
Dream Deceivers (David Van Taylor, 1992)
Elephant (Gus Van Sant, 2003)
Foxes (Adrian Lyne, 1980)
Gerry (Gus Van Sant, 2002)
Gummo (Harmony Korine, 1997)
Heavy Metal Parking Lot (Jeff Krulik, John Heyn, 1986)
Home Alone (Chris Columbus, 1990)
Julien Donkey-Boy (Harmony Korine, 1999)
Kids (Larry Clark, 1995)
Lolita (Adrian Lyne, 1997)
My Own Private Idaho (Gus Van Sant, 1991)
Over the Edge (Jonathan Kaplan, 1979)
Rumble Fish (Francis Ford Coppola, 1983)
Streetwise (Martin Bell, 1984)
Sunday (Harmony Korine, 1998)
The Virgin Suicides (Sofia Coppola, 1999)

Art

Larry Clark, *Teenage Lust* (1982)
Philip-Lorca diCorcia, *Hustlers* (1990-92)

Music

Air, soundtrack for *The Virgin Suicides* (1999)
Angelo Badalamenti, soundtrack from *Twin Peaks* (1990)
Captain Beefheart, *Trout Mask Replica* (1969)
Iggy Pop, *The Idiot* (1977)
Lou Reed, *Transformer* (1972)
Royal Trux, *Twin Infinitives* (1991)
Sonic Youth, *Confusion Is Sex* (1983)

SPOOK HOUSE

Books and essays

James George Frazer, *The Golden Bough* (1890)
Christopher Grunenberg *et al*, *Gothic: Transmutations of Horror in the Late 20th Century* (1997)
Michael Jackson, *Moonwalk* (1988)
Henry James, *The Turn of the Screw* (1898)
Mike Kelley, 'Playing with Dead Things: On The Uncanny', *The Uncanny*, (1992)

Films and television

Bram Stoker's Dracula (Francis Ford Coppola, 1992)
Charmed (TV series, 1998-2006)
The Craft (Andrew Fleming, 1996)
Dracula (Terence Fisher, 1958)
The Exorcist (William Friedkin, 1973)
Flesh (Paul Morrissey, 1968)
Heathers (Michael Lehmann, 1988)
Interview with a Vampire (Neil Jordan, 1994)
Kranky Klaus (Cameron Jamie, 2003)
The Making of 'Thriller' (Jerry Kramer, 1983)
Only Lovers Left Alive (Jim Jarmusch, 2013)
Salem's Lot (Tobe Hooper, 1979)
Spook House (Cameron Jamie, 2003)
Suspiria (Dario Argento, 1977)
Titicut Follies (Frederick Wiseman, 1967)
The Wiz (Sidney Lumet, 1979)
The Wizard of Oz (Victor Fleming, Mervyn LeRoy, King Vidor, George Cukor, Norman Taurog, 1939)
The Wolf Man (George Waggner, Reginald Le Borg, Julien Duvivier, 1941)
The X-Files (TV series, 1993-)

Art

Matthew Barney, *The Cremaster Cycle* (1994-2002)
Matthew Barney, *Drawing Restraint 7* (1993)
Sue de Beer, *Disappear Here* (2004)
Hieronymus Bosch, *Garden of Earthly Delights* (c. 1490-1510)

Cameron Jamie, *Goat Project* (2000-1)
Cameron Jamie, *The Neotoma Tape* (1983-95)
Mike Kelley, Cameron Jamie, *Gothic* (1997)
Karen Kilimnik, *Heathers* (1994)

FOR ARTHUR AND ALL THE OTHER MUTTS

Books and essays

Anne Carson, 'Twelve Minute Prometheus (after Aishkylos)' (2008)
Dennis Cooper, 'Rebel Just Because: The Leonardo diCaprio Interview',
Smothered in Hugs: Essays, Interviews, Feedback, Obituaries (2010)
Jules Michelet, *La Sorcière* (1862)
Arthur Rimbaud, *Illuminations* (1886) (translation by John Ashbery, 2012)
Maurice Sendak, *Where the Wild Things Are* (1963)
Enid Starkie, *Arthur Rimabud* (1947)

Film and television

The Basketball Diaries (Scott Kalvert, 1995)
This Boy's Life (Michael Caton-Jones, 1993)
Total Eclipse (Agnieszka Holland, 1995)
Under the Skin (Jonathan Glazer, 2013)
What's Eating Gilbert Grape (Lasse Hallström, 1993)

Art

Henri Fantin-Latour, *By the Table, Rimbaud, Verlaine and the Bad Men* (1872)
Mike Kelley, *Pay For Your Pleasure* (1988)
Karen Kilimnik, *Prince Albrecht at Home at the Castle on A School Break*
(1998)

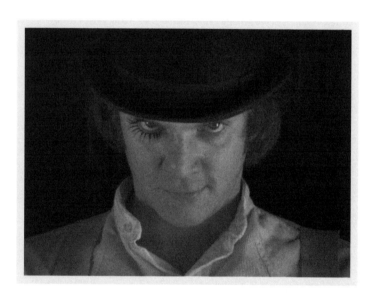

Acknowledgements

This book wouldn't exist without the friendship, intellectual razzle-dazzle or daring of the following droogs and co-conspirators: Jennifer Higgie, Bruce Hainley (a stellar dude), all my waifs in south-east London, David Noonan, Joshua Smith (bringing the ruckus forever), Jacques Testard and Ray O'Meara, my partners in crime. Howls of thanks due to Alissa Bennett, Karl McCool at EAI, Dave Markey (for Spook House lore), David Campany, Paul Clinton, Francesca Gavin, Phoebe James from Artangel and all the artists (living and dead) who let me use their magic pictures. And to Ma, Pa, Puss, Bub and Archie: love, straight from my rotten heart.

Current and forthcoming books by Fitzcarraldo Editions

Counternarratives by John Keene (Fiction)
Winner of the 2017 Republic of Consciousness Prize
'We have become accustomed in recent years to the
revisionary spirit of much postcolonial fiction, but the
ambition, erudition and epic sweep of John Keene's
remarkable new collection of stories, travelling from
the beginnings of modernity to modernism, place
it in a class of its own.'
— Kate Webb, *TLS*

Football by Jean-Philippe Toussaint (Essay)
Translated from French by Shaun Whiteside
'Toussaint has established himself as one of contemporary
French literature's most distinctive voices, turning the
existential tradition into something lighter, warmer
and ultimately more open.'
— Juliet Jacques, *New Statesman*

Second-hand Time by Svetlana Alexievich (Essay)
Winner of the Nobel Prize in Literature 2015
Translated from Russian by Bela Shayevich
'In this spellbinding book, Svetlana Alexievich
orchestrates a rich symphony of Russian voices telling
their stories of love and death, joy and sorrow, as they
try to make sense of the twentieth century, so tragic
for their country.'
— J. M. Coetzee, winner of the 2003 Nobel Prize
in Literature

The Hatred of Poetry by Ben Lerner (Essay)
'Lerner argues with the tenacity and the wildness of
the vital writer and critic that he is. Each sentence of *The
Hatred of Poetry* vibrates with uncommon and graceful
lucidity; each page brings the deep pleasures of crisp
thought, especially the kind that remains devoted to
complexity rather than to its diminishment.'
— Maggie Nelson, author of *The Argonauts*

A Primer for Cadavers by Ed Atkins (Fiction)
'The most imaginative, sincere, and horribly, gloriously
intent contemporary writer – certainly from Britain –
I've read.'
— Sam Riviere, *Poetry London*

Bricks and Mortar by Clemens Meyer (Fiction)
Longlisted for the 2017 Man Booker International Prize
Translated from German by Katy Derbyshire
'This is a wonderfully insightful, frank, exciting and heart-
breaking read. *Bricks and Mortar* is like diving into a Force
10 gale of reality, full of strange voices, terrible events and
a vision of neoliberal capitalism
that is chillingly accurate.'
— A. L. Kennedy, author of *Serious Sweet*

Nocilla Experience by Agustín Fernandez Mallo (Fiction)
Translated from Spanish by Thomas Bunstead
'The best novel I read in 2016. Thrillingly, incandescently
brilliant.'
— Stuart Evers, author of If *This is Home*

The Doll's Alphabet by Camilla Grudova (Fiction)
'That I cannot say what all these stories are about is
a testament to their worth. They have been haunting
me for days now. They have their own, highly distinct
flavour, and the inevitability of uncomfortable dreams.'
— Nick Lezard, *Guardian*

Compass by Mathias Enard (Fiction)
Winner of the 2017 Man Booker International Prize
Translated from French by Charlotte Mandell
'One of the finest European novels in recent memory.'
— Adrian Nathan West, *Literary Review*

Notes from No Man's Land by Eula Biss (Essay)
'The most accomplished book of essays anyone has
written or published so far in the twenty-first century.'
— *Salon*

Flights by Olga Tokarczuk (Fiction)
Translated from Polish by Jennifer Croft
'Olga Tokarczuk is a household name in Poland and
one of Europe's major humanist writers, working here
in the continental tradition of the "thinking" or essay-
istic novel. Flights has echoes of W. G. Sebald, Milan
Kundera, Danilo Kiš and Dubravka Ugrešić, but
Tokarczuk inhabits a rebellious, playful register very
much her own. ... Hotels on the continent would do well
to have a copy of Flights on the bedside table. I can think
of no better travel companion in these turbulent,
fanatical times.'
— Kapka Kassabova, *Guardian*

Essayism by Brian Dillon (Essay)
'Dillon's brilliantly roaming, roving set of essays on
essays is a recursive treasure, winkling out charm,
sadness and strangeness; stimulating, rapturous and
provocative in its own right.'
— Olivia Laing, author of *The Lonely City*

Companions by Christina Hesselholdt (Fiction)
Translated from Danish by Paula Russell Garrett
'I am quite certain that this book will do something
to Danish literature. Hesselholdt is part of a generation
of remarkable female authors who had their breakthroughs
at the beginning of the 1990s and who in the past decade
have turned their writing in new and surprising directions.
None of them has moved to as wild and, yes, as promising
a place as Hesselholdt has come to now.'
—— *Information*

This Little Art by Kate Briggs (Essay)
'Kate Briggs's *This Little Art* shares some wonderful
qualities with Barthes's own work – the wit, thought-
fulness, invitation to converse, and especially the attention
to the ordinary and everyday in the context of meticulously
examined theoretical and scholarly questions. This is
a highly enjoyable read: informative and stimulating
for anyone interested in translation, writing, language,
and expression.'
—— Lydia Davis, author of *Can't and Won't*

Fitzcarraldo Editions
8-12 Creekside
London, SE8 3DX
United Kingdom

ISBN 978-1910695-35-7

Design by Ray O'Meara
Typeset in Fitzcarraldo
Printed and bound by TJ Books

fitzcarraldoeditions.com

Fitzcarraldo Editions